PAINTED GARDENS

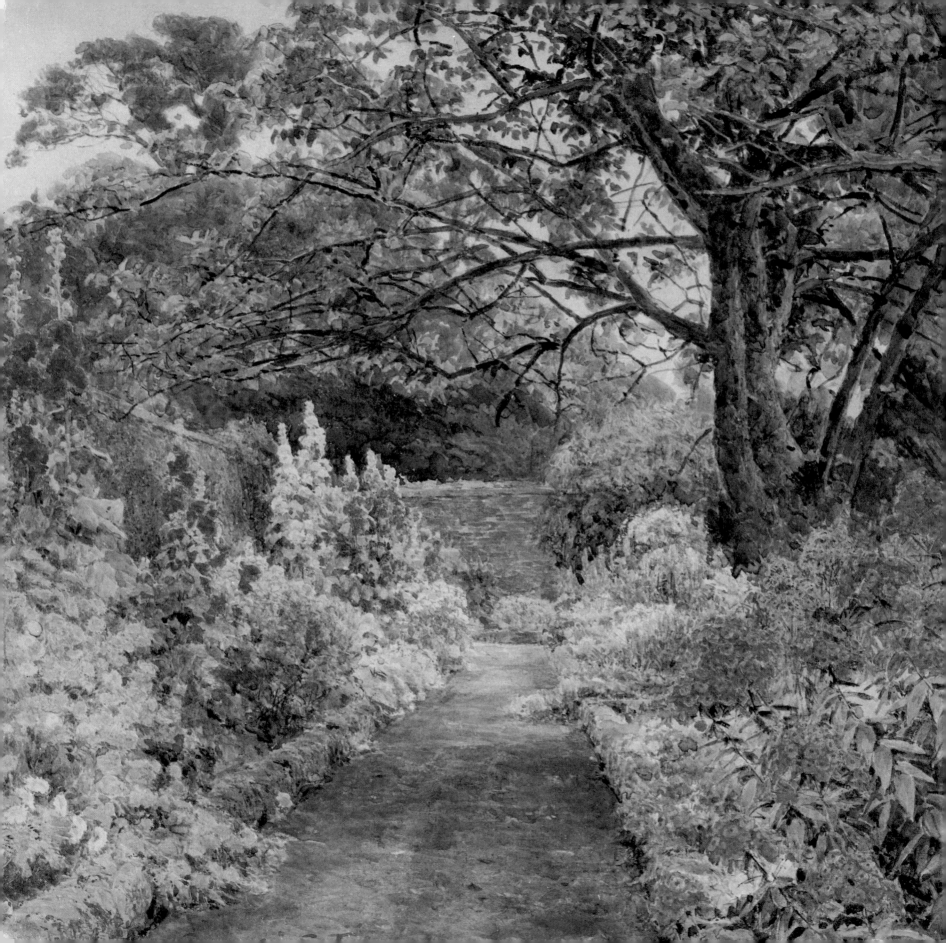

PAINTED GARDENS

ENGLISH WATERCOLOURS 1850-1914

Penelope Hobhouse &
Christopher Wood

PAVILION

This edition published in Great Britain in 1995 by
PAVILION BOOKS LIMITED
26 Upper Ground, London SE1 9PD

Originally published in hardback in 1988

Text copyright © Penelope Hobhouse and Christopher Wood 1988
Illustration copyright on page 203
Front cover painting by Margaret Waterfeld courtesy of
the Christopher Wood Gallery
Jacket designed by Bernard Higton

A CIP catalogue record for this book is available from the
British Library

ISBN 1 85145 638 4

Printed and bound in Spain

2 4 6 8 10 9 7 5 3 1

This book may be ordered by post direct from the publisher.
Please contact the Marketing Department.
But try your bookshop first.

Contents

Part One:
Victorian and Edwardian Garden Painters
by Christopher Wood

Contents

Part Two:
The Gardens
by Penelope Hobhouse

Contents

Acknowledgements

Christopher Wood suggested this book; I am fortunate to have been asked to be his co-author. I am very grateful to him for this; while writing my section my interest in the gardens has been enormously stimulated by his knowledge of the painters' lives and techniques. Many others have helped me. Sir Ralph Anstruther of Balcaskie, Lady Ashbrook at Arley Hall, Major Tony Hibbert at Trebah, Mr and Mrs James More-Molyneux at Loseley Park, Commander and Mrs Saunders-Watson at Rockingham Castle and The National Trust are amongst owners who have made my research easier and have reassured me of the future of their gardens. Dr Brent Elliott, at the Lindley Library, has answered many of my questions. Without Ray Desmond's comprehensive *Bibliography of British Gardens* my task would have been daunting. I would also like to thank Dr Lally Cox, Mr Paul Edwards and Mr George Heath for opportune help. Christopher Wood has arranged with most of the owners for reproduction of the original paintings, but, in particular, I am grateful to Mr and Mrs William Frederick, Junior, of Delaware who allowed us to select from their collection of Margaret Waterfield's fine portrayals, among the most exciting in the book. Pavilion have been, as always, a pleasure to work with. I much appreciated Penny David's and Helen Sudell's editorial skills and wish to thank them and Trevor Vincent, the designer, for bringing this book to fruition.

Penelope Hobhouse

There are many people who have helped me with this book, and all of them have contributed to making it an enormously enjoyable project. Firstly, the descendants of some of the garden artists, Mrs Eve Ekstein and Colonel Patrick Elgood (descendants of G. S. Elgood), Mrs Nancy Dowson-Weiskopf (Beatrice Parsons' niece) and Mr and Mrs Derek Rowe (grandson of E. A. Rowe). Secondly, there are the many owners of garden pictures, and sometimes the actual gardens too – Mr and Mrs David Anderson, John Berkeley, Mr and Mrs Richard Bernays, the late Sir Robert Cooke, Neil Cousins, Mr and Mrs Fulke Fitzherbert-Brockholes, the Hon. Michael and Mrs Zoe Flower, Baron Jean Louis de Gunzburg, Colin Houghton (who kindly introduced me to so many people in Broadway), Rodney and Felicity Leach, Andrew Lloyd-Webber, Ngaere Macray, Mr and Mrs Richard Mellon, Mrs W. Mond, Mrs Sarah More-Molyneux, Mr and Mrs Edward Morant, Anne, Countess of Rosse, Mr Edward and Lady Henrietta St George, Mr and Mrs K. St Johnston, the Earl of Shelburne, Dr and Mrs Edmund Sonnenblick, Mr and Mrs Tom Stoppard, Michael Thomas, and Mrs. H Wakefield. Thirdly, Jen Cox of Sotheby's, and Miranda North Lewis of Christies, have both helped with transparencies; also David Posnett of the Leger Gallery, Andrew Patrick of the Fine Art Society, and Chris Beetles. Finally Harriet Bridgeman and all the helpful girls at the Bridgeman Library. Lastly, my greatest debt is to my wonderful co-author, Penelope Hobhouse. To work with her on this book has been both a delight and an inspiration. I shall have happy memories of our many talks over tea at Tintinhull.

Christopher Wood

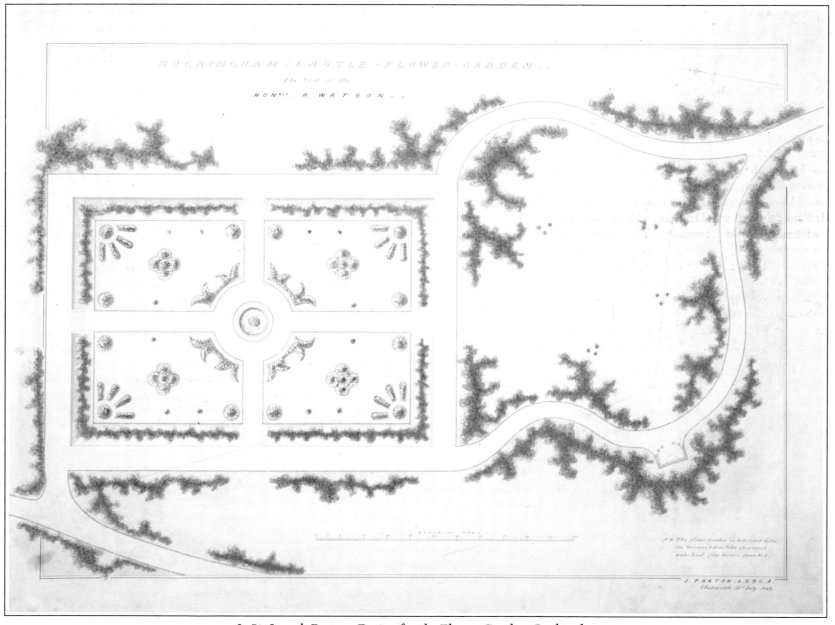

2. Sir Joseph Paxton. *Design for the Flower Garden, Rockingham Castle*, Northamptonshire, 1848.

Part One

VICTORIAN AND EDWARDIAN
GARDEN PAINTERS

by Christopher Wood

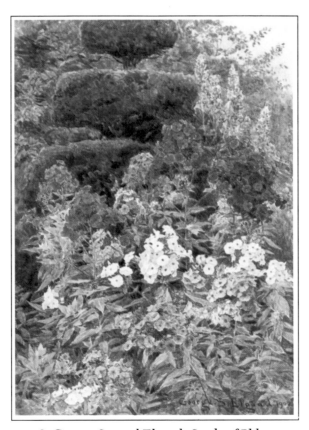

3. George Samuel Elgood. *Study of Phlox*.

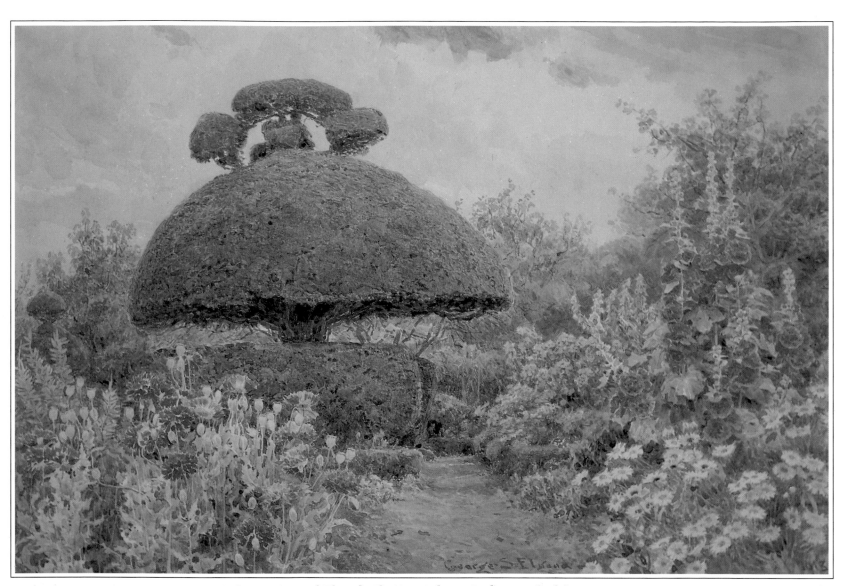

4. George Samuel Elgood. *The Yew Arbour, Lyde*, Herefordshire, 1913.

Introduction

The English are a nation of gardeners. Gardening is a national obsession, so it is to be expected that English art should reflect this. Yet, surprisingly, although English literature abounds with references to gardens and flowers, English art, with the exception of one important period, does not. The exceptional period, from about 1850 to 1914, was the late Victorian and Edwardian, the golden age of English garden painting. This seems to be the only period in English art when a small group of professional artists, notably George Samuel Elgood, Ernest Arthur Rowe and Beatrice Parsons, devoted themselves entirely to painting gardens. English art has produced many flower painters and botanical artists, but this was the only school of English garden painters. And most of them, with few exceptions, were watercolourists. The watercolour medium is best suited to capturing the subtle colours and atmosphere of English gardens. Indeed, there is possibly some connection between the damp, misty English climate and the English genius for watercolour.

Interest in gardening, and in garden history, increased steadily during the nineteenth century, and a school of garden painters emerged primarily to satisfy an obvious demand from the proud garden owners to have their gardens recorded. Illustrations were also needed for the many books and periodicals on gardening that proliferated in the late nineteenth and early twentieth centuries. Gertrude Jekyll's *Some English Gardens*, for example, a sumptuous colour book produced in 1904, was illustrated by G. S. Elgood, and Rowe contributed colour plates to the *Studio* magazine's three Special Numbers *The Gardens of England* published between 1907 and 1911.

Victorian pictures of gardens fall into two main types – the formal garden and the cottage idyll. Helen Allingham was, and remains, the best of the cottage-garden painters, although she did some grander gardens as well, in particular Gertrude Jekyll's own garden at Munstead Wood, and Lord Tennyson's garden at Farringford. But it is the formal garden on which this book concentrates, in other words the domain of Elgood, Rowe and Parsons. They alone were garden painters to the exclusion of almost all else, and their works make up the vast majority of the illustrations in this book. Between them they must have painted almost every famous and interesting garden in England. Quite apart from its beauty as pictures, their work now forms a fascinating historical record, as many of the gardens they painted have since disappeared or have been drastically altered.

Elgood, Rowe and Parsons were specialist garden painters, but there were many other artists who included gardens in their repertoire. Alfred Parsons, for example, the illustrator of Miss Willmott's *The Genus Rosa*, painted both landscapes and garden watercolours, particularly in and around Broadway, where he lived. Numerous Victorian lady amateurs were involved in painting or writing about gardens, including Margaret Waterfield and Eleanor Vere Boyle. Eleanor Fortescue-Brickdale and Kate Greenaway, both professional artists, were fond of introducing gardens into their book illustrations. Landscape painters who painted the occasional garden scene included Atkinson Grimshaw, the Leeds painter of grimy docks and moonlight scenes, and the little-known E. Adveno Brooke, whose *The Gardens of England* of 1856–57 is the only book to record some of the great gardens of the early Victorian period. Jacob Thompson, the Cumbrian landscape painter, painted a remarkable picture of the garden at Drummond Castle in Scotland, and John Henry Lorimer, the Scottish painter, painted some excellent pictures of the gardens at his own house, Kellie Castle.

The great majority of these garden pictures were painted between about 1880 and 1920. This was when the painting of gardens reached its peak. Also, they strongly echo the movement towards old-fashioned English gardens, and traditional English flowers, that was such a feature of the late nineteenth century. Both John Ruskin and William Morris were ardent advocates of old English gardens, and of a freer, more natural style of planting, and many of their ideas are reflected in the paintings reproduced in this book. William Robinson, in his key book, *The English Flower Garden* of 1883, quoted William Morris to support his theories. Even the children's books of Kate Greenaway and Walter Crane are part of the same

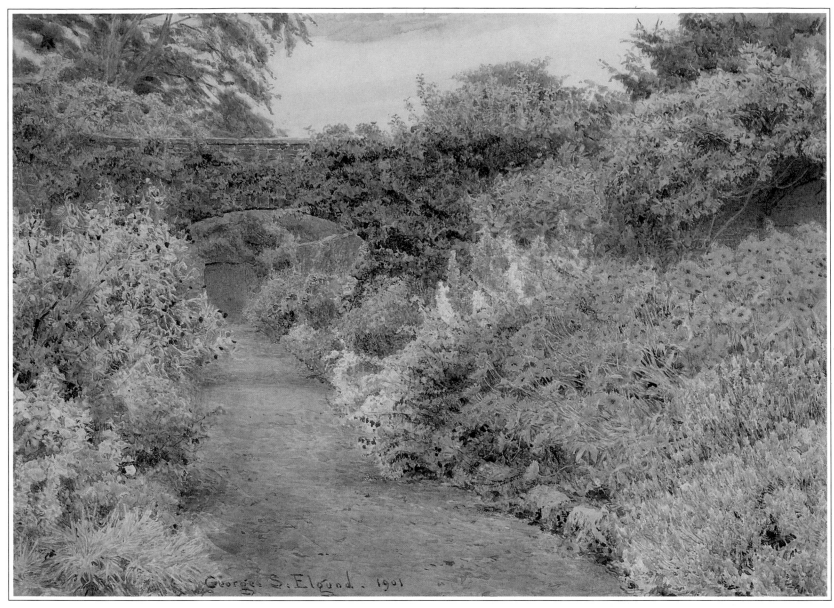

5. George Samuel Elgood. *Blyborough*, Lincolnshire, 1901.

movement, projecting an idyllic image of the 'olde worlde' English garden, full of topiary, knot and herb gardens, nut walks, orchards, arbours, bowling greens and all the traditional old English flowers – roses, lilies, daisies, poppies, honeysuckle. 'The Pleasaunce' was a favourite name for a garden of this type. Lord Battersea called his seaside house and garden at Overstrand in Norfolk 'The Pleasaunce', and when in 1875 Atkinson Grimshaw painted his wife in the garden of their Jacobean house, Knostrop Old Hall, he gave the title *In the Pleasaunce* to the picture.

Victorian gardens, like so much Victorian art, architecture and literature, were deeply influenced by history and historical associations. The only trouble with the old English garden is that nobody could quite agree on what an English vernacular garden really was. The gardens illustrated in this book certainly reflect the extraordinary richness and variety of the results produced by the search for a truly English style. It could well be called the battle of the styles, for by about 1900 almost everything possible seemed to be happening at once. Above all, the image that these pictures project is a deeply romantic

one. We seem to be glimpsing an ideal world of green lawns bathed in sunshine, immaculate yew hedges, impeccable borders bursting with brilliant flowers in profusion, doves and peacocks – a world too perfect, perhaps, to have ever really existed.

One curious omission is that of gardeners. The odd wheel-barrow appears, the occasional tool, but an actual gardener, hardly ever. This may be surprising considering the vast armies of gardeners needed to maintain these great gardens. Dukes, Rothschilds and wealthy enthusiasts like Miss Ellen Willmott might employ a hundred men; even Gertrude Jekyll once lamented that she was down to 'only twenty men' in the garden. Most owners of modern gardens are lucky if they have the services of one, but even the most modest Victorian country house or villa would have employed five or ten. The absence of gardeners from these pictures certainly reflects their lowly importance at that time; they were purely the labour force to carry out the wishes of their master. In the early Victorian period, the head-gardener was a great and powerful figure; but the late Victorian period was the age of the gentleman, or gentlewoman, amateur.

GEORGE SAMUEL ELGOOD RI 1851–1943

The greatest master of the garden picture, and the hero of this book, is undoubtedly George Samuel Elgood. He was a professional watercolourist, a member of the Royal Institute of Painters in Watercolour, a painter of landscapes, Italian scenery and buildings, but it is as a garden painter that he will be remembered. He held no less than twelve one-man exhibitions at the Fine Art Society up to the First World War, and most of the works exhibited were of gardens. His output was greater than that of any other garden painter, except possibly Beatrice Parsons, and he was also an extremely knowledgeable gardener himself. He held very strong personal views about gardens and their design; he also shared many of Gertrude Jekyll's ideas about design and colour, which made him the ideal illustrator for her books. It is therefore worth considering Elgood's career in some detail.

George Samuel Elgood

Elgood came from a Leicester family, and first studied art at the Leicester School of Art under Wilmot Pilsbury, a talented watercolour landscape painter, who also often painted cottage gardens. Elgood then moved to London, to study architectural drawing at the South Kensington School. His studies were cut short by the sudden illness of his father, and he had to return to Leicester to work in the family business. He continued to paint in his spare time, mostly in and around Leicester, but by the early 1880s he was again free to devote himself to painting full-time. At about this time he married Mary Clephan, a lady of

6. George Samuel Elgood. *Gredington*, Shropshire, 1895.

some means, and also an artist, and together they travelled the country painting buildings, landscapes and flowers. Elgood's sister Elizabeth married another Leicester artist, John Fulleylove. By 1881 Elgood had gained election to the Royal Institute of Painters in Watercolour, and in 1883 to the Royal Institute of Painters in Oil.

In 1881 Elgood made his first visit to the country that was to have such a profound effect on his art – Italy. Although he also painted in France, Spain and Sicily, it was to Italy that he was to return almost every year, spending at least four or five months painting and sketching. Clearly he was fascinated from the beginning by Italian gardens, which form the majority of his Italian subjects. He painted many of the great Renaissance gardens and villas, such as Isola Bella, the Villa d'Este and the Villa Borghese; also smaller gardens such as the Villa Garzoni and the Villa Bracchietti in Tuscany. These and many others were to appear as illustrations to his book *Italian Gardens*, published in 1907. Although these gardens are not strictly relevant to this book, they are important in the development of Elgood's style. His familiarity with, and love of, Italian gardens gave him a strong sense of the importance of structure and design in a garden. This feeling lies behind all his pictures of English gardens, as does his love of formal and architectural elements. Many English gardens show Italian influence anyway, but Elgood tended to emphasize Italianate features such as balustraded terraces, flights of steps, old walls, statuary and fountains. Above all he loved clipped yew hedges, which he painted better than any other English artist. Flowers he liked, too, and his pictures are full of flowers, but nearly always with some formal framework, such as box or yew hedges, paths or walls. Elgood, therefore is a paradoxical phenomenon, an Englishman who painted English gardens with an Italian accent.

The cult of the old English garden, one of the many offshoots of the Arts and Crafts movement, also had its effect on Elgood's style. He had a strong preference for old and historic gardens, such as Levens, Melbourne, Penshurst, Cleeve Prior and Montacute, and these were to be the inspiration for many of his

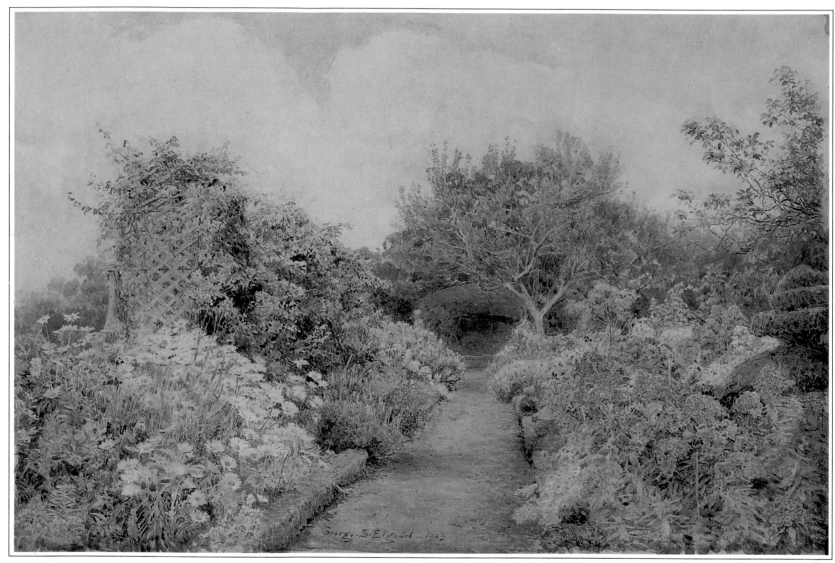

7. George Samuel Elgood. *The Artist's own Garden at Knockwood*, Kent, 1903.

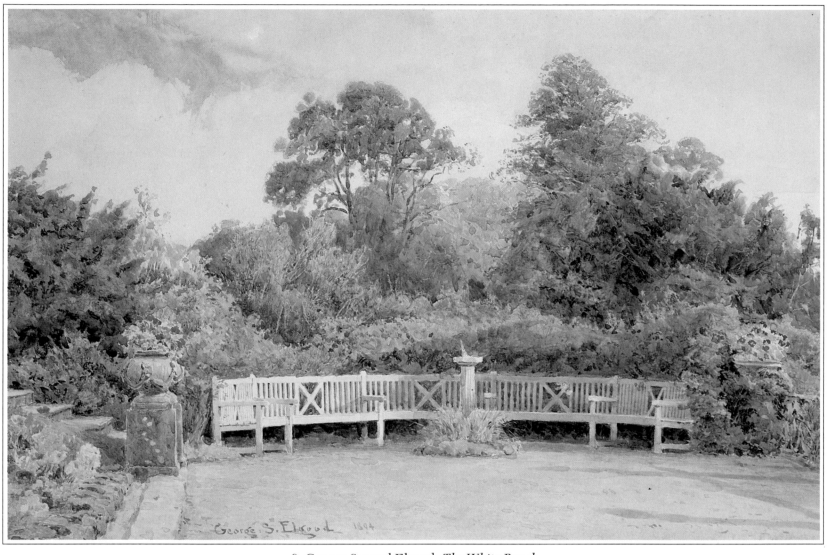

8. George Samuel Elgood. *The White Bench.*

finest watercolours. All these gardens appear in what was to be his greatest book, *Some English Gardens*, first published in 1904, with commentary on each garden by Gertrude Jekyll. This is now quite a rare and valuable book, and we have reproduced many of the fifty plates from it here, using the original watercolours where possible. Nothing can better illustrate Elgood's complete mastery of the delicate and yet demanding art of garden painting.

Elgood's genius lay in his extraordinary knack of combining form and colour in gardens in a harmonious and natural way. His pictures never look forced or exaggerated, and are entirely believable as truthful views of the gardens as they were at that time. His work always shows a clear sense of design, reflecting his love of Italian gardens, and his architectural training. He chose his viewpoint carefully, making the most of the features he wanted to accentuate. Like Jekyll, he clearly believed in the harmonious combination of formal design and free planting, but he also enjoyed painting purely formal gardens such as Melbourne or Brockenhurst, concentrating simply on hedges, grass and sculpture and eliminating the flowers altogether.

But when he came to paint flowers, Elgood also showed a finely developed sense of colour. He painted many herbaceous borders and flower gardens filled with a profusion of flowers, such as at Blyborough, Crathes, Kellie and Knockwood – his own garden in Kent. His preference, however, was always for soft, pale colours, and he was also keenly aware of the crucial

19

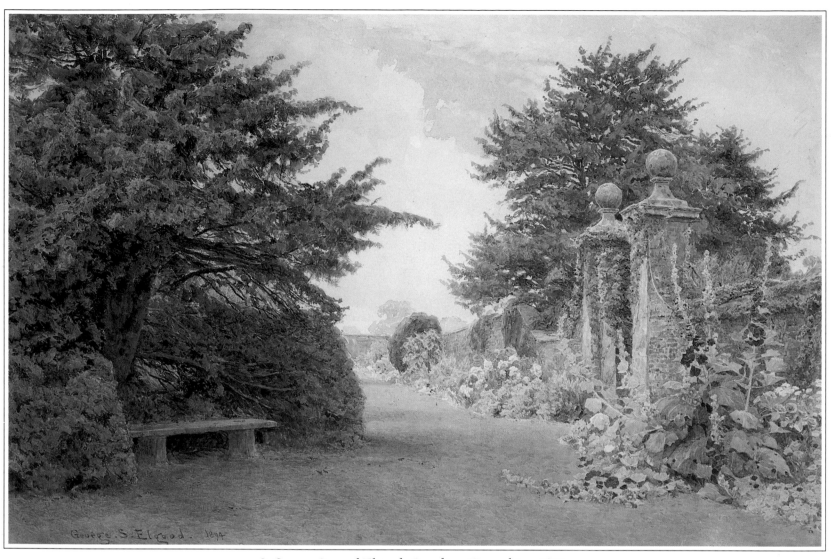

9. George Samuel Elgood. *Beaulieu*, Hampshire, 1894.

importance of colour combinations and gradations. In contrast to the bright borders of Beatrice Parsons or Lilian Stannard, Elgood's colours are muted but marvellously subtle and atmospheric, and bathed in a delicate blue-grey haze. This ability to envelop his pictures in a transparent veil of gauze is similar to the work of Albert Joseph Moore, also a wonderful painter of flowers. Many of the plates in *Some English Gardens* are simply studies of flowers in borders, and these show not only acute observation, but also a complete understanding of how the plants grow. The titles of the plates in themselves reflect how much Elgood appreciated the art of grouping and massing – 'Orange Lilies and Monkshood' for example, or 'White Lilies and Larkspur'. George Elgood would surely have agreed

with Gertrude Jekyll that gardening is painting pictures.

Elgood was especially good at conveying the mellow quality of old stone steps, gateways, walls, roofs and brickwork, usually covered with moss, ivy, or climbing plants. One can see this in many of his pictures, such as the gardens at Penshurst, Beaulieu and Berkeley Castle. But above all he was an absolute master of painting yew hedges, topiary and cedar trees, all of which appear constantly in his work. No one has captured the blue-green colour and the texture of the English yew hedge as well as Elgood, and no artist has enjoyed depicting the amazing shapes of English topiary as much as he did. His pictures of the topiary at Levens, to choose an obvious example, are outstanding. Even old, misshapen yew hedges appealed to him too,

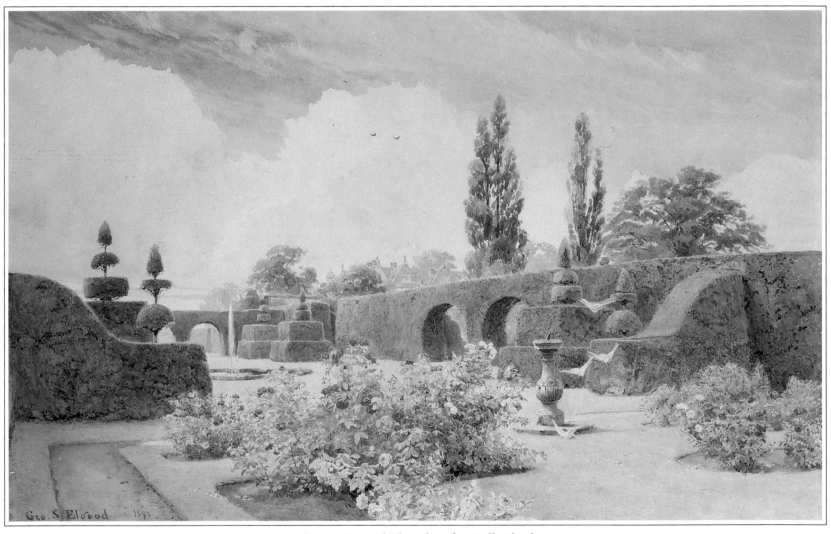

10. George Samuel Elgood. *Arley Hall*, Cheshire.

such as the ancient yew alley at Rockingham. Perhaps Elgood is at his most completely successful when he manages to combine all these elements in one picture, such as the lovely view of Cleeve Prior, where he fuses together traditional flowers, grass, yew hedges and a mellow old building in perfect sympathy. His only weakness was occasionally to introduce figures in historical costume – usually Regency or eighteenth-century. These seem pointless and incorrect to the modern viewer, but they were probably put in for commercial reasons, to help his watercolours sell.

Elgood held his first exhibition at the Fine Art Society in 1893, and it was a great success. Most of the pictures were of gardens, and among the buyers was Princess Victoria, who bought a view of the dragon gateway of the Villa Garzoni to hang at Marlborough House. Elgood held many more exhibitions at the Fine Art Society, and clearly never lacked patrons or admirers. The lists of buyers show that it was rarely the owners of gardens who bought the pictures of them. Elgood was himself a keen gardener, first in Leicestershire, then at Knockwood, near Tenterden in Kent. This was an old timbered farmhouse, surrounded by ancient apple trees. Here he created a garden of his own, with, as one might expect, herbaceous borders, yew hedges and topiary, walks, steps and a sundial. Eventually Knockwood itself became a favourite subject. Here Elgood was to live for the rest of his life, dividing his time between London, Kent and Italy.

As he grew older, Elgood grew increasingly crotchety, eccentric and reclusive. Some of his own gardening books survive, with his notes and comments in pencil in the margins. These reveal not only his own, extremely trenchant views on gardens, but also his great contempt for garden designers. Beside a passage which mentioned 'the good landscape gardener' he scribbled 'there is no such person!'. Edwin Lutyens and Thomas Mawson came in for particularly strong treatment. 'Most of the well-known designers,' he wrote, 'know nothing about design or gardens except to run up huge bills. The great Lutyens for instance – would spend £2000 or £3000!'. Elsewhere he wrote of Mawson that he never made a garden in his life – all he could do was buy balls wholesale by the dozen. Architects who designed gardens were obviously his *bêtes-noires*, and beside one plate he wrote 'the arcitect [sic] who designed this porch ought to be whipped'. In his own house, Elgood resolutely eschewed all modern conveniences, refusing to instal heating, electric light or even running water. He died a cantankerous, bearded old recluse, in 1943 at the age of 92, by which time the golden age of English gardens which he had so lovingly depicted had long since passed away.

11. George Samuel Elgood. *Yew Arches, Murthly Castle*, Perthshire, 1905.

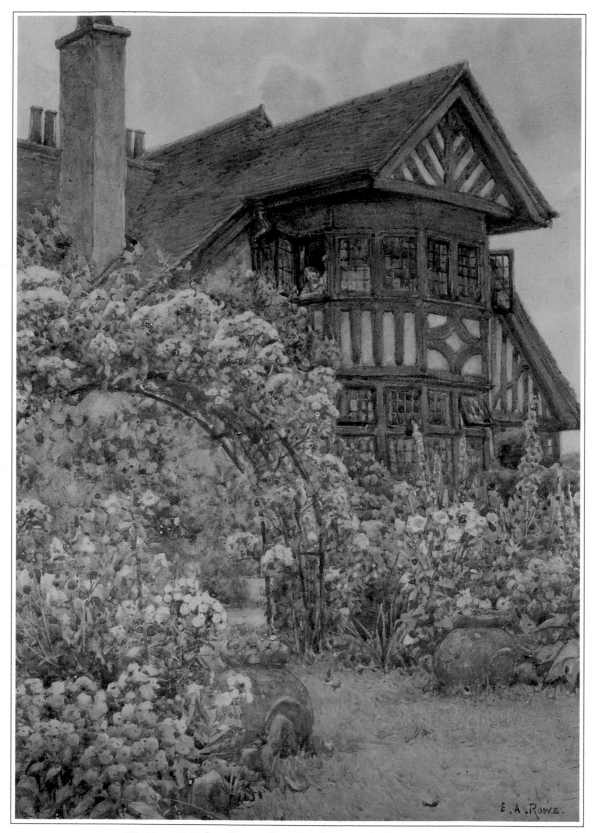

12. Ernest Arthur Rowe. *Ravello*, the Artist's House in Kent.

ERNEST ARTHUR ROWE 1862–1922

Rowe, next to Elgood, was the greatest painter of gardens of the late Victorian period. Like Elgood, he lived in Kent, loved Italy, and painted many of the greatest gardens of England, yet the two men do not seem to have known each other. In view of Elgood's well-known testiness and sarcasm towards other garden artists, this is perhaps not so surprising. Elgood and Rowe painted many of the same gardens, even from the same spot, so there may have been some element of rivalry between them. Their work can look very similar, and they clearly shared a love of topiary, but Rowe's style is brighter and harder than Elgood's. His colours are stronger, and lack that bluey-green tinge so characteristic of Elgood. But a large, highly finished watercolour by Rowe, such as his views of Arley or Berkeley Castle, can be just as fine and impressive as anything Elgood could produce. Also Rowe avoided introducing figures in bogus eighteenth-century costume.

Fortunately, many of Rowe's notebooks, diaries and letters survive in the possession of his descendants, so we know more about his career than that of any other garden painter. He studied first as a lithographer from 1878–83, then at the Royal Institute during 1884–6, winning the President's Medal in 1885. At first he painted landscapes, but during the 1890s he seems to have become steadily more interested in gardens. We know from his diaries and letters that he was friendly with several other garden painters, including Beatrice Parsons, Henry Terry, William Affleck and L. N. Nottage. He also frequented the London Sketch Club, where he was friendly with Arthur Rackham. His views on art seem to have been thoroughly traditional, as in 1892 he recorded 'went to New English Art Club in morning (disgusted)'.

Most of Rowe's finest garden pictures were painted between 1890 and 1914. He kept an appointments book called his 'Book of Wanderings', listing the exact dates when he worked at each garden. They show that he travelled all over England, Scotland and Ireland, painting most of the greatest gardens in the land – Levens, Melbourne, Campsea Ashe, Compton Wynyates,

Ernest Arthur Rowe

Arley, Hampton Court, and Abbey Leix in Ireland. He also painted many Kentish gardens, in particular Hever Castle and Penshurst, which were both near where he lived. His letters reveal that he usually had to make appointments with the head-gardener, after writing to the owner first. He also suffered much from bad weather, and wrote in 1892 at Helmingham, the Tollemaches' house in Suffolk, where he was working with Henry Terry, 'worked in the garden under an umbrella in the morning and for an hour in the afternoon, then gave it up as a bad job. Rained all day.' At Penshurst on 6 July 1892 he

recorded a '24 × 20 drawing blown into fishpond'. His water-colours nonetheless give the impression that the sun was always shining.

Rowe's diaries also show that it was extremely hard to make a living as a garden painter. Between 1885 and 1895 he earned only about £100 per annum, and in 1890 made only £30. In 1895 he sold a watercolour for £68, and after this things began to improve. By the turn of the century his income was up to £300, and in 1899 he felt able to marry. His wife, Sophie Slater, was the daughter of a clergyman. They had met in 1895 at Davos, in Switzerland, where Rowe had gone for his health and she was working as a nurse. By 1907, Rowe was prosperous enough to build a house, which he named Ravello, near Tunbridge Wells. The name seems incongruous, as we can see from Rowe's many pictures of the house that it was built in traditional Kentish half-timbered style. All his life Rowe suffered from poor health, and like Elgood, usually went to Italy every winter, often with his greatest friend the now-forgotten painter Alfred Howell Moore. There he painted many Italian landscapes, and garden scenes, but he did not make a speciality of Italian gardens in the same way as Elgood. He did illustrate one or two garden books, in particular *Hardy Perennials and Herbaceous Borders* by Walter P. Wright, published in 1912, with plates by Rowe and Beatrice Parsons.

The First World War dealt a severe blow to Rowe's career, and in 1914 he had to sell his beloved Ravello, and move to a smaller house in Tunbridge Wells. After the war his career revived, and he held several exhibitions at the Grafton Gallery, and the Greatorex Gallery, in London. Here his works were seen by Queen Mary, who became a great admirer, and bought several of his garden pictures. This revival, however, was short-lived, as Rowe died in 1922 at the age of 60. In March 1925 a memorial exhibition of his work was held, at which sixty works were exhibited, priced between £12 and £45. For the next fifty years Rowe was completely forgotten, until the revival of interest in Victorian garden watercolours restored him to his rightful place.

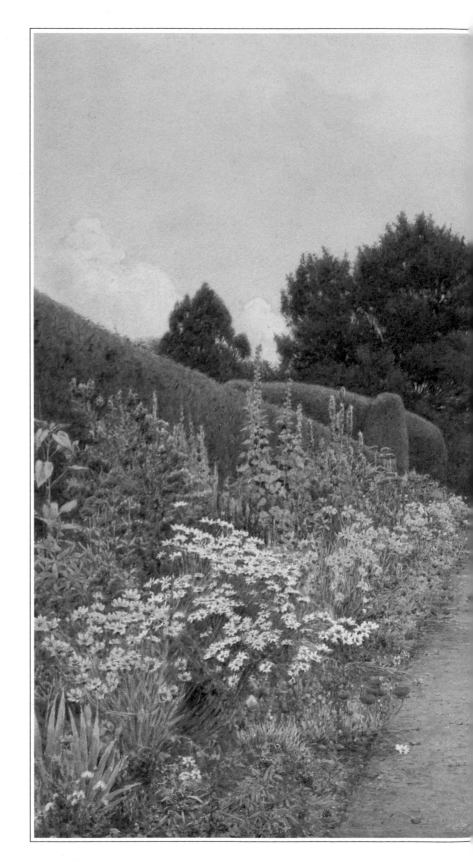

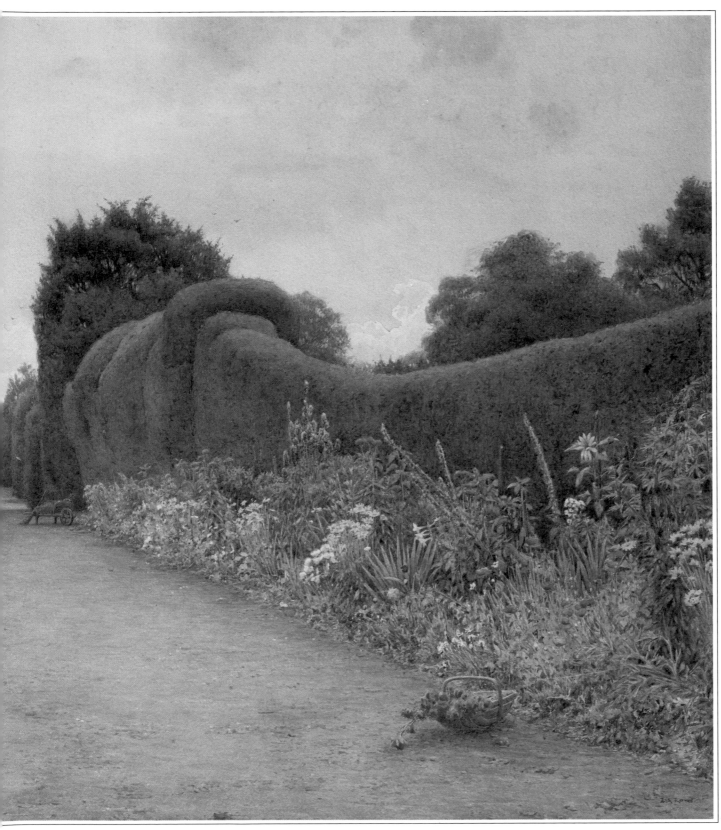

13. Ernest Arthur Rowe. *Holme Lacy*, Herefordshire, 1902.

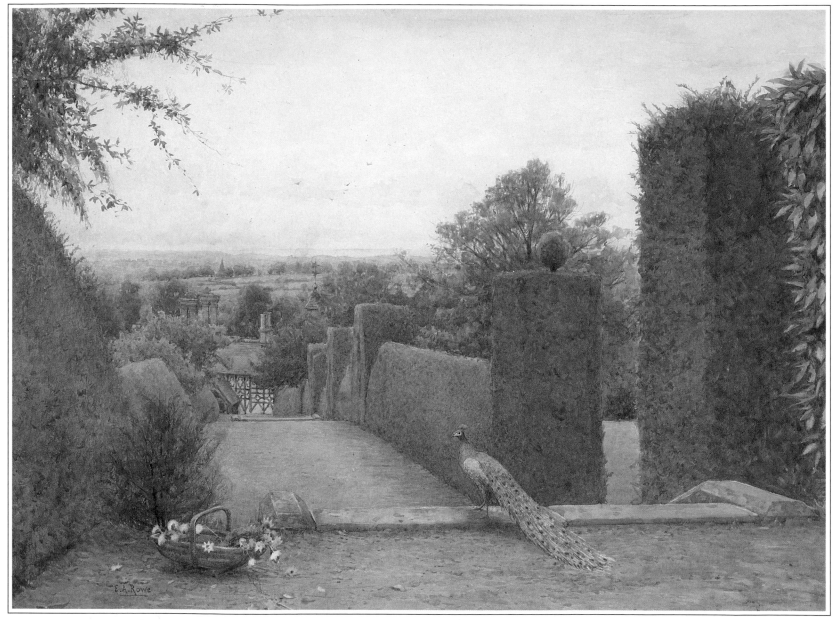

14. Ernest Arthur Rowe. *Abberton Church from Rous Lench Court*, Worcestershire.

BEATRICE PARSONS 1870–1955

The work of Beatrice Parsons, the third of the major figures in this book, has a very different quality from that of Elgood or Rowe. Whereas Elgood and Rowe liked formal gardens full of topiary and architectural elements, Parsons liked above all to paint borders and flower gardens in the full glory of their summer colours. She is the queen of the blazing border, and her watercolours exude a wonderful feeling of heat and sunshine. They are also most informative about Edwardian flower gardens and exactly how they were planted. Yew hedges and topiary, with one or two exceptions, are almost completely absent from her work.

Parsons had a thorough academic training, and studied at the Royal Academy Schools. Her early works, mostly exhibited at the Academy in the 1890s, were religious subjects. Her brother Karl Parsons was also a religious painter and designer of stained glass. (She was not related, as is often thought, to the Broadway painter Alfred Parsons.) Around 1900, Beatrice Parsons began to paint garden subjects, and showed one of these to a dealer called Dowdeswell. According to a story told by Beatrice's niece, Nancy Dowson Weiskopf, also a garden artist, Dowdeswell put his finger over the figure in the picture, and asked Beatrice to paint him forty pure garden pictures, promising her a one-woman exhibition. The first exhibition took place at Dowdeswell's gallery in 1904, and was an instant success. Forty out of the forty-four pictures were sold.

From that moment, Beatrice's career as a professional garden artist was assured. She continued to paint gardens, not only in England but Europe and Africa as well, until well into the 1930s, holding regular exhibitions at Dowdeswell's and the Greatorex Gallery. Her clientèle was wide, but seemed to consist mainly of the creators of new gardens rather than the owners of old ones. Cyril Flower, 1st Lord Battersea, for example, commissioned her to paint many views of his garden at The Pleasaunce, near Overstrand in Norfolk. The house had been designed for him by Edwin Lutyens. Beatrice's many views of the borders at The Pleasaunce show an astonishing,

Beatrice Parsons

rather confusing blaze of colours, slightly garish when compared to Elgood or Rowe, but nonetheless painted with wonderful fidelity. She also made several visits to Gravetye Manor, home of William Robinson, the celebrated garden writer and one of the chief exponents of the herbaceous border. Blickling Hall, in Norfolk, was another favourite, and the subject of numerous fine watercolours. Queen Mary was an admirer of Parsons, and bought her works, but she is not known to have painted any royal gardens. The Princess Royal did commission her to paint at Harewood. Rose gardens were a speciality, and roses feature in many of her borders, as do gladioli and white daisies, which she seems to have especially liked. Beatrice also painted the gardens of large suburban houses, mainly around London, and particularly in Hampstead, and also scenes in London's parks. Another speciality was spring gardens, especially in Devon, Cornwall and Somerset, with trees in blossom and spring bulbs. These are among the most harmoniously coloured and more successful of her works. She was also one of the few garden painters to paint

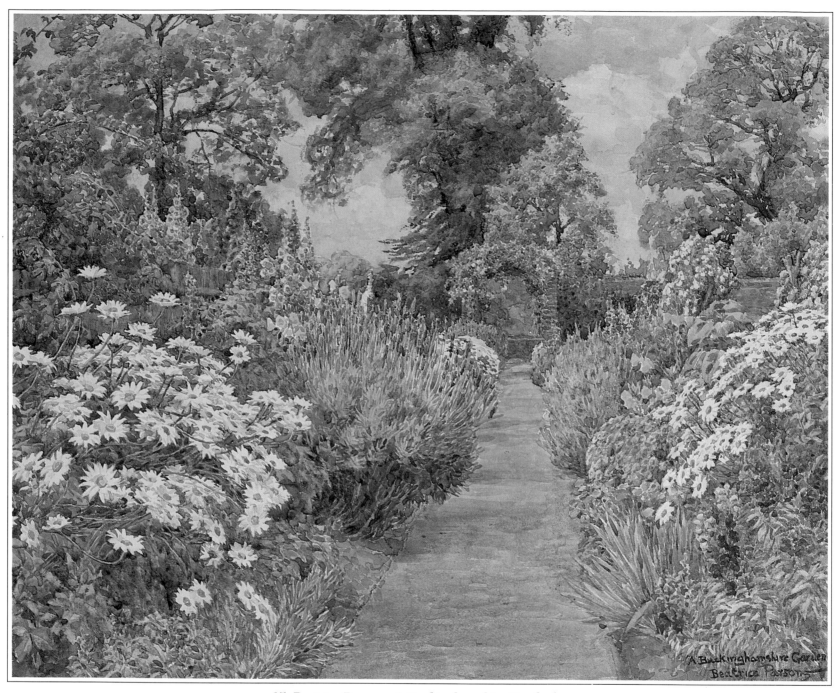

15. Beatrice Parsons. *A Buckinghamshire Garden*.

rhododendron gardens, for example Trebah, in Cornwall.

Beatrice Parsons' clients were by no means confined to England, and she painted gardens in France, such as the Villa Maryland in the Bay of Beaulieu; in Italy, at La Mortola, Thomas Hanbury's famous garden, and also in Tangier and elsewhere in Morocco. Her bright, colourful style was particu- larly well suited to the stronger colours of the Mediterranean, and these are among her most successful works. She also illustrated a number of garden books, including *Gardens of England* (1911) and *The Charm of Gardens* by D. C. Calthrop (1910). The special feature of Parsons' work, as opposed to that of Elgood and Rowe, is not only her completely different

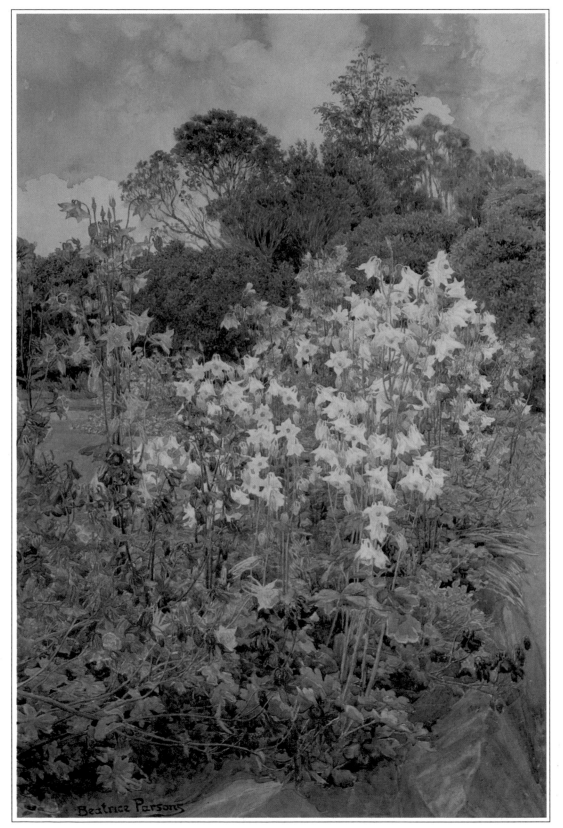

16. Beatrice Parsons. *Columbine*.

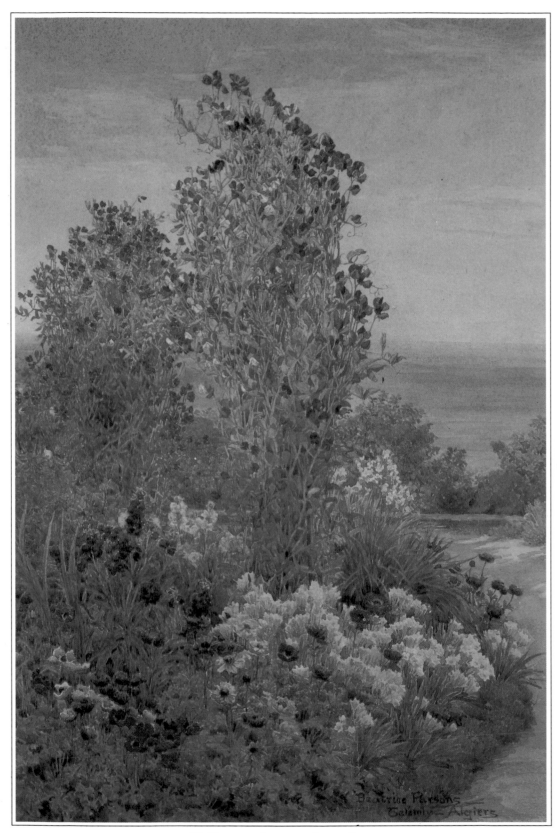

17. Beatrice Parsons. *Sweet Peas*.

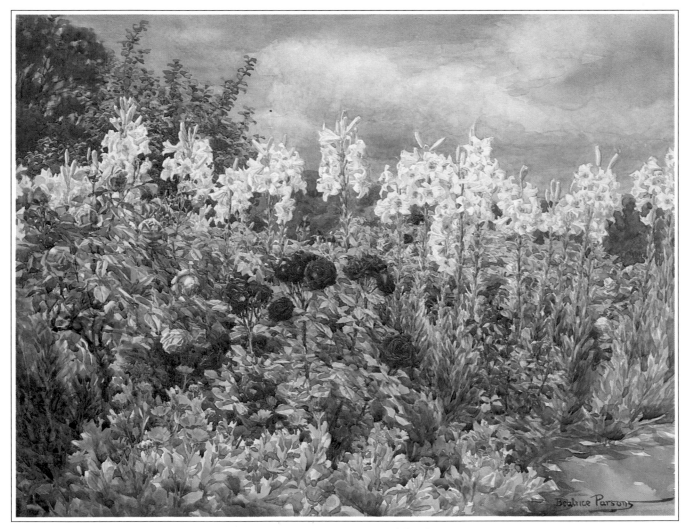

18. Beatrice Parsons. *Our Lady's Flowers.*

technique, but also the amazing variety of gardens and plants which she painted. Although her colours may sometimes be bright, this is probably an accurate representation of the gardens she painted, and her flowers always look extraordinarily fresh and natural. Her occasional studies of flowers, such as those of sweet peas and of columbines illustrated here, are as pretty and as sensitive as any of the pictures in this book. The idyllic world of the great Edwardian garden does seem, in Beatrice Parsons' pictures, to have survived into the 1920s and 30s, but the Second World War must have destroyed it for ever. She seems to have virtually stopped painting in the 1940s and 50s, and she died, completely forgotten, in 1955.

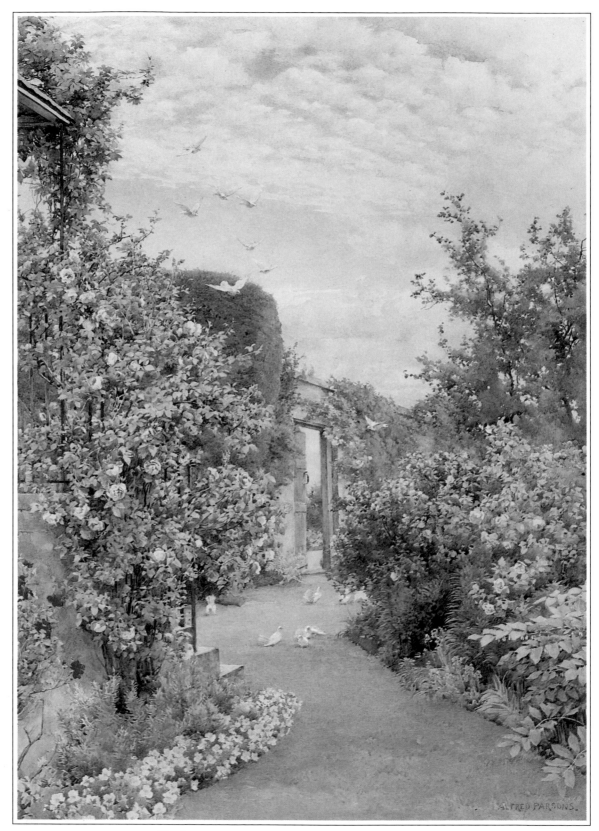

19. Alfred Parsons. *China Roses, Broadway*, Worcestershire.

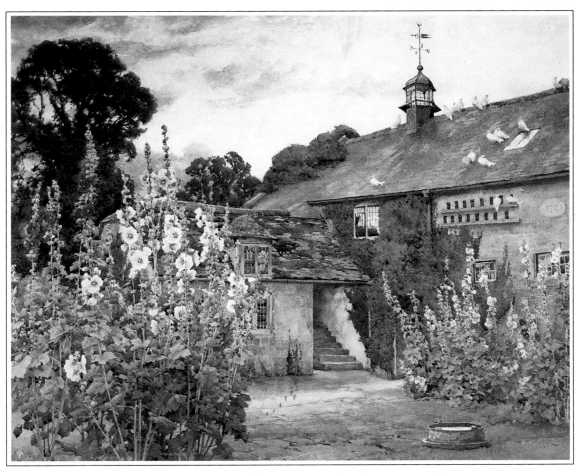

20. Alfred Parsons. *Russell House, Broadway*, Worcestershire.

SOME LANDSCAPE PAINTERS

Apart from the professional garden painters, such as Elgood, Rowe and Parsons, there were a number of landscape painters who occasionally painted gardens. One of the earliest and most interesting of these was the little-known **E. Adveno Brooke**. As a painter he is almost entirely forgotten. He painted landscapes, river scenes, and fishing subjects, and exhibited them at the Royal Academy, and other London exhibitions, from 1844 to 1864. In the 1850s, however, he painted a series of garden pictures, which were used to illustrate *The Gardens of England*, published by T. MacLean in 1856–7 and dedicated to the Duchess of Sutherland. The book is illustrated with chromolithographs after Adveno Brooke, and although the colours are somewhat lurid, the pictures represent a fascinating survey of early Victorian gardens. Among them are Trentham, Bowood, Alton, Shrubland and Elvaston, all of which are illustrated here, in the later sections dealing with individual gardens. Only one or two of Brooke's original paintings of the

gardens survive, so darkened and discoloured by bitumen as to be more or less invisible, but *The Gardens of England* will ensure that his name has a permanent place in English garden history.

Among the very few landscape painters to devote himself at all seriously to gardens was **Alfred Parsons RA** (1847–1920). Alfred Parsons had a long and distinguished career as a painter, watercolourist and illustrator. He exhibited at the Royal Academy from 1871, becoming an Associate in 1897 and a full member in 1911. He worked for many years as an illustrator for the American magazine *Harper's*, which brought him into contact with two American artists resident in England, F. D. Millet and E. A. Abbey. All these artists eventually bought houses in the beautiful Worcestershire village of Broadway, and they formed the nucleus of what is now known as the 'Broadway Group'. Broadway's chief claim to fame is that the American painter John Singer Sargent was a regular visitor, and painted many pictures in and around Broadway, including the famous *Carnation, Lily, Lily, Rose*. Parsons eventually built his own house, Luggers Hill, in Broadway, and laid out the garden. He designed several other gardens, most notably Court Farm, also in Broadway, which survives untouched. Most of Alfred Parsons' pictures are of his own garden, or other gardens in Broadway, such as Russell House (plate 20). All are painted in watercolour, in a strong and colourful style, very similar to that of Beatrice Parsons, but showing a stronger sense of design, as one would expect from a man so involved with garden design.

Parsons will be best remembered, however, for his long and turbulent association with one of the greatest gardeners of the day, Ellen Willmott. This redoubtable spinster was one of the most remarkable of all English gardeners. She owned three gardens, Warley Place in Essex as well as one in France and another in Italy. The garden at Warley Place alone contained a hundred thousand species, and was tended by over a hundred gardeners. A plan of the garden by William M. Walker (plate 118) survives, and also a number of delightful watercolours by Parsons (plates 114–7), who also painted Miss Willmott's

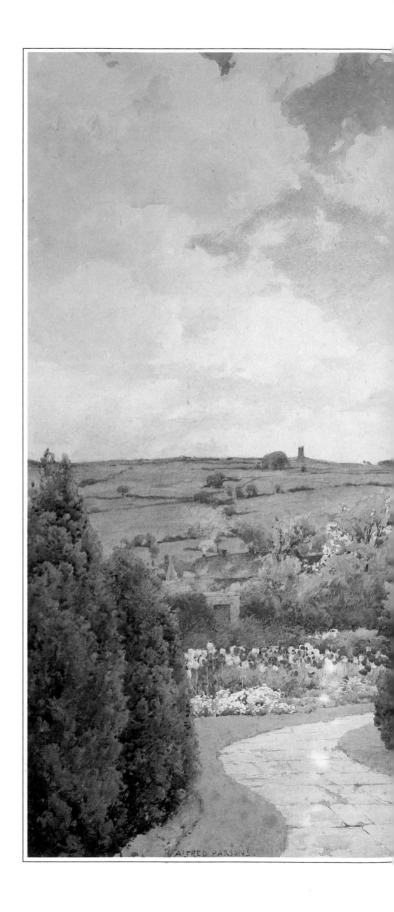

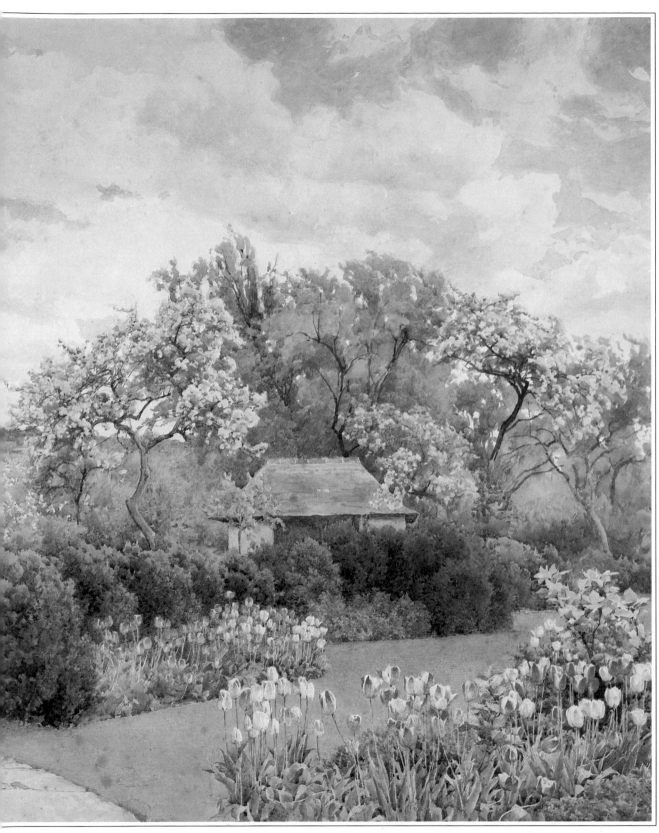

21. Alfred Parsons. *The Artist's Garden at Luggers Hill, Broadway*, Worcestershire.

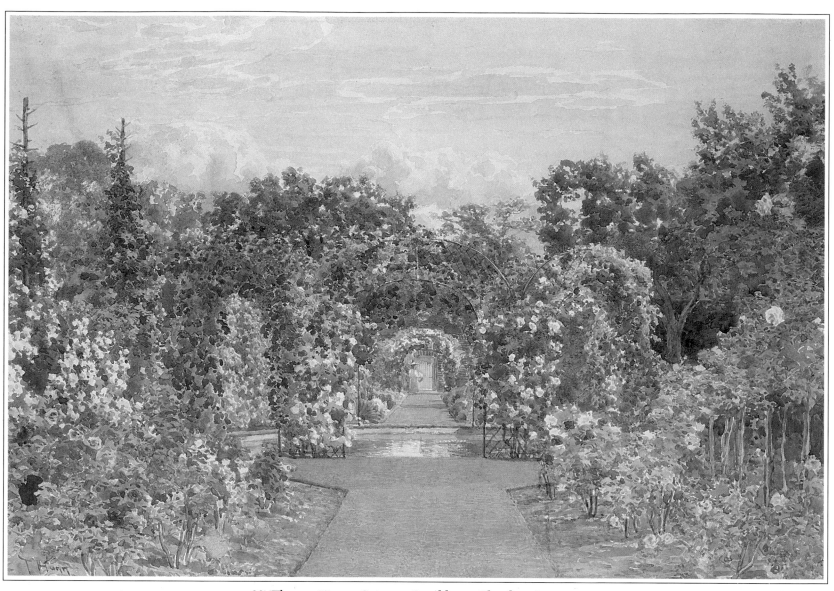

22. Thomas Hunn. *Crimson Rambler at Clandon*, Surrey.

gardens in France and Italy. This association resulted in Parsons being commissioned to illustrate Ellen Willmott's magnum opus *The Genus Rosa*. This books contains 132 plates after watercolours by Alfred Parsons. The production of the book was a long and unhappy story, ending in an irrevocable quarrel between Parsons, Miss Willmott and the publisher, John Murray. The root of the quarrel lay in the choice of printer, as Parsons felt that the quality of both printing and paper were inadequate, and did not do justice to his water-colours. Parsons had a particular reason for supporting his printer, Whitehead, since he had a commercial interest in the firm supplying their paper. Miss Willmott insisted that their

estimate was too high, and chose another printer to do the job. So acrimonious did the dispute become that in about 1902 Parsons removed himself to New York, to avoid litigation. Eventually he grudgingly apologized, but took no further part in the production of the book. Due to financial problems, but also to endless prevarications by Miss Willmott, the book was not finally published until 1914. By this time Willmott and the long-suffering publisher, John Murray, were on extremely bad terms. A thousand copies of the book were printed, but the First World War affected sales, and by the time Parsons died in 1920, only 260 had been sold. The full story of this tragic dispute, which rumbled on even after Parsons' death, is told in

more detail in a recent biographical essay of Parsons by Professor Bryan Brooke and published in *A Garden of Roses* by Graham Stuart Thomas. Looking at Parsons' delightful watercolours of Warley Place, and at his plates for *The Genus Rosa*, it is sad to reflect that the production of these beautiful watercolours resulted in quite so much unhappiness for all concerned.

Another watercolourist who seems to have made a regular speciality of gardens was **Thomas H. Hunn**, who worked between 1878 and 1908. Hunn lived near Guildford, and mostly painted gardens in Surrey such as Clandon, Great Tangley (plates 80 and 81) and Sutton Place. Hunn had a pale, delicate style, which is quite distinctive, and his watercolours reveal a considerable feeling for gardens. **Henry M. Terry**, who worked from 1879 to 1920, also painted occasional garden views. He was a friend of E. A. Rowe, and they are known to have painted gardens together, notably at Montacute and Compton Wynyates. Even more obscure is **L. N. Nottage**, about whom little is known, but he did produce watercolours of well-known gardens, in particular Brockenhurst and Hatfield (plate 87). Another artist to paint Brockenhurst (plates 66 and 67) and its remarkable Italianate topiary was **Walter Tyndale RI** (1855–1943). Tyndale was a distinguished topographer, and is now best known for his illustrated books on Japan, Egypt and Italy, all published by A & C Black. He illustrated a book on Japanese Gardens in 1912, but examples of English gardens by him seem to be rare. **Thomas H. Tyndale**, less well known and working around 1900 to 1910, painted watercolours of cottage gardens and may have been a relation.

Other examples of Victorian garden pictures tend to be isolated. **Jacob Thompson** (1806–79) a Cumbrian painter of landscapes and highland scenes, was commissioned in 1847 by Lord Willoughby de Eresby to paint the very elaborate gardens at Drummond Castle, Perthshire (plate 23). Thompson was intensely religious, and recorded his thoughts about the garden in his diary – 'The Garden at Drummond appears more beautiful than ever . . . Terrace above terrace with statues and busts of the great men of bygone days placed side by side;

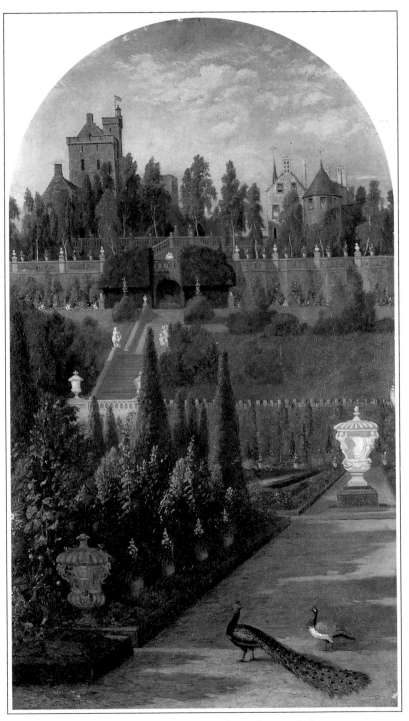

23. Jacob Thompson. *Drummond Castle*, Perthshire, 1847.

39

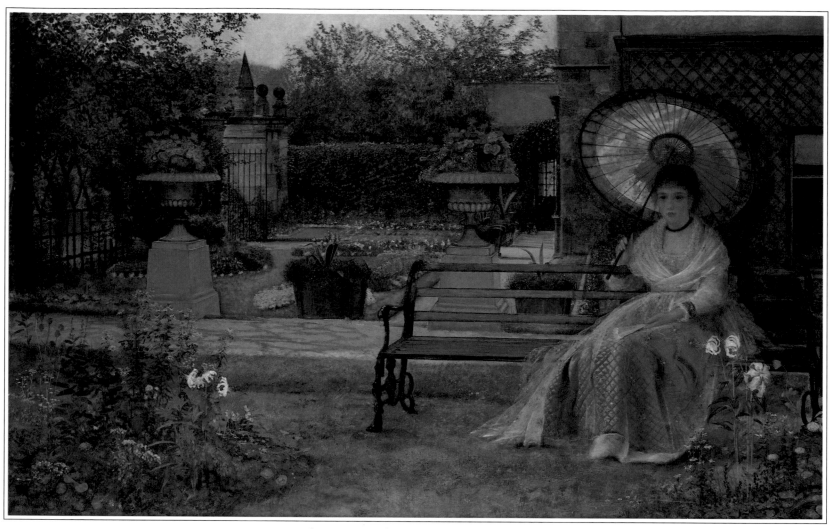

24. Atkinson Grimshaw. *In the Pleasaunce*, 1875.

flowers of every hue perfuming the air with fragrance. How grateful I feel that through the goodness of God I am permitted to enjoy these blessings, and that my mind has been so constituted by his boundless power that I am enabled to derive unspeakable pleasure from musing upon his works!' One should not forget that for many Victorians, gardens were only another manifestation of God's infinite goodness.

Another Scottish garden inspired a number of flower pictures – Kellie Castle, in Fife. This was rented, as a ruin, by the Scottish painter John Henry Lorimer RSA (1856–1936). He and his brother, the well-known architect Sir Robert Lorimer, restored and rebuilt the castle during the 1870s, and it became a regular summer retreat for the Lorimer family. John Henry Lorimer made a number of paintings of the gardens, in

particular the marvellous study of madonna lilies (plate 94). The Scottish historian J. L. Caw in his book *Scottish Painting* (1908) wrote of Lorimer's work that 'some of the finest and most personal things he painted are either studies of sprigs or blossoms, or great clumps of flowers'.

Most Victorian pictures of gardens are in watercolour; both Jacob Thompson's and J. H. Lorimer's pictures are unusual in that they are oil paintings. Another painter in oil, who made several pictures of his own garden, was the Leeds artist **Atkinson Grimshaw** (1836–93). It may come as a surprise to those who think of Grimshaw only as a painter of moonlight scenes and grimy docks, that he painted several delightful pictures of his wife Theodosia in the garden of their house, Knostrop Old Hall. One, entitled *In the Pleasaunce* (plate 24)

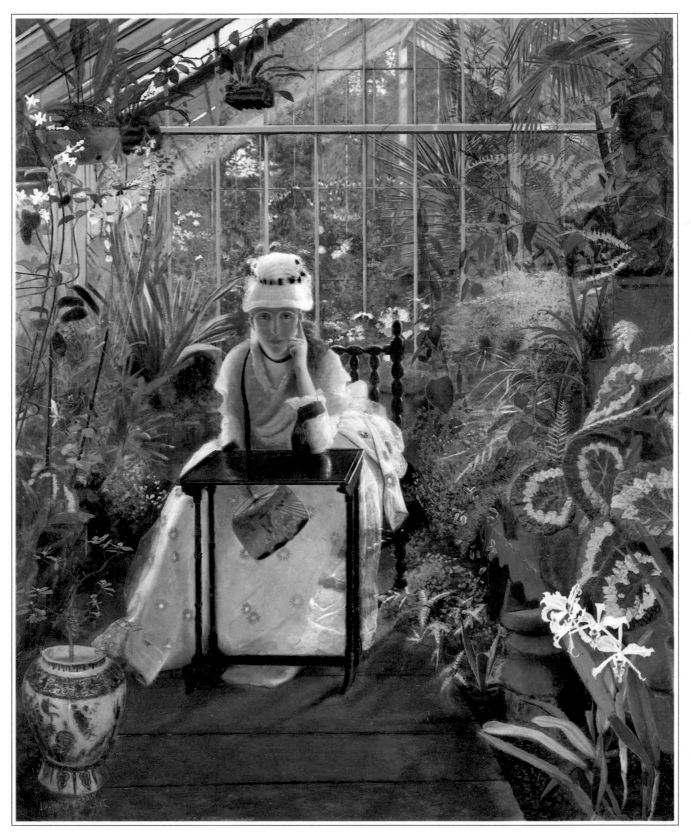

25. Atkinson Grimshaw. *Il Penseroso*.

has already been mentioned. He also made a wonderful study of Mrs Grimshaw seated in the conservatory entitled *Il Penseroso* (plate 25). Both pictures are fascinating evidence of the shift of aesthetic taste in the 1870s towards an 'olde English' garden style, but still combined with a good deal of bedding plants. Grimshaw also endlessly used Knostrop Old Hall as a background for his night scenes; garden pictures by him are sadly rare. Even rarer are garden pictures by the great landscapist **Benjamin Williams Leader** RA (1831–1923). Only one lone example by him survives (plate 26), probably a view of his own garden near Malvern, in Worcestershire.

Plans and designs by garden architects are unfortunately rare, and very few from this period survive in good condition. The design by Walker for Warley Place has already been mentioned; we also illustrate Francis Inigo Thomas's marvellous panorama of Athelhampton (plate 27) and George Kennedy's design for the formal gardens at Bowood (plate 44). Among the distinguished amateurs, mention should be made of Piers Egerton-Warburton, owner of Arley Hall in Cheshire. Landowner, agriculturalist, sportsman, gardener, antiquarian, poet and artist, Egerton-Warburton epitomized the best kind of Victorian squire. He made many watercolours of old buildings and towns in Cheshire and also painted the house and gardens at Arley, one of which we illustrate here (plate 55), along with other views of this great garden by both Elgood and Rowe. One of Egerton-Warburton's more charming eccentricities was to have all the signposts on his estate inscribed with directions in rhyming couplets, composed by himself.

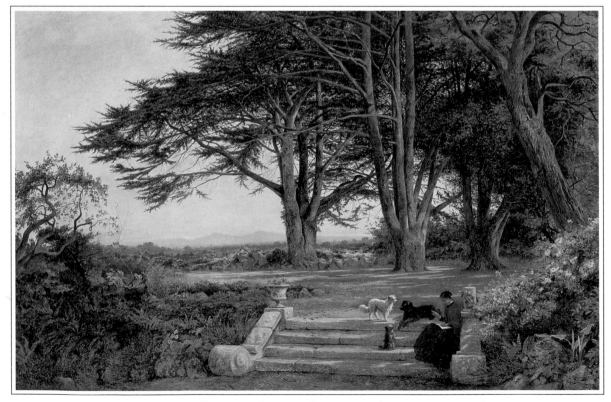

26. Benjamin Williams Leader. *Garden near Malvern*, Worcestershire.

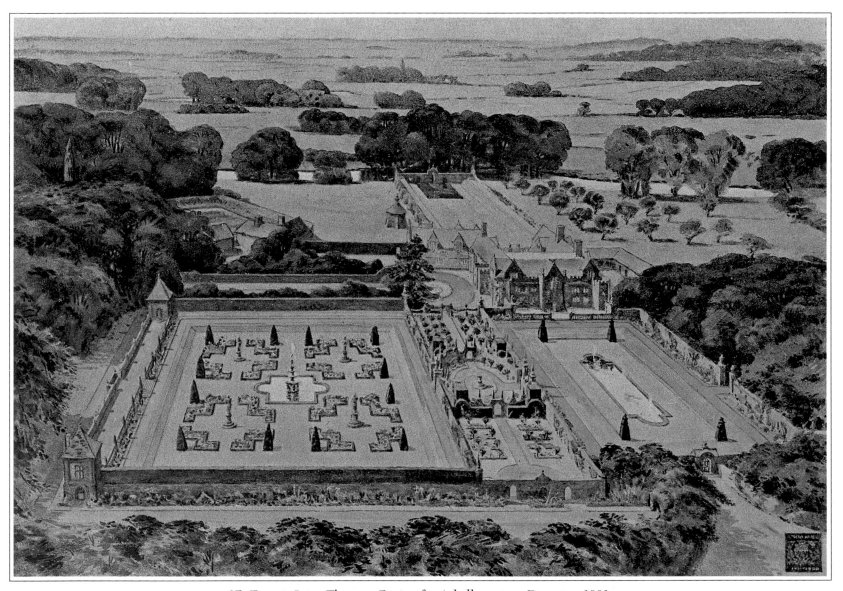

27. Francis Inigo Thomas. *Design for Athelhampton*, Dorset, c.1901.

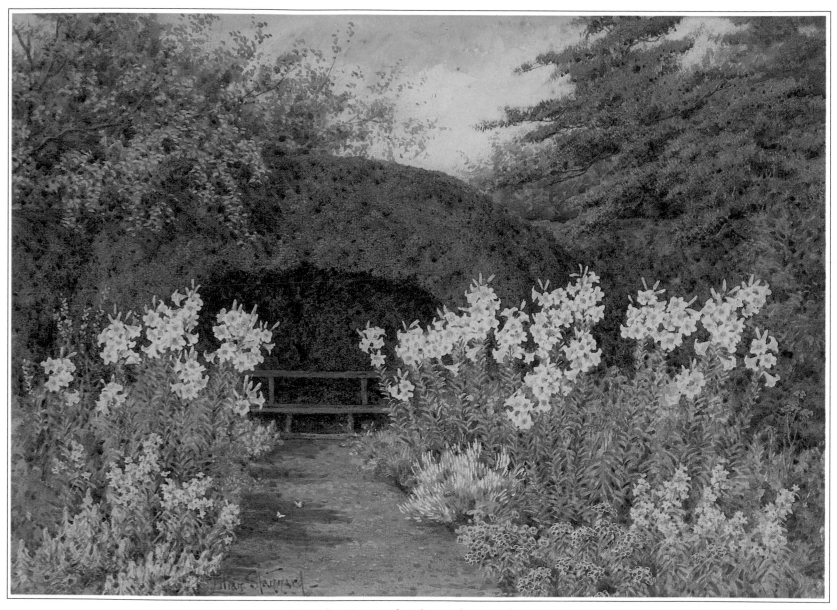

28. Lilian Stannard. *Lilies and Yew Arbour*.

SOME LADY PAINTERS

Painting flowers and gardens were among the favourite pastimes of the Victorian lady. Much of their work is too amateurish to justify inclusion in this book, or the gardens they painted are not sufficiently interesting. Some lady amateurs, however, did attain a professional standard, and exhibited their work in public. One such was the remarkable Irish watercolourist, **Mildred Ann Butler** (1858–1941), who became an Associate of the Royal Watercolour Society. She painted both landscapes and garden scenes, mostly of her own house in Ireland, in a delightfully fluid and fresh impressionistic style. Among the countless other amateurs, **Rose Champion de Crespigny** is perhaps worthy of mention for her interesting watercolours of the gardens at Gredington in Shropshire, also painted by Elgood.

The most productive of all the lady garden painters were the two Stannards – **Lilian Stannard** (1877–1944) and her niece **Theresa Sylvester Stannard** (1898–1947). They were both members of the Bedfordshire family of Stannards, one of those remarkable artistic dynasties of the Victorian period. Lilian's brother, **Henry John Sylvester Stannard** (1870–1951), the father of Theresa, was best known for his watercolours of pretty village scenes, but he did occasionally paint a garden. Both Lilian and Theresa, however, became specialists in garden subjects, and held exhibitions of them in London, at Ackermann's, the Mendoza Gallery, Walker's and elsewhere. Queen Mary, who obviously had a keen eye for a garden picture, was an admirer of the Stannards' work, and bought regularly at their exhibitions. Another admirer of Lilian's work was Lady Ludlow, who commissioned her to paint the gardens at Luton Hoo. Both the Stannards developed a distinctively bright, impressionistic style, in which the flowers are not delineated with quite the precision of Beatrice Parsons. But at their best, they are effective and decorative, and their watercolours are certainly among the prettiest of all Victorian garden pictures. Sometimes the garden they depict can look a little fanciful or overly-romantic compared to the strictly accurate observations of Parsons, Elgood or Rowe. Many of the gardens painted by

Margaret Waterfield

the Stannards are not specifically identified, and have titles like *An Old Water Garden* or *A Sunny Corner*. Lilian did paint one specific series of the gardens of Cambridge colleges. The Stannards also painted a great many cottage gardens, featuring the picturesque old thatched houses of their native Bedfordshire, and of Hertfordshire. It is still possible that many of their best garden pictures are still hidden away in private collections, and have not yet come to light.

Another lady painter of gardens whose work is not often seen is **Edith Helena Adie**, working from about 1892 to 1930. She exhibited landscapes, buildings and gardens, at the Royal Academy and elsewhere, and contributed a view of Hampton Court (plate 84) to the *Studio* Special Number on Gardens.

Many Victorian lady artists came to garden painting by way of book illustration. One of the most interesting of these was **Margaret Waterfield** (1860–1950), who illustrated a small number of gardening books between 1905 and 1922. The best known is *Garden Colour*, published by J. M. Dent in 1905, with a number of delightful colour plates by Waterfield. Her style is extraordinarily broad and impressionistic, but she

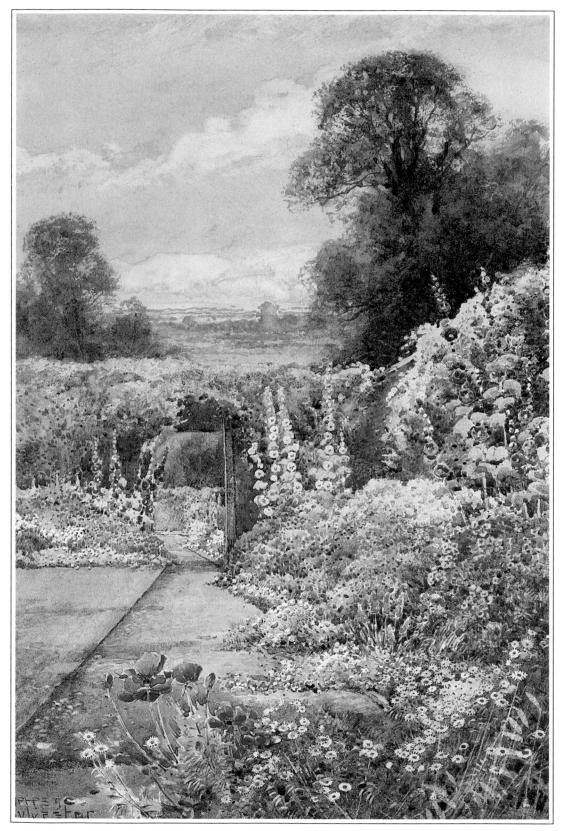

29. Theresa Sylvester Stannard. *Summer Garden*.

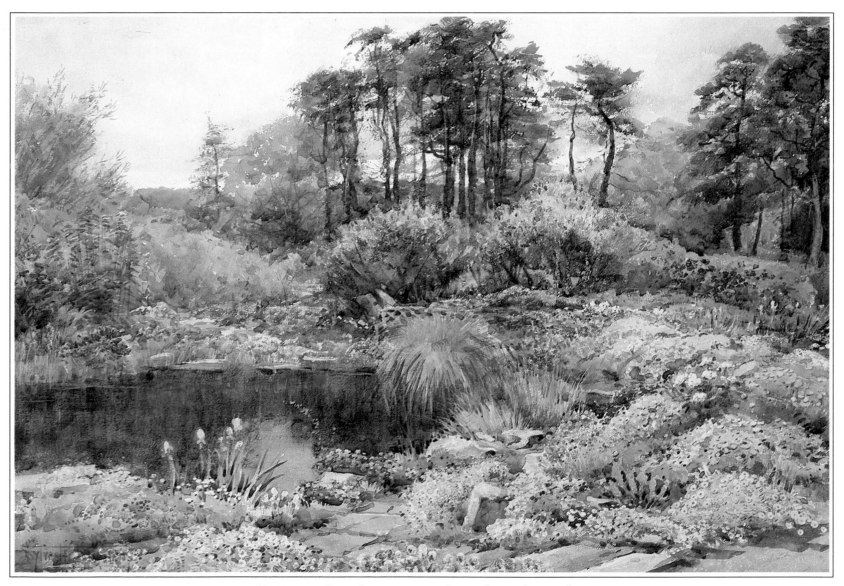

30. Henry John Sylvester Stannard. *Garden with a Pond.*

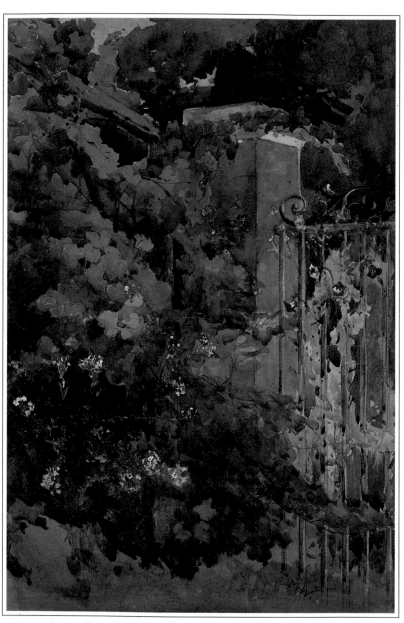

31. Margaret Waterfield. *Purple-leaved Vine and Plumbago.*

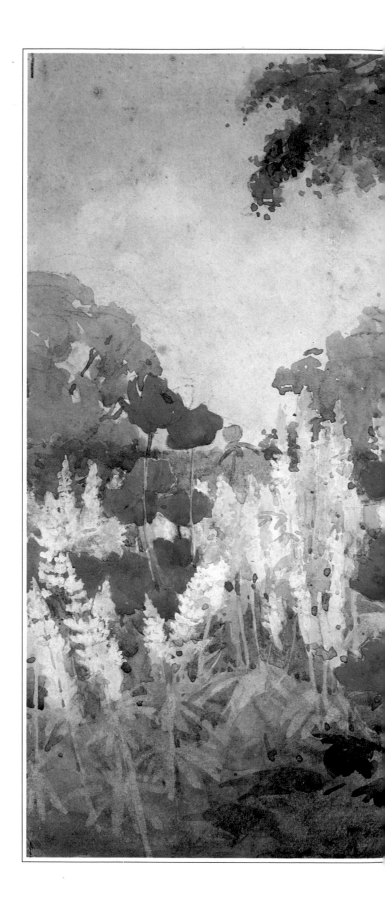

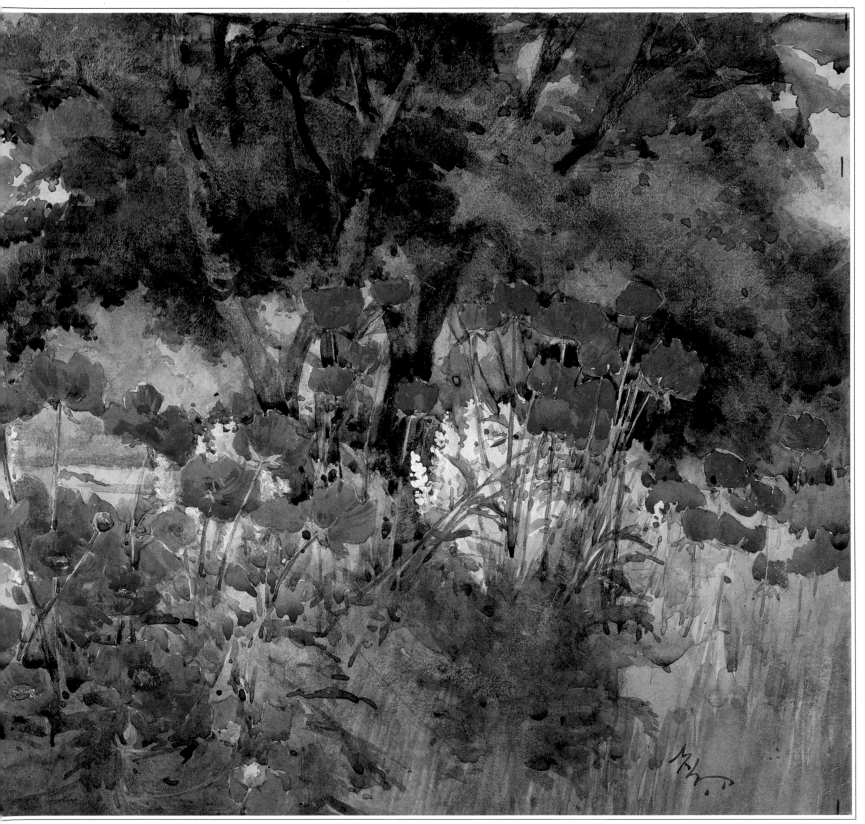

32. Margaret Waterfield. *Oriental Poppies*.

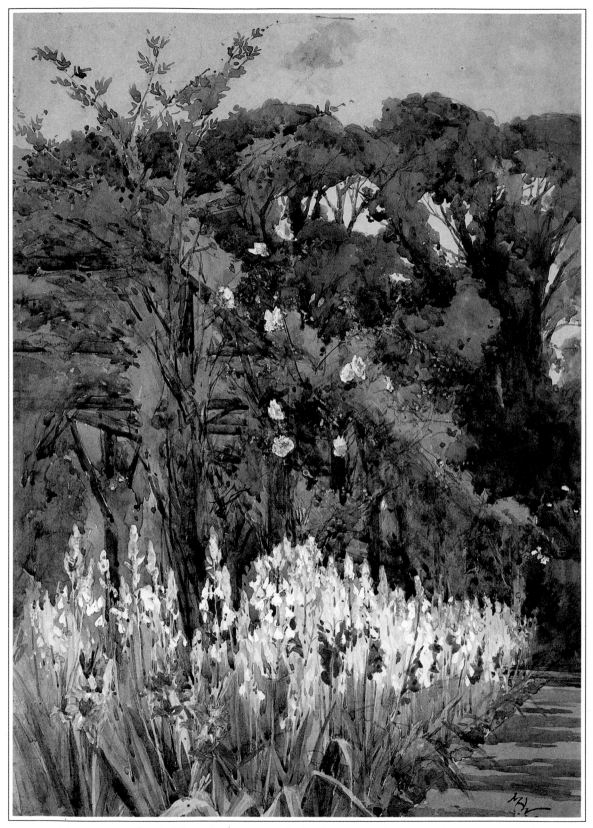

33. Margaret Waterfield. *Summer Hyacinths* (Galtonia Candicans) *under a Rose Pergola.*

manages none the less to suggest the shapes and colours of flowers extremely well. Unfortunately very few of her water-colours seem to have survived, except for a delightful group of studies of her parents' house and garden at Nackington House, near Canterbury in Kent. Another contributor to the book *Garden Colour* was the distinguished amateur artist and illustrator **Eleanor Vere Boyle** (1825–1916), generally known by her initials as EVB. Born Eleanor Vere Gordon, she married in 1845 the Hon. and Revd. Richard Boyle, a younger son of the eighth Earl of Cork. Boyle was parish rector on his father's estate at Marston, near Frome. Here Eleanor was to live happily for the next forty years, combining her duties as rector's wife with a remarkable career as an illustrator of children's books. These have now become collectors' items, in particular *Child's Play* and *Story without an End*. Eleanor used the money from these books to finance a great many good works on the estate at Marston, including the bringing of running water to two villages, and the building of a splendid gothic schoolhouse (now occupied by the author). In 1886 Richard Boyle died, and Eleanor moved to Huntercombe Manor, near Burnham in Buckinghamshire. Here she devoted the rest of her life to gardening and writing garden books. Most of these were illustrated with line drawings by herself. Her most popular work was *Days and Hours in a Garden*, first published in 1884, and later reprinted at least seven times. Until her death in 1916, at the age of 92, she continued to produce many more books about gardening, written in a prosy, discursive style that is typical of the era, but always illustrated with her own charming drawings. She must certainly have been one of the best known garden writers of her day. Another distinguished illustrator, also called Eleanor, was **Eleanor Fortescue-Brickdale** (1872–1945). As an artist, she belongs to the late, romantic phase of the Pre-Raphaelite movement, and is often compared to Byam Shaw, whose work she admired, and in whose school she taught. Fortescue-Brickdale was not a garden painter in the narrow sense, though she did paint the garden at Biddestone House in Wiltshire (plate 34), but she often introduced gardens into the backgrounds of her book

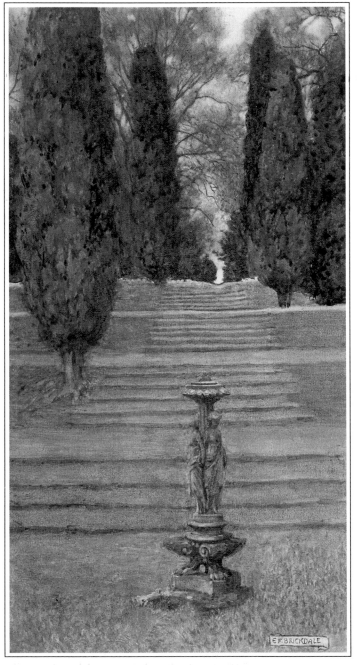

34. Eleanor Fortescue-Brickdale. *Biddestone House*, Wiltshire, 1909.

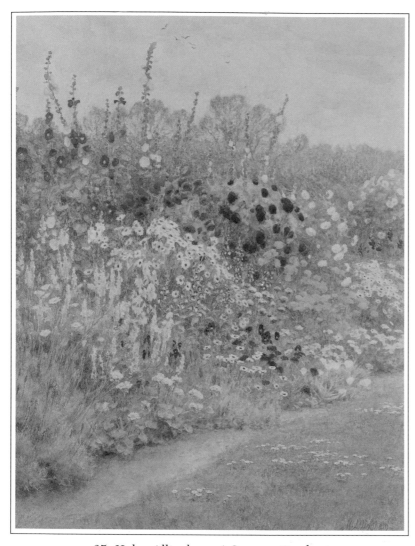

35. Helen Allingham. *A Summer Border*.

illustrations. Many depict medieval or Elizabethan figures in what are intended to be old-fashioned English gardens, and Fortescue-Brickdale therefore is another of that group of illustrators, like Walter Crane and Kate Greenaway, whose works project an image of the 'olde worlde' English garden.

THE COTTAGE GARDEN

The cottage garden is not really the subject of this book, but some discussion of it is relevant, because the painters of cottage gardens often painted grander gardens as well. Also, it is sometimes difficult to draw the line between a cottage garden and the garden of a small country house. Writers like Robinson and Jekyll encouraged gardeners to study cottage gardens and learn from them, and even Elgood, the painter of the grandest and most formal gardens, also painted a cottage garden if he found a sufficiently interesting or picturesque one.

The cottage and its garden were for the Victorians a highly potent image, symbols of not only a rustic innocence which they felt they had lost, but also of a way of life that they knew to be rapidly disappearing. The artist who above all made the cottage and its garden her own was **Helen Allingham RWS** (1848–1926). Her husband was the Irish poet William Allingham, author of the famous lines:

> *Up the airy mountain,*
> *Down the rushy glen,*
> *We daren't go a-hunting,*
> *For fear of little men.*

They were part of a literary circle which included Browning, Carlyle, Tennyson and Ruskin, who became a particular admirer of Helen's work. In *The Art of England* (1884) Ruskin linked her with Kate Greenaway, and praised her works for 'the gesture, character and humour of charming children in country landscapes'. Allingham illustrated several books, the two best known being *Happy England* (1903) and *The Cottage Homes of England* (1909). Both books contain a wealth of information about cottages and their gardens, but their intention was not purely sentimental and picturesque. Allingham

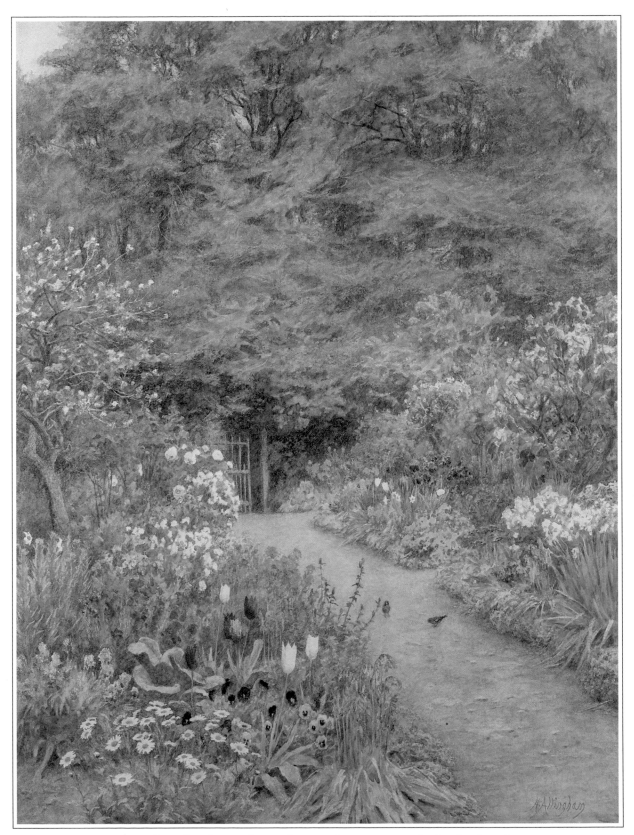

36. Helen Allingham. *The Kitchen Garden at Farringford*, Isle of Wight.

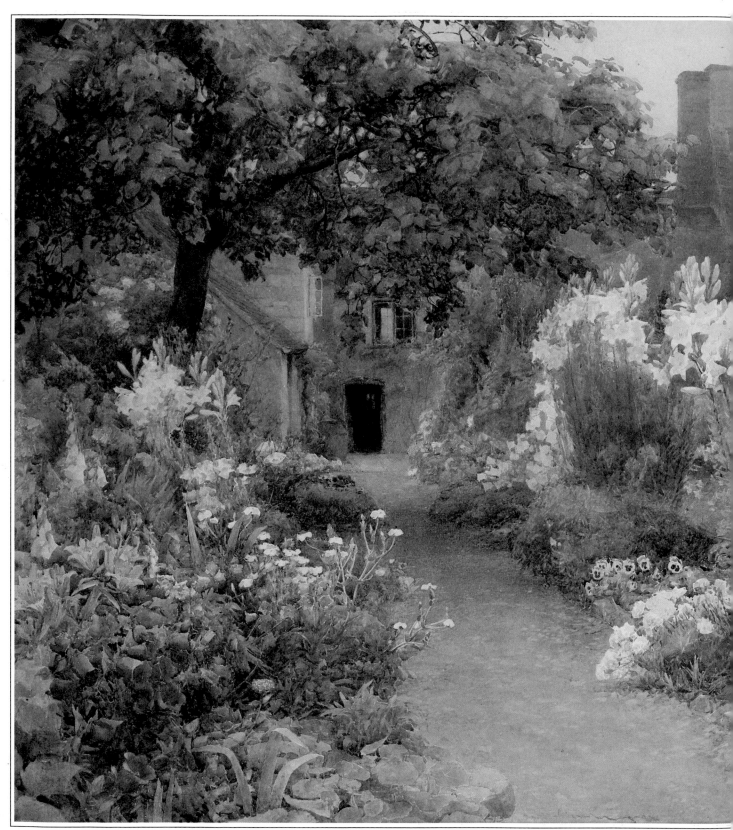

37. Ernest Albert Chadwick. *A Country Garden.*

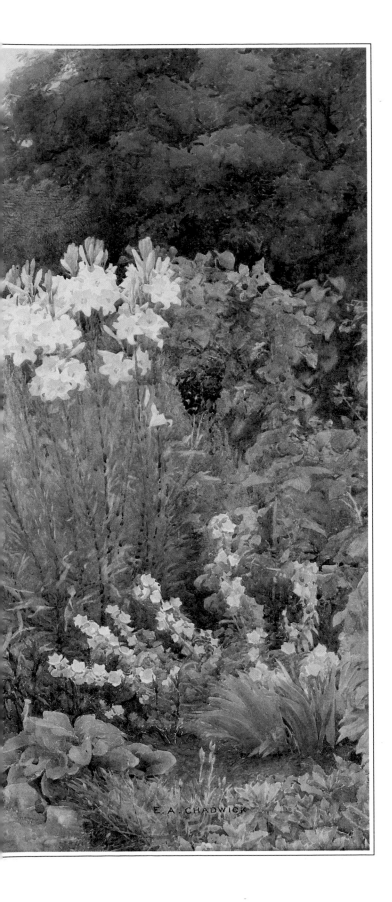

E.A. CHADWICK

was a passionate preservationist, determined to record old cottages before they were modernized, built on to, or even demolished completely. A hundred years later, we can now appreciate how right she was, and be grateful that she recorded what she did so lovingly and so beautifully.

As already mentioned earlier, Allingham painted several other gardens, most notably Gertrude Jekyll's garden at Munstead Wood (plates 104 and 105), and Lord Tennyson's gardens both at Farringford on the Isle of Wight (plate 36) and at Aldworth in Surrey. A selection of these were eventually published in a book entitled *The Homes of Tennyson* (1905). She also made many studies of flowers and garden borders. These, like her cottage watercolours, are distinguished by their accuracy of observation and wonderful delicacy of colour. No one was better than Allingham at capturing the soft, pale greens of the English countryside. She is often compared to **Birket Foster** (1825–99) who was her neighbour in Surrey, and whose work she definitely admired. Foster also painted cottage gardens, but usually only as a vehicle to include groups of rosy-cheeked children at play. Delightful though his pictures are, his colours can seem both garish and artificial when put next to a watercolour by Allingham. I agree with W. Graham Robertson, who wrote of Allingham in his book *Time Was* (1931): 'Her lovely little transcripts of the Surrey lanes and woodlands, of the school of Birket Foster – but, to me, fresher, more fragrant and close to nature than the work of the elder painter – are delights to the eye and lasting memorials of the fast-vanishing beauty of our countryside.'

Allingham had many imitators, but no equals. Arthur Claude Strachan was more a follower of Birket Foster, and only the little-known Ethel Hughes can sometimes equal her delicacy of colour. It only remains to mention two other stray painters, whose work occasionally focused on the garden. The first is **Ernest Albert Chadwick** (born 1876), a painter of landscapes who was capable of the occasional startlingly beautiful garden scene (plate 37). Unfortunately the gardens he painted are rarely identified, and very few of his garden pictures are known, so he remains a tantalizing figure. Finally, there is

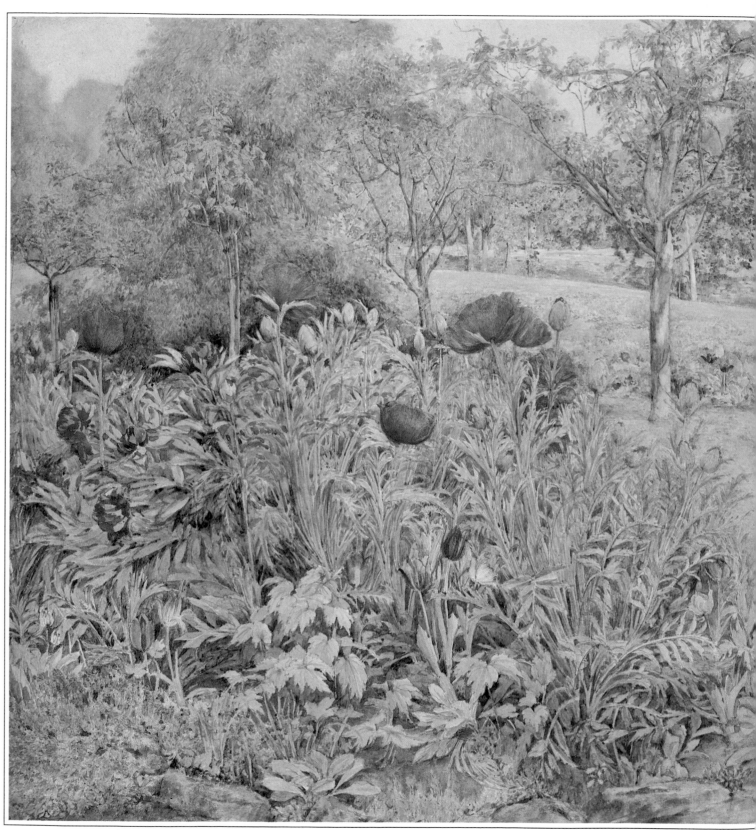

38. Edward Kington Brice. *Garden with Poppies*.

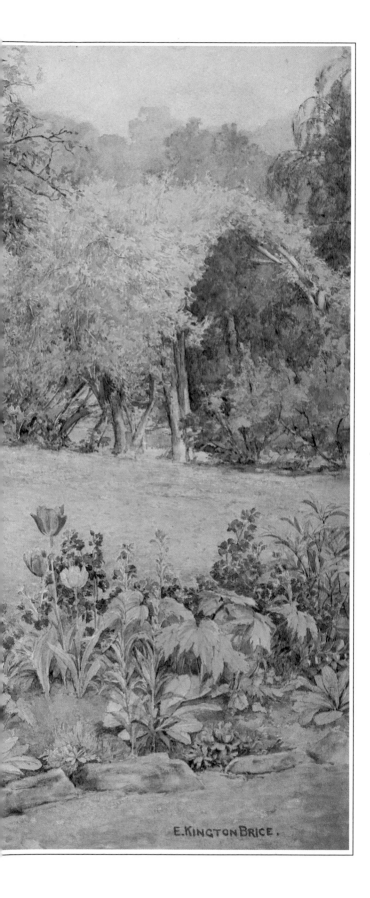

Edward Kington Brice (1860–1948), who was working until the early part of this century. Brice was a painter of both landscapes and imaginative figure subjects, but he produced a small number of watercolours of what must probably be his own garden at Ashton under Hill, near Evesham in Worcestershire (plate 38). These are so strikingly attractive that one can only wish he had devoted more of his time to them. Brice and Chadwick belong to that group of landscape painters for whom the garden was only, regrettably, a very occasional subject. One day, more of their work, and of others like them, may come to light.

Perhaps all of these painters, Elgood, Rowe and Parsons included, idealized what they saw. Their gardens are always perfect, almost too perfect, painted just as their owners would like them to be seen – under the best conditions. How, indeed we would secretly all like our own gardens to look. But perhaps these painters knew that the long traditions of English country life were soon to be changed forever, first by the agricultural depression of the 1880s and '90s, then by the motor car, and finally by the Great War. If they did idealize what they saw, we should forgive them, and be grateful, a hundred years later, that a whole epoch of English gardens should be so beautifully recorded and preserved.

Part Two

THE GARDENS

by Penelope Hobhouse

39. George Samuel Elgood. *Ramscliffe*, Leicestershire, 1898.

40. Margaret Waterfield. *Red and White Irises*.

Introduction

The Gardens of England illustrated by E. Adveno Brooke with chromolithographs was published in 1856–57. It is dedicated to the Duchess of Sutherland whose garden at Trentham is portrayed in the book. It seems that the written text to accompany the paintings was assembled from contributions by various individuals, including some of the head-gardeners of the grand properties concerned. In some cases the writer is hazy about the reality of the layout; but enough is shown and written to demonstrate the ingenuity and sheer technical skill involved in such monumental creations. Mr Brooke spent several summers 'not for a mere casual visit or a hurried sketch but for the purpose of patient and careful labour' to complete his part in the publication. In spite of his labours, individual plants are not meant to be recognized, it is overall effects of architecture and colour that are of crucial importance. Although within the paintings urns overflow with scarlet geraniums, tulips and forget-me-nots decorate spring borders, and in one instance, Salvia patens appears as part of a ribbon border at Trentham, in general massed annuals are painted with sweeps of colour and realistic plant portrayal is not important; style is everything.

A representative selection of Adveno Brooke's paintings has been included in this book, chosen deliberately to contrast with the gentle garden pictures of the later 1800s and early 1900s. In the later paintings a new breed of artists concentrates on flower and flower-bed detail as well as composition; the gardens seem mellow with age, with moss and lichen growing on ancient walls and flowers smothering the base of what appear to be genuinely old yew or box bushes trained or clipped as hedges or topiary; these in their turn frame Tudor manor houses (see Compton Wynyates, Brickwall, and Penshurst Place) or medieval castles (see Berkeley Castle). The pictures are given nostalgic old-fashioned titles such as Gardens Gay and Joyous, marking a return to simple and above all quite modest gardening styles. The beds of herbaceous plants, many of them known and loved for centuries, also included more recently introduced annuals and tender plants – plants which had, at first, been used mainly for massed bedding effects. Instead of being cut and twisted to perform in colour patterns, arranged in concentric circles or chain patterns at the pleasure of the Victorian head-gardener, these plants were now treated as individuals and were allowed to grow in natural-looking clumps in the new 'free' style. The artists painted these 'quality' plants in borders (see Munstead Wood), in Robinsonian woodland (see Trebah) or in natural-looking drifts in meadows (see Warley Place).

The Adveno Brooke gardens, created in the first half of the nineteenth century, all contained elements which influenced garden fashions for the next fifty years. Each stresses the formal architectural setting, usually interpreted by terraces, balustrading, broad steps and elaborate bedding-out schemes or box and gravel parterres with which the early Victorians loved to frame the large houses that firmly dominated the layout. Most are what we might call Barry-type 'Italianate', but two of the gardens, Alton Towers and Elvaston Castle, are strongly individualistic. The former was an assemblage of 'themes' exemplified by buildings in differing styles and a hotchpotch of planting features; at Elvaston avenues and hedges of yew and newly introduced conifer species, strange and fantastic topiary and allegorical garden-theme enclosures were equally extraordinary, a demonstration of man's ingenuity in manipulating the natural form of both plants and landscape. Other early Victorian gardens were typified by those of Loudon's suburban villa and were on a reduced scale; in these planting was 'gardenesque' and was designed to show off plants, often newly introduced, to their best advantage, blending art with nature. Meandering paths took the place of Italianate terraces, and bedding out was in island beds on the lawn instead of in patterns in vast parterres. Gardens such as Biddulph Grange at Stoke-on-Trent exaggerated the thematic or compartmental approach: separate garden areas were for individual garden styles and planting themes, but, unlike Elvaston or Trentham, plants and buildings were placed together in environmental settings. Near the Italian-style house the compartments were geometrical; farther away enclosures were informal to suit styles such as 'China' and an 'American' garden besides an herbaceous border, a dahlia walk and a rose garden. Biddulph was the forerunner of a series of theme gardens which by the

last quarter of the century were extended in quite different ways to include nostalgic cottage-garden-like plants and garden areas for Tudor period plants or Shakespeare's flowers (see The Pleasaunce). Equally 'revivalist' in theme, were mazes and topiary to accompany Tudor or early Jacobean houses (see Compton Wynyates and Hatfield House).

As the century proceeded, garden development became more eclectic. Head-gardeners perfected 'artificiality'; bedding-out schemes became ever more elaborate. Labour was cheap and plentiful, resources were often unlimited, and horticultural knowledge and techniques were constantly expanding gardening horizons. It seems likely, however, that borders of mixed flowers survived the bedding craze; in large establishments a double border down the centre of a kitchen garden was kept in good trim for cut-flowers, in smaller gardens and in beds lining cottage-garden paths the hardy plants were still cultivated, not for two or three month's enjoyment of blazing colour but for a steady progression of flowering interest for nine months of the year. Mid-century horticultural journalists writing for all classes and not only about the grand trend-setting gardens described perennials and old-fashioned annuals still furnishing flower-beds. These mixed borders posed problems to the disciplined gardener: plants flowering at different times and growing to different heights were difficult to organize and the resulting 'mixtures' did not fit into any symmetrical pattern. In the 1850s Donald Beaton and Shirley Hibberd continued to extol the importance of hardy herbaceous borders, but recognized the difficulty in fitting their 'irregularities' into fashionable layouts where massing annuals of uniform height and colours reinforced rigidity. Hibberd continued to remind readers that 'the bedding system is an embellishment added to the garden; the hardy herbaceous border is a necessary fundamental feature'. At Arley Hall in an 1846 reconstruction of the garden to match a new Jacobean-style house, a double herbaceous border was included (it still exists) in the main ornamental garden. Rose gardens also were banished to isolated enclosures where they would be viewed only at a peak season, (as at Hatfield House), an idea that could be recommended to modern designers.

By the 1880s the Arts and Crafts Movement sought a return to earlier artistic and creative values in literature, painting and rural crafts which were thought to have existed in medieval times – or at least before the mass production of the Industrial Revolution. Gardening was not excepted; as a reaction to the vast and monumental extravaganzas made possible by new horticultural developments, the search for simplicity and a vernacular garden style on a much more modest scale emerged. At first these gardens were portrayed in paintings or idealized in poetry; hollyhocks, lilies, sunflowers and old-fashioned roses illustrated historical epics, Kate Greenaway stories or even nursery rhymes, and bore little resemblance to fashionable contemporary garden styles. A painting by Millais of *Ophelia* in 1852 anticipated the spirit of 'wild' gardening. William Robinson published *The Wild Garden* in 1871, *The English Flower Garden* in 1883; although his encouragement to grow hardy flowers to replace garish annuals was not entirely original, he became the vigorous prophet of more natural-style gardening. Both Robinson and Reginald Blomfield (and, of course, the influential J. D. Sedding) drew inspiration from the Arts and Crafts Movement. Robinson's seemingly revolutionary recommendations, during the 1870s, to abandon vulgar and ostentatious bedding-out patterns in favour of 'naturalizing innumerable beautiful natives of many regions of the earth' where they would thrive and flourish, was an extension of the nostalgia evoked from cottage-gardens and old-fashioned plants, both symbols of the best of 'old' English styles and ways, to *all* hardy plants. These might, in Robinson's view, not only furnish beds and borders but improve natural pond edges and the fringes of woodland. Blomfield equally hankered for a return to old-fashioned gardens; but for him these were exemplified by seventeenth-century garden formality, where architects created a garden layout entirely in keeping with the design of the house, before allowing the gardener any choice in planting style or plants. These gardens were typified by tone terracing, straight lines of clipped yew hedging and 'revivalist' topiary shapes, enthusiastically described by Rossetti at Brickwall in 1866, which gave a feeling of antiquity and mellow age, all laid out in strong geometric form. Blomfield and his

41. Alfred Parsons. *Nymans*, Sussex.

disciples, designers such as Inigo Thomas who illustrated *The Formal Garden in England*, distinguished these from the Victorian Italianate, which Robinson particularly abhorred (Robinson named Alton Towers and Trentham as well as many others as his aversions); perhaps, indeed, when they talked of 'English Renaissance' period gardens they hardly realized the debt English sixteenth- and seventeenth-century layouts owed to the pure spirit of Italian garden symmetry (see Brockenhurst) something quite different from the nineteenth-century interpretation and extension of its themes. In these, wide vistas were dominated by house and terraces; in Tudor and Jacobean English adaptations of Renaissance style the garden remained a series of inward-looking enclosed units. In the gardens recommended by Blomfield and Sedding, simply planned garden 'rooms' had direct axial contact with the house; raised terraces, secluded alleys, bowling greens and orchards, resembling those described in Gervase Markham's *The Country Farm* (1615) and William Lawson's *A New Orchard and Garden* (1618), were incorporated in a geometric layout surrounded by perimeter hedging.

Now that nearly a hundred years have passed it appears that the Robinson/Blomfield controversy was centred round varying interpretations of the word 'formal'; today it all seems a storm in a teacup; Robinson and Blomfield took extreme lines but in reality had much in common. Robinson found inspiration in the unsophisticated English cottage garden and natural scenes enriched with foreign introductions; Blomfield could build the perfect frame in which cottage-garden plants and appropriate 'foreigners' could look their best growing side by side. Many of the gardens illustrated in this book could be praised by either of these authorities; some of our greatest English gardens, such as Hidcote, combine Blomfield's formality with both Robinsonian flower-bed planting and Robinsonian woodland scenes in the outer garden (as at Shrubland where Robinson was called in to 'rationalize' extreme formality in a wild setting). Both Robinson and Blomfield praised Devey's restorations of seventeenth century garden layouts at Penshurst and Brickwall. Possibly Blomfield would find it hard to approve of the

plantsman's garden at Trebah; in fact neither he nor Sedding discussed woodland gardens in their books: these plant collections were not to be confused with a garden, which was attached to a house, and as such inextricably linked with it for design purposes. Plantsmen's gardens were outside the mainstream of fashion and style. Interestingly, Jane Brown's recent history of *The English Garden In Our Time* (1987) also ignores the plantsman. Robinson, whose own garden at Gravetye is illustrated by Beatrice Parsons (plates 78 and 79), believed in decent order and formality near a house, even terracing was considered necessary and acceptable, especially when, as at Berkeley Castle and Rockingham Castle, the land falls steeply; the natural woodland and meadow schemes he recommended also needed appropriate settings. Within less than a decade, the Jekyll and Lutyens partnership established a fusion between the extremes of Robinsonian cant and Blomfield rigidity, the partners taking their themes from both protagonists to produce gardens which for beauty of flower colour combined with a sense of geometric order have never been surpassed. It is this gardening style which the painters capture in most of the pictures in this book; it seems astonishing how many of the gardens painted at the turn of the century still survive and are lovingly maintained in the 1980s and seem to have assured futures.

We have become accustomed to tales of neglect and wholesale destruction; yet out of more than thirty gardens portrayed twenty-one are still recognizable, and most are open to a discerning visiting public. Arley Hall, Balcaskie, Berkeley Castle, Blickling Hall, Brockenhurst Park, Cleeve Prior, Crathes Castle, Gravetye Manor, Hampton Court Palace, Hardwick Hall, Hatfield House, Hever Castle, Kellie Castle, Kildonan Lodge, Levens Hall, Melbourne Hall, Montacute House, Penshurst Place, Rockingham Castle, and Trebah all exist or have been restored to good order. Many are still in private hands. This is not, then, just a history book showing and describing past garden glories and illustrating a particular *genre* of painting; instead it celebrates the survival of some of our most important flower gardens.

THE E. ADVENO BROOKE GARDENS

The five gardens illustrated in this section are taken from
The Gardens of England (published in 1857) by E. Adveno Brooke.
Additional views of Elvaston, painted later, are by
Ernest Arthur Rowe and George Maund.

42. E. Adveno Brooke. *The Colonnade, Alton Towers*, Staffordshire.

ALTON TOWERS

Staffordshire

Alton Towers in Staffordshire lies a few miles east of the Potteries and west of the Derbyshire coalfields. The whole conception of the extensive garden landscape placed in the then remote valley in the foothills of the Peak District, was a romantic folly which in scope and imagination has seldom had equal.

In *The Gardener's Magazine* of 1831 John Claudius Loudon, after a visit in 1826, gives an amazing description of the garden development. This began before the end of the Napoleonic wars in 1814 to 1827 under the Fifteenth Earl of Shrewsbury and was carried on by the Sixteenth Earl (1791 – 1852) during the 1830s and 1840s. 'An immense pile of building in the way of a house, with a magnificent conservatory and chapel . . . a lofty prospect tower not built on the highest part of the grounds; a bridge, an embankment over a valley, without water underneath, ponds and lakes on the top of hills, . . . a valley naturally in a high degree romantic with wood, water and rocks, filled with works of the highest degree of art in architecture and gardening . . . such a labyrinth of terraces, curious architectural walls, trellis-work arbours, vases, statues, stairs, pavements, gravel and grass walks, ornamental buildings, bridges, porticoes, temples, pagodas, gates, iron railings, parterres, jets, ponds, streams, seats, fountains, caves, flower baskets, waterfalls, rocks, cottages, trees, shrubs, beds of flowers, ivied walks, rock-work, shell-work, root-work, moss houses, old trunks of trees, entire dead trees & etc, that it is utterly impossible for words to give any idea of the effect'. In 1833 in *Encyclopedia of Cottage, Farm and Villa Architecture* he describes the scenery created 'not . . . as a model for imitation. On the contrary, we consider the greater part of it in excessively bad taste, or rather, perhaps, as the work of a morbid imagination joined to the command of unlimited resources. Still, however there are many excellent things in it'.

Astonishingly also this 'pile' was not the main seat of the Shrewsburys; that was at Heythrop in Oxfordshire. Alton was considered by the Fifteenth Earl as a retreat – the existing lodge hardly more than a cottage as the original castle was in ruins. In 1831 Heythrop was burned and Pugin was employed by the Sixteenth Earl to extend and gothicize this house. More terraces were built, colonnades in stone and conservatories extended garden interest.

In many ways Alton Towers represents, on the grandest scale, the Georgian passion for creating private elysiums rather than a new interest in garden features as such. Perhaps it marks a transition between the idealised landscape of the eighteenth century to a more personal and subjective view which illustrates man's inventiveness rather than his adaptation of nature to a pictorial scene.

The garden and its architecture can thus be considered in two phases. The first was the 'romantic folly' landscape described above. Here, by the 1840s, Alexander Forsyth, the head-gardener, was planting rhododendrons and other shrubs, experimenting with a heather garden, and adding many more trees which partly disguised the great variety of architectural features, creating unity with coverings of vegetation. (By 1870 Forsyth's planting had matured to clothe the steep hillsides and, indeed, was by then considered to have already grown too dense, so that vistas were being opened up through the woods.)

The second period of building by the Sixteenth Earl, after Heythrop had been destroyed by fire in 1831, saw formal terraces flung out and new conservatories built, architectural features which surrounded the 'new' house – Alton Towers, as it was now named. W. A. Nesfield laid out a box and gravel parterre in the pattern of the initial 'S' with scarlet geraniums; tender-plant bedding-out schemes in ribbons and patterns abounded. These themes, illustrated by E. Adveno Brooke, demonstrate Victorian garden taste as opposed to the wider landscape style and exotic buildings at Alton Towers – which do not concern this book. The two paintings show the Colonnades from opposite viewpoints. One painting (plate 42) shows the intimate garden in front of the Colonnades facing south towards the Pagoda; a planting of tulips lines the terrace, and urns overflow with scarlet geraniums; 'grog' from the nearby Potteries is used instead of gravel. In the background is the Gothic Folly from which the whole garden is visible. In the

opposite view (plate 43) looking towards the gorge and cenotaph monument, the upper terrace, where the Golden Gate Walk had been altered by W. A. Nesfield to a parterre pattern known as Lady Mary's Terrace, is visible. Twelve-foot-high stone walls in strange scalloped shapes frame a line of urns, and charming basketwork flower-beds decorate the lawn.

43. E. Adveno Brooke. *The Gardens, Alton Towers*, Staffordshire.

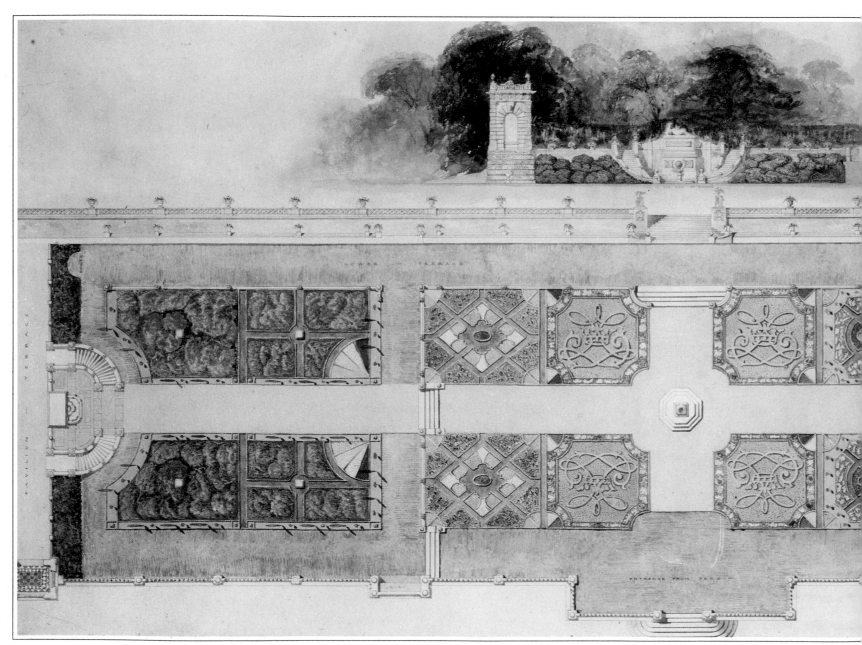

44. George P. Kennedy. *Design for the Formal Garden at Bowood*, Wiltshire, 1848–9.

BOWOOD

Wiltshire

The Great Park at Bowood remains much as it was laid out by Capability Brown between 1762 and 1768. Josiah Lane's cascades were built later in the century on the instigation of The Hon. Charles Hamilton of Painshill, rather than inspired by Brown himself, and a change in site of the Doric Temple in 1864, gives extra interest to the landscape. The house, and its surrounding terraces and Pleasure Grounds, have undergone considerable changes since the first building began in 1725 and since Keene and Adam remodelled the early Georgian building. The upper terrace, in front of a wing built by Adam, in E. Adveno Brooke's painting, was not thrown out until 1817–18 when Smirke was the designer; it is shown in a drawing by Buckler of the whole complex in 1823. Charles Barry worked at Bowood during the 1830s and 1840s for the Third Lord Lansdowne, who, in 1839, added fountains on the upper terrace which survive today. In 1849 W. A. Nesfield was invited to submit a plan for the important lower terrace; uncharacteristically the master of the great parterre suggested a green slope would best set off the imposing upper terrace and elegant classical building. He was again approached but declined the commission; he was occupied with designing gardens in front of Buckingham Palace, gardens which were never made.

Eventually the lower terrace and its garden layout was designed by George Kennedy in 1851 (plate 44). Kennedy, a Scotsman, had designed the parterres at Drummond Castle in Perthshire in the form of a St Andrew's Cross. His first suggestions included brilliant carpet bedding in a design of monograms and coronets but a simpler plan was finally decided upon and implemented by the head-gardener, Mr Spencer. A description written in 1867 by a local Wiltshire rector describes it as having been laid out by Spencer who certainly was responsible for planning much of the pinetum. Describing the new terrace layout: 'The contrast is very pleasing from an English park to, so it seems, the quiet, trim, but by no means tame beauty of a garden of some old Italian noble. I feel that I ought to have a copy of Dante in my hand or a volume of the sonnets of Petrarch'. This terrace was painted by Brooke within

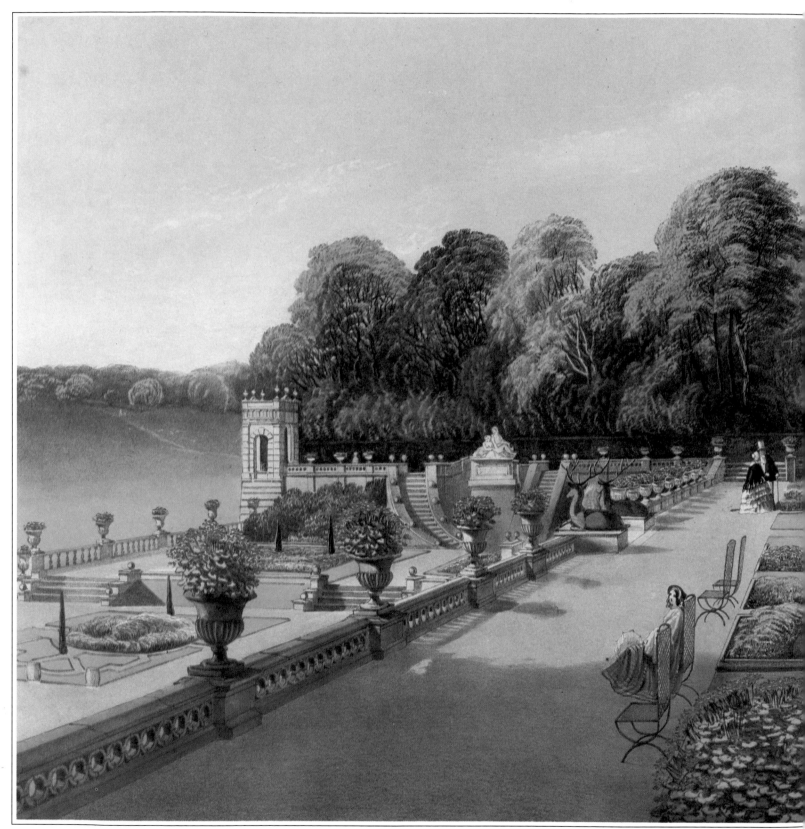

45. E. Adveno Brooke. *Upper and Lower Terraces, Bowood*, Wiltshire.

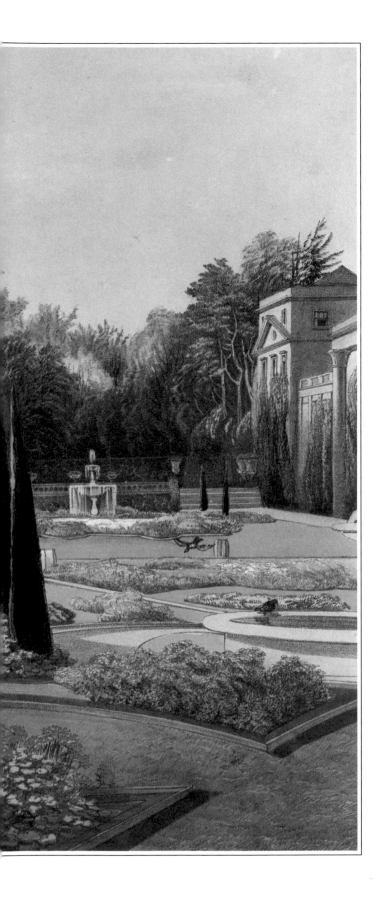

a few years of its completion. Although planting is different and the main house much altered and diminished, the two terraces and the basic parterre schemes, remain much as they are in Adveno Brooke's portrayal.

The two terraces, backed to the west by a bank of fine trees, stretched the width of the façade extending 285 feet east and west. In Adveno Brooke's painting (plate 45) the upper terrace, sixty feet across, had colourful stone-edged flowerbeds of annuals grouped around two symmetrically placed marble fountains; pairs of pencil-slim Irish yews look like Italian cypresses and scarlet geraniums decorate tall urns which sit on the open work balustrading which divides the two terraces. Today the Irish yews are thick cylinders, twelve feet tall and four feet wide, and galtonias flourish and flower in beds of Frensham roses, standard 'Dorothy Perkins' giving more bulk and substance to the flat area. The lower parterre, at the base of an eight feet wall, is reached by broad steps set between a pair of bronze stags. To the west a raised walk is reached by a double stone stairway, framed by densely planted and clipped evergreens, which include laurustinus (*Viburnum tinus*) and *Phillyrea*. In the 1850s a double row of Irish yews separated flowerbeds as they do today. Patterns of gravel, turf and flowers were 'aglow with the liveliest colours' where today, simplified for easier maintenance, blocks of bush roses occupy circular beds.

Even in the 1850s, as now, shrubs and climbers grew against the sheltered warm south-facing walls of the two terraces. The large-leaved *Vitis coignetiae* colouring scarlet in autumn, wisteria, *Actinidia kolomikta*, *Magnolia grandiflora*, ceanothus, escallonias and tender bottlebrush plants from Australia all thrive. At their feet agapanthus, a form of *A.campanulatus* with a particularly strong and vivid blue flower, grows in the well-drained soil. Today, with the big house much reduced in size, the terraces assume even more importance and seem a fitting frame to Adam's elegant classical façade which backs them. Looking south, the view sweeps over Lancelot Brown's park and across the curving lake to mature woodland and vistas stretching into the Wiltshire countryside.

ELVASTON CASTLE

Derbyshire

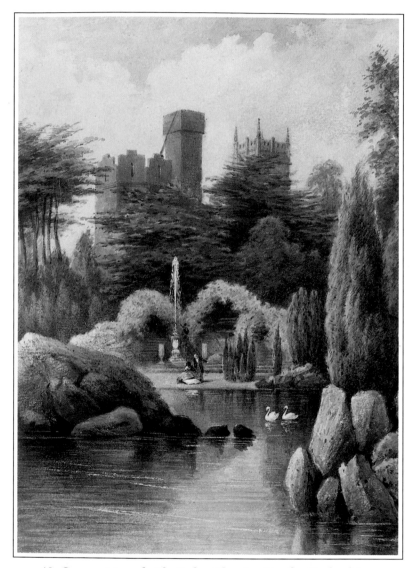

46. George Maund. *The Lake, Elvaston Castle*, Derbyshire.

Elvaston Castle, originally a seventeenth-century house, was remodelled to a design by James Wyatt in 1817. The garden on a flat site only four miles from the centre of Derby had not attracted Capability Brown when his assistance had been sought by the Third Earl of Harrington. He declined, finding the situation had no 'capabilities'; instead he gave six seedling cedars of Lebanon which were planted near the house. The Fourth Earl, who succeeded in 1830, employed William Barron, a young Scotsman, to transform the garden. The age of technical advance allowed owners or head-gardeners a new degree of freedom from limitations imposed by a site. The concept of *genius loci*, Alexander Pope's insistence that 'the genius of the place is all', had to be revised for the Victorians; instead, a description of Elvaston Castle in 1852 gives credit to man's ingenuity: 'so noble a creation . . . we say creation, because all that is wonderful about it must be ascribed to the inventive genius of man, and chiefly that of Mr Barron.' The first four years at Elvaston were usefully employed in laying drains. From then until the Earl's death in 1851 a vast planting programme was carried out; eighty gardeners performed the work of planting, grafting and clipping. Barron's speciality was transplanting of mature trees; in this, in grafting of both conifers and deciduous trees and in pruning he became an acknowledged expert. Cedars already thirty feet in height were moved to make an eastern avenue and vast yews from other distant estates were introduced to get quick garden effects. A topiary arbour with clipped birds, some nineteen feet high and thirteen feet in circumference, and a thirty-three-foot yew all had to make a journey through the streets of Derby, shattering adjacent windows.

Avenues, arranged in parallel rows, included double lines of Irish juniper, red cedars and variegated cypress, Chinese junipers and yews, both clipped and free growing, and others of great complexity made Elvaston famous; newly introduced conifers from north and south America added to planting possibilities, monkey puzzles (*Araucaria araucana*) and wellingtonias (*Sequoiadendron giganteum*) becoming popular

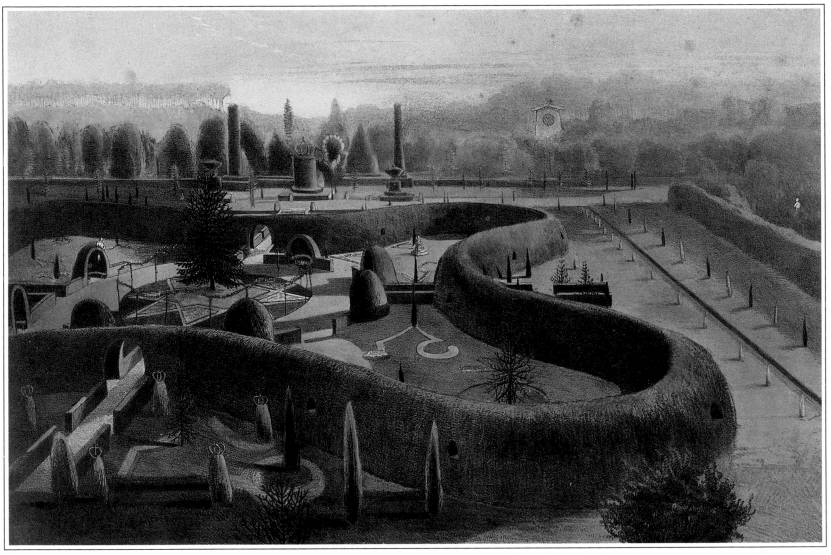

47. E. Adveno Brooke. *Mon Plaisir, Elvaston Castle*, Derbyshire.

favourites for specimen planting as well as for avenues. Nearer the castle a series of formal gardens were laid out to a symbolic programme; the gardens became a shrine to the worship of love considered as a chivalrous quest. They were to immortalize the romantic love between the Earl and his mistress (later his wife). These gardens were painted by E. Adveno Brooke soon after they were planted. Various enclosures of yew specimens, clipped to resemble architectural features, with inner devices of lovers' knots and hearts, expressed the themes. The golden yew *Taxus baccata* 'Elvastonensis' came from a sporting branch of a yew at the entrance to the Italian garden. Gardens with exotic titles were the Alhambra garden with a Moorish theme and the garden of Fairstar which was more gothic in taste.

Bedding-out did not interest the Fourth Earl and never became a feature at Elvaston. From 1851 under the Fifth Earl eight men had more than their work cut out to maintain the clipping programmes for topiary, enclosures and avenues. By 1876 many trees had suffered from severe frosts; Thomas Baines questions some of Barron's techniques: he suggests that by providing mounds of rich earth for trees to grow in, too-rapid growth was encouraged and the resulting soft shoots were more prone to severe weather.

Mon Plaisir (plate 47) by Adveno Brooke is the most famous of Elvaston's inner gardens; the painting must have been completed only ten years or so after the garden was laid out. Based on a seventeenth century design by Daniel Marot, it was

48. Ernest Arthur Rowe. *Elvaston Castle*, Derbyshire, 1898.

his interpretation of a medieval enclosure. Curving walls of yew stood for the walls and bastions of a Norman castle: inside arbours, archways and alcoves were tightly shaped in living green and golden yew. At its central point a monkey puzzle with unique spine-tipped leaves on densely carried symmetrically placed branches, stood in a star-shaped bed surrounded by yews carved into niches for statues. Two other specimens stood in opposite angles of the yew hedge which surrounded the garden.

In 1898 E. A. Rowe painted some of the thousand conical yew pyramids which were a feature at Elvaston (plate 48). By this date they had been *in situ* for more than fifty years. They were maintained at a uniform size and height above a continuous hedge of yew which formed one of the lines of avenues. The intricate design shown in the painting is hard to explain. In 1849 and 1850 Robert Glendinning had described the new gardens at Elvaston as 'the greatest work of gardening skill, both in extent and in design, which perhaps any man ever accomplished in one life time before.' This was indeed the age of the head-gardener; Glendinning, a horticultural journalist, began his career in the 1830s as head-gardener at Bicton in Devon.

George Maund painted the lake at Elvaston (plate 46) at the turn of the century. The lake was dug during the 1830s while Barron was still completing his drainage operations. The rock garden was built in 1838. Unstratified and seemingly placed sometimes in random fashion and sometimes in circles or arranged as arches, most of the rockwork skirted the lakeside, in places towering to forty feet. Glendinning is at no loss for words to praise the efforts: 'When we contemplate . . . that this is entirely a work of art, and consider the tens of thousands of tons of rocks all brought from a great distance, employed in its formation, we are left to conclude that it has not only no rival as a work of art, but there is nothing at all approaching it, in any garden in the country.' It is hardly Reginald Farrer's idea of a rock garden, envisaged as a place for growing desirable alpines. Of course Barron did not intend these rocks as other than landscape features to give his new lake a wild and romantic air – he made no claims to 'naturalism'.

SHRUBLAND PARK

Suffolk

Charles Barry transformed the gardens at Shrubland Park by furnishing the steep slope which dropped suddenly from the edge of the broad west terrace on which the original house stood with a magificent double staircase which totalled 170 steps with various returns and rests. The chalk escarpment was seventy feet high and at the base of the stairs, stretching a mile north and south along the valley floor, the sloping land was levelled and different style gardens were laid out to complete the scheme. The main panel garden (illustrated by Brooke, plate 49), an oriental garden, a maze, a box garden, a canopy garden, a French garden and a Swiss chalet were all included in the scheme.

Barry's plan, the final one adopted after several proposals were put forward, resembled the terraced descent of the Villa d'Este where Piero Ligorio, at the end of the sixteenth century, laid out hanging gardens and fountains on a similarly steep site. At Shrubland Barry built an ornate archway at the head of the stone stairway to frame a loggia and a circular reflecting pool and fountain jet eighty feet below. Elaborate parterres, painted by Brooke, show the contemporary style of bedding out: panels set in the grass contain scrolls of colourful annuals surrounded by pale gravel. Beyond the loggia a concealed dell – where a rustic bridge was thrown across a chasm – contrasted with Victorian formality. The impact of the whole layout was enhanced by the richly wooded wild deer park in which it lay dramatically concealed. From the balcony outside the main house the loggia and distant countryside alone were visible.

Barry was not the first architect to be called in by Sir William Middleton; J. P. Gandy Deering, a pupil of James Wyatt, was employed in 1830 to enlarge the house and build the new terrace along the west façade. Barry completed his work and then transformed the gardens. An article in *The Cottage Gardener* (1853) by Donald Beaton is roughly contemporary with E. Adveno Brooke's portrayal of the new terrace gardens at Shrubland Park. Charles Barry remodelled the gardens in 1850–52 shortly before Donald Beaton's retirement as head-gardener; virtually everything Beaton describes was completed

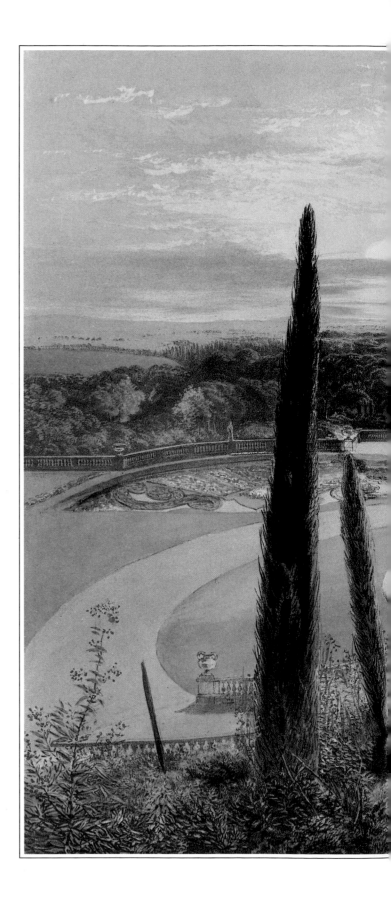

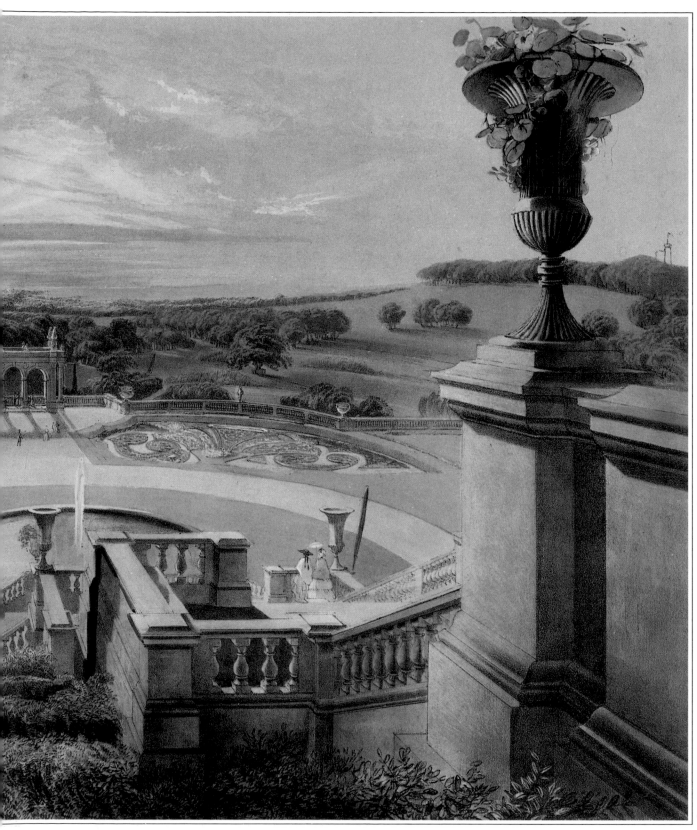

49. E. Adveno Brooke. *Lower Terrace Walk, Shrubland Park*, Suffolk.

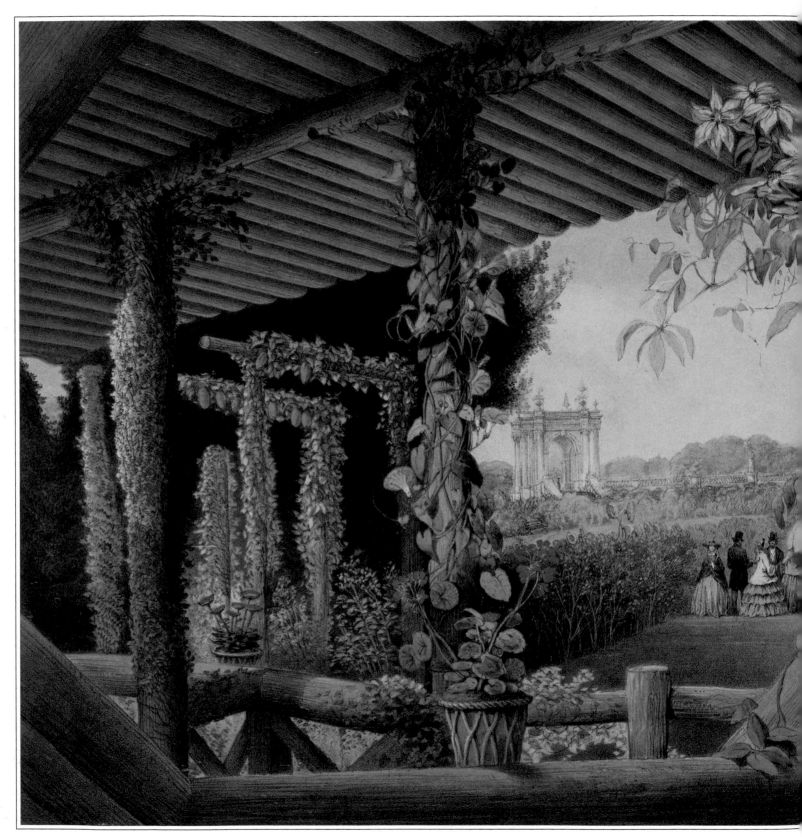

50. E. Adveno Brooke. *The Rustic Seat, Shrubland Park*, Suffolk.

after he left and planting was done by his successor. Nevertheless he is enthusiastic – not at all dismissive of the grandeur in effects. Descending the new flight of stairs, he describes scarlet geraniums in vases; the outer-edge box, grown from seed from Box Hill in Surrey, is clipped tightly. To the south a Swiss chalet is visible; to the north along the slope a statue of Diana can be glimpsed. A few years later another visitor, Robert Fish, describes his impressions as he reaches the temple at the top of the hidden stairway. He goes on to describe the 'Swiss-Italian summer-house built chiefly with unpeeled fir poles, colonnaded at both ends with similar fir poles, covered with Virginian creeper, clematis, wild roses etc'. A similarly rustic seat is portrayed in Adveno Brooke's second painting (plate 50). Wild flowers and nasturtiums fill a narrow border edged with rustic timbers, and similar rough arches at the corners are festooned with clambering gourds and pumpkins, 'presenting a fine combination of simplicity and suitability'. Beyond this garden, farther east, is the Rosary, where a walk of double arches is thickly covered with climbing roses. The next two gardens were already in existence before Barry's alterations. A concealed heated wall provided a framework for tender conservatory plants to bloom in summer. Lemons, magnolias, *Cassia corymbosa*, *Plumbago*, tender passion flowers, acacias and roses all thrive here and amaze the casual visitor. Beyond is the Fountain Garden where fuchsias and geraniums arranged in intricate colour schemes are bedded out each summer. A hanging basket garden and a bank of dahlias were still to come before a gate opens into the parkland beyond the garden.

William Robinson was consulted about simplifications at Shrubland in 1888. His planting of hardy exotics and natives can be traced in the woods and in schemes for some of the remaining parterres. Forty gardeners had once tended Shrubland; by Robinson's time there were eight. It is almost a relief that today most of the gardens centred round the great staircase have been grassed over; the maze which in part remains dates to before Barry's time. The stonework and balustrading remain to give a sense of dramatic order.

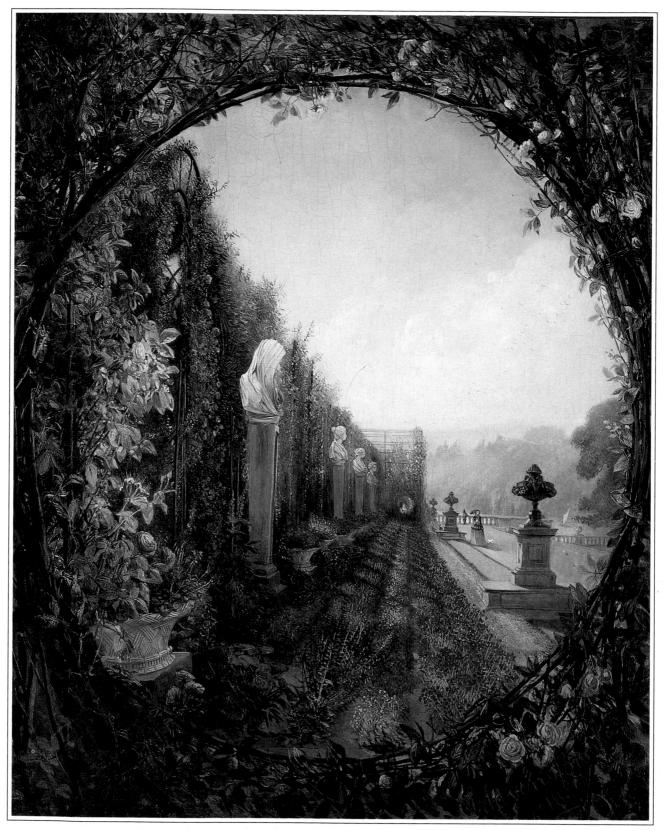

51. E. Adveno Brooke. *The Trellis Window, Trentham*, Staffordshire.

TRENTHAM HALL

Staffordshire

The vast Italianate house at Trentham completed in the middle of the nineteenth century was finally abandoned by the Duke of Sutherland in 1905 and offered to the Staffordshire County Council. It was demolished in 1910. The pollution of the river Trent by the towns of the Potteries made life unhealthy and indeed dangerous. Only Charles Barry's entrance to the west front – a vast conservatory fifty by thirty-five feet, once green and jungle-like with creepers and ferns, remains. Today Trentham is visited by 500,000 visitors. Although lacking a great house to frame, the much simplified gardens reflect the vast scale of Victorian expansion.

Trentham was the first house and garden which really reflected the influence of Charles Barry's Italian journey: he had visited Italy immediately after the Napoleonic Wars. In 1833 he began remodelling the house, which had already been extensively altered from the original seventeenth century design for the Second Duke and Duchess of Sutherland. In 1840 he started on the garden which had been restructured by Lancelot Brown who in 1759 had brought the distant lake much nearer to the existing house. Barry's estimates for improving the house amounted to £40,000; of this £14,811 was for the gardens, and was to cover the formal gardens, pleasure grounds and an *Isola Bella*-type island construction in the lake, complete with a gondola and gondolier. On the flat and unpromising site of about eleven acres, Barry excavated for two great terraces between the level area on which the house sat and the lake to the south, a distance of 300 yards. George Fleming came as head-gardener in 1841 to execute Barry's grandiose plans. His technical skills, in drainage plans, glass ranges, experiments in heating and, above all, in innovations in bedding-out schemes made Trentham famous.

Slate paving extended between the conservatory and a protruding wing on the east side of the house; semi-circular beds filled with lobelia and window boxes of geraniums decorated this area. Barry's top garden terrace was centred on a fountain, the lower was laid out as two rectangular panels between which a gravelled path led to the balustrading above the lakeside and to a cast of Cellini's *Perseus*. Corner pavilions marked the angles of balustrades on which urns filled with geranium stood. Portugal laurels trained like orange trees decorated the gravel paths. The lower Italian Terrace, carved out of swampy ground, was much broader, extending east and west; along its eastern side a fifteen-foot ironwork covered way wreathed in roses, honeysuckle, vines and clematis provided a shady and cool walk 140 yards along. Adveno Brooke's painting (plate 51) shows this trellised way with allegorical busts of the four seasons set on columns alternating with ornamental baskets containing flowers all along the length. At its feet a ten-foot ribbon border contains five or six rows of flowering plants. In the painting showing the promontory (plate 52) a gondola and gondolier enliven the scene and emphasise the intended Italian effects. Ornamental planting and a covered gazebo extend the flower garden to the shore.

Ribbon borders were long narrow beds planted with parallel lines of colourful flowers, perhaps blue nemophilas, yellow calceolarias, and scarlet geraniums. In Brooke's painting it is difficult to identify plants with any certainty. There were variations in this planting style. At Trentham Fleming planted a rivulet of forget-me-nots which meandered streamlike through the pleasure grounds and down towards the lake; in another bed a walk of flowers in carefully graded colour succession followed the hues of the rainbow. These schemes were on the vast scale, stretching two hundred yards at least.

The western side of the terrace was fringed with a thickly planted shrubbery. Yews and cypresses made vertical accents in the main terrace and originally calceolarias and heliotrope were massed to 'look like crops' in the parterre beds. To the east of the lake pleasure grounds of trees, shrubs and flower-beds extended to about eighty acres while on the west and south hanging oakwoods were reflected in the water. On the distant hill Chantry's bronze statue of the First Duke stands on a tall column.

By the 1860s permanent planting of China roses, dwarf shrubs and perennials had replaced the annual displays on the Italian Terrace although pelargoniums, the elegant *Humea elegans*, calceolarias, penstemons and verbenas still decorated

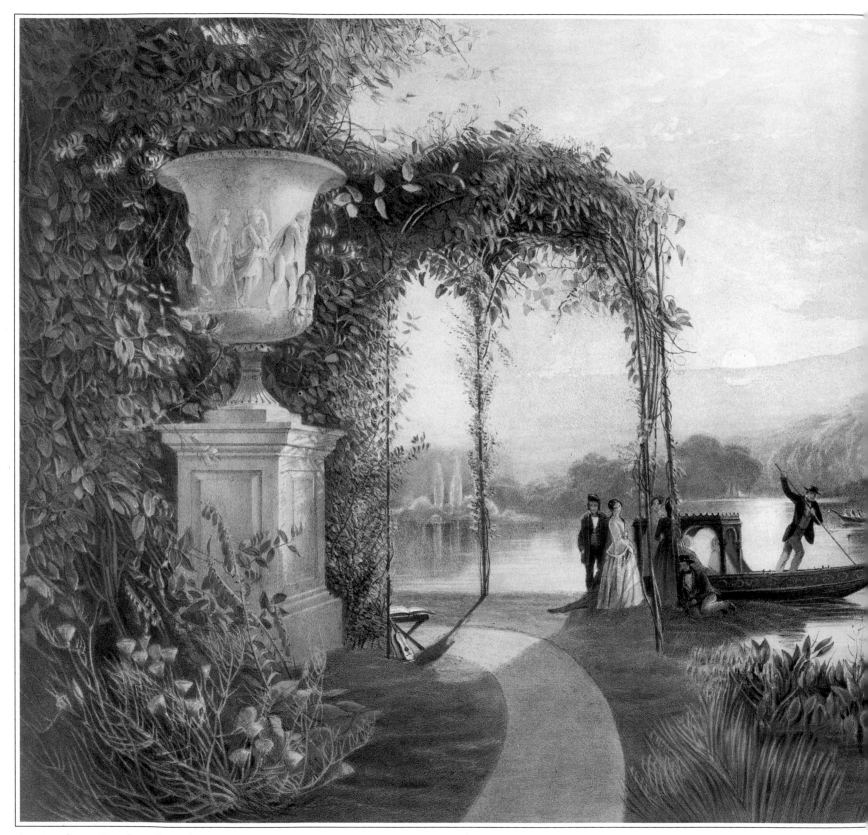

52. E. Adveno Brooke. *The Lake, Trentham*, Staffordshire.

the upper flower garden round the fountain. Zadok Stevens, Fleming's successor liked to tone down the most garish flower colours, using more pastel bedding tints instead of 'hot' scarlets. By the 1870s the writing is on the wall; an article in *The Gardeners' Chronicle* already proclaims contamination from the foul waters of the Trent. Today Trentham is a popular amusement park and Barry's Italian Terrace, simply planted with old yews, better reflects the style he emulated. Fleming's years of complicated colour patterning marked an era when limitless resources were at a head-gardener's disposal.

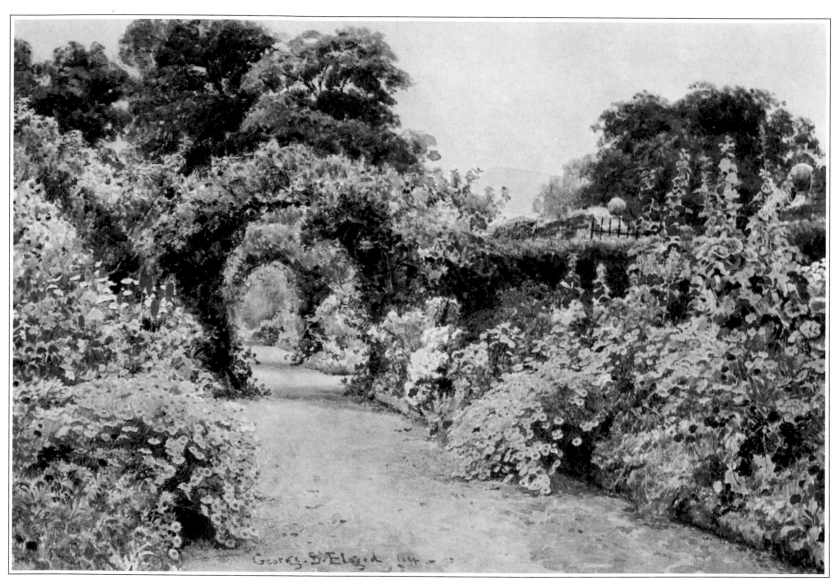

53. George Samuel Elgood. *Abbey Leix*, County Laois, Eire.

ABBEY LEIX

County Laois, Éire

Abbey Leix occupies the site of a Cistercian Abbey founded in 1183. The present house dates to 1783. Built for the First Viscount de Vesci, it was designed by James Wyatt.

By 1835 the grounds of Abbey Leix are described in Brewer's *Beauties of Ireland* as 'very extensive and greatly enriched with woods of a fine and venerable growth'. This must have mainly applied to the slopes on the far side of the river Nore, where ancient oaks, undercarpeted with bluebells, survived from primeval forest, although a specimen western Himalayan spruce (*Picea smithiana*) is vast at 100 feet high and must date almost to the year of its introduction in 1818; a North American Sitka spruce (*Picea sitchensis*) stands taller and will have come from Douglas's first seeds in the 1830s. Lord de Vesci, the Fourth Viscount, who succeeded in 1875, planted extensively using a mixture of rare conifers, broad-leaved trees and rhododendrons. It is mainly his planting that we see today in the arboretum.

The south-facing Italianate terraces were also built after 1839. The Third Viscountess's mother (wife of the Eleventh Earl of Pembroke) was a Woronzoy, and they are modelled, although on a more modest scale, on those of the famous Villa Aloupka in the Crimea, which belonged to her family. By the end of the century, when Gertrude Jekyll visited and George Elgood painted the garden, box-edged beds under the house walls were filled with low-growing plants. Inside a low enclosing wall the main parterre had a central fountain, a three-tiered *tazza*, from which four paths radiated between beds where planting was mainly of tender things such as large-flowered gladiolus. Tall Irish yews (still called Florence Court yews by Gertrude Jekyll, because the first fastigiate yews, *Taxus baccata* 'Fastigiata', were found at Florence Court in Co. Fermanagh in 1780), accentuated the corners of the beds.

To the west, broad steps descended to a lawn and wilder grass planted with trees and shrubs. Beyond this was a series of walled enclosures. Vines grew against the walls and in several of the garden compartments there were wide borders of hardy flowers. The illustrations show a view by George Elgood (plate 53 and to be found in *Some English Gardens*) and one by Ernest Arthur Rowe (plate 54). Both views were painted in approximately the same season, probably July or August. They show a charming scene of walls curtained thickly with climbers joined by arches wreathed with clambering roses and honey-suckle (Miss Jekyll also mentions the white everlasting pea, *Lathyrus latifolius* 'Albus', always a favourite of hers). Stone- and box-edged beds are ten feet wide and are dominated by luxuriant golden-flowered *Anthemis tinctoria*, the ox-eye chamomile. Clumps of hollyhocks, Japanese anemones and phlox are augmented with groups of annual chrysanthemums, gladiolus, kniphofias and carnations. Tall oaks are beyond the garden walls to the west; to the south, in Rowe's painting, conifers grow in the arboretum.

Little remains today of this rich planting; the walled garden at Abbey Leix, where Gertrude Jekyll describes a centrally placed creeper-covered summer-house from which grass paths radiate between the flower-beds, has suffered from World Wars and escalating labour costs. The pictures remain to remind us how the rich fertile soil of these Irish lowlands and the high rainfall will provide perfect growing conditions for summer borders as well as fine trees.

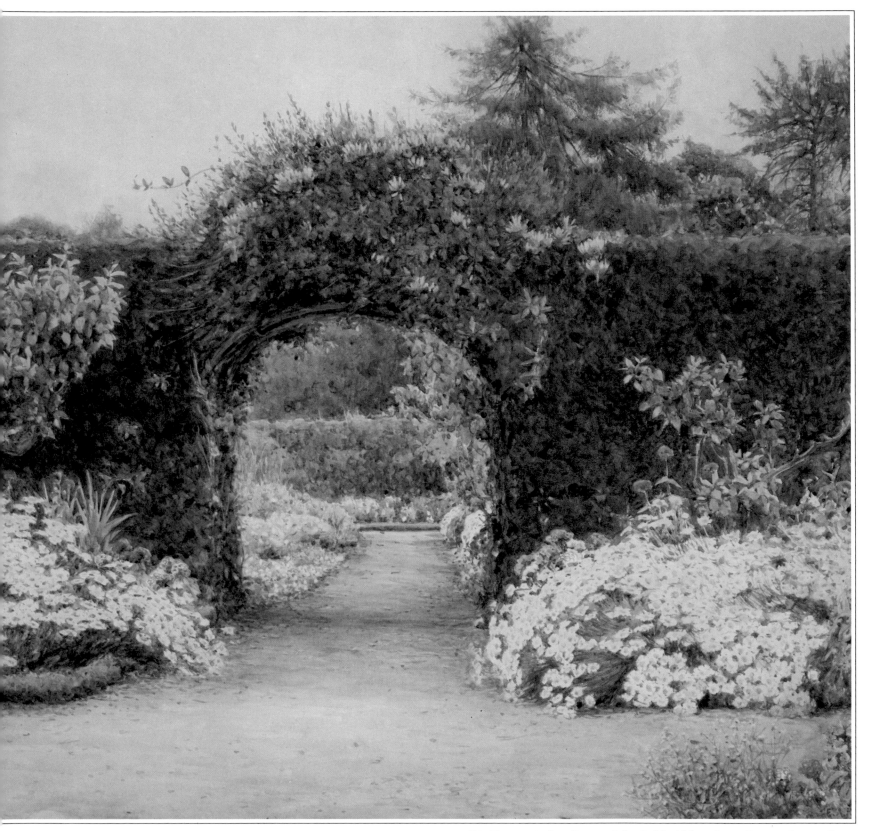

54. Ernest Arthur Rowe. *July Gold, Abbey Leix*, County Laois, Eire.

ARLEY HALL

Cheshire

Arley Hall and the land surrounding it has belonged to the same family for centuries, although inheritance has not always come through a direct male heir. The garden layout, little altered in essentials even in 1988, dates from the 1840s when Rowland Egerton-Warburton planned it to complement his new Jacobean-style house, which he had begun to build in 1833. As with the design and details of the house, the owner played the major part in its conception. It is his garden which George Elgood came to paint in 1889, and his garden which his great-granddaughter Viscountess Ashbrook has planned and planted so successfully in the years since the 1939–45 War, rationalizing and adapting it to high maintenance costs and a changed style of living.

The garden at Arley is remarkable in many ways, but becomes an important focal point in garden history for the double herbaceous border marked on the garden plan of 1846 – forty years before William Robinson and Gertrude Jekyll began to preach their gospel – which was planted with colourful hardy perennials for display. Before the 1870s it was normal to find flower borders only in the walled kitchen garden, their flowers intended for house decoration. However at Arley the planting scheme was very much a part of the overall ornamental garden and designed to be visited in a garden tour. The border was backed on one side by the high eighteenth-century brick wall (the walled garden would have been built in the same period as the house that was demolished for the neo-Jacobean building) and the facing border was framed by a tall hedge of yew. A broad gravel path edged with mown grass strips stretched between the wide twin borders and was aligned on a stone alcove framed by topiary buttresses of yew. Across this walkway an axis of clipped evergreen oaks (*Quercus ilex*) and yews focused on an elegant gateway in the wall. The ilex avenue ran southwards from the yew, framing, across a sunken circular garden at the edge of the terrace, the vista into the eighteenth-century park. These two features, together with the terrace (known as the Furlong Walk and separated from the park by a sunken wall and ha-ha along its length), were Mr Egerton-Warburton's innovations; the garden planting and

many other details may well have been contributed by his wife Mary, whose sister was married to Mr Bateman, the owner and maker of the gardens at Biddulph Grange near Stoke-on-Trent. Obviously, as the new house was being completed, it was determined that the garden should be kept to the west to occupy the area south of the existing walled garden, leaving the main vista to the park exactly as it had always been, open and free.

Beside the main features already mentioned – the double borders, known as the Alcove Walk, ilex walk and Furlong Terrace – the new garden contained topiary yew and a formal parterre overlooked by a picturesque tea-house in timber and brick. At the end of the Furlong Walk, beyond the sunken sundial garden, Mary Egerton-Warburton constructed a rock garden known as the Rootree; a photograph exists of her in a crinoline standing on a mound directing operations. The plants used were mainly hardy. To the east Mr Egerton-Warburton laid out an Italianate parterre, calling in a professional designer, W. A. Nesfield, for this feature alone. As well as incorporating herbaceous borders much earlier than might be expected, the gardens at Arley are historically interesting for the fact that the layout of the main new garden, completed before the middle of the nineteenth century, was the brainchild of gifted amateurs and reflected their experience of travel in Europe and their interest in hardy plants. A further interest lies in the number of separate garden features that were incorporated in the whole design; a parallel can be drawn with the contemporary developments at Biddulph Grange, a garden of considerable influence on Victorian garden fashions.

George Elgood came to paint the garden in 1889 and Miss Jekyll describes more garden features in *Some English Gardens* (pub. 1904). A maze lay behind the stone alcove at the further end of the herbaceous borders and to the left a bowling green surrounded by raised terraces gives way to another enclosed garden area. She remarks how mazes in the 1900s were out of fashion ('old garden toys seldom planted now'); she is faintly disapproving about their 'bewildering perplexities' and might be surprised how popular they are today, their care

55. Piers Egerton-Warburton. *Gates at Arley Hall*, Cheshire, 1889.

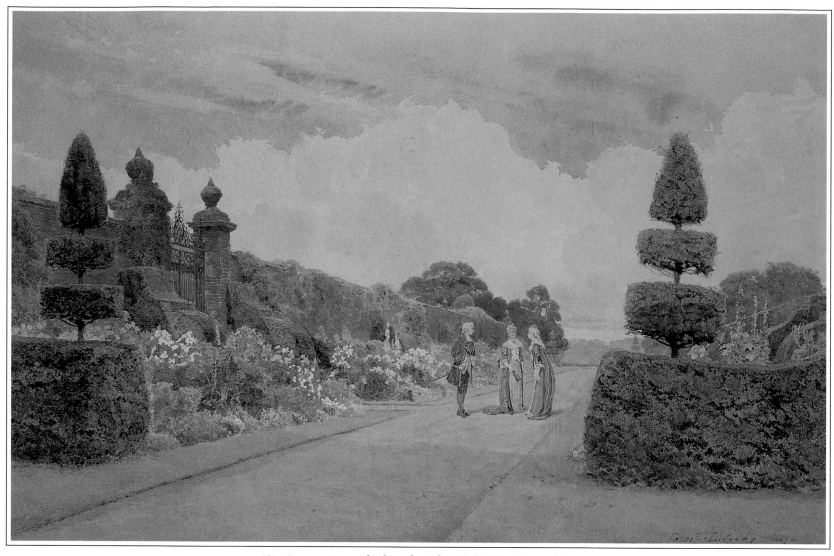

56. George Samuel Elgood. *Arley Hall*, Cheshire, 1889.

made easier with mechanization and herbicides. By the 1890s the oaks of the ilex walk were cut into cones, interspaced with yew in more fanciful shapes. Elgood's paintings show that the tea-house parterre has been replaced by a pattern of concentric rose-beds which Miss Jekyll described as connected by elaborate spandrels. She places the rose-beds in another area farther west; even she is not infallible. She also mentions Nesfield's parterre lying to the east in front of Salvin's chapel (added in the 1840s with later additions by Street) – 'elaborate scrolls and arabesques of clipped box'. Elgood paints the southern forecourt with a central sundial supported by a kneeling slave in lead (plate 59). One painting by Mr Piers Egerton-Warburton (plate 55), shows the walled garden gateway; and other

paintings by Elgood (plate 56) and Rowe (plate 58) reveal aspects of the long borders, showing the gateway and brick pillars set in the massive brick walls which contain flues for heating. These views, taken from opposite directions, show the contrast of the elaborate finials of the formal buttressed yew with the brilliant informality of the border planting. Today the views remain much as they were nearly a hundred years ago; the gravel path and side strips of lawn have been replaced with a central grass panel, one of Lady Ashbrook's 'improvements' to make upkeep simpler; aesthetically the new style seems more satisfactory. Another picture shows the ilex topiary (plate 57) where conically shaped evergreen oaks are interplanted with more complicated yew patterns; today the ilex is shaped

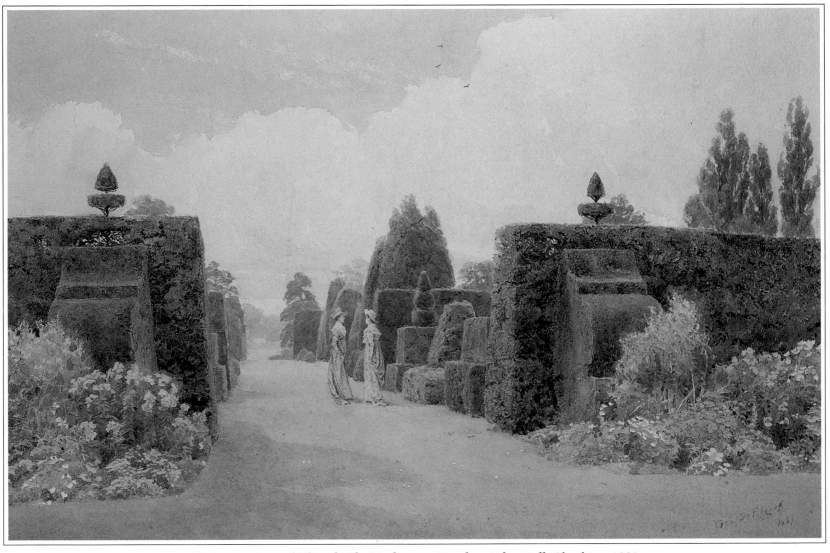

57. George Samuel Elgood. *The Herbaceous Border, Arley Hall*, Cheshire, 1889.

into vast drums which dominate the central walk of grass.

The glory of the Edwardian garden lay in the great borders and the ilex topiary; this is still true today. An article in *Country Life* of 1901 describes the taste and skill with which the Alcove Walk is formed. 'The contrast between the dark yew, the fresh green of the grass, and the radiant colonies of hardy flowers is most admirable. Larkspurs and foxgloves, poppies and phloxes, snapdragons and lupins – these and a crowd of other glorious flowers are grouped in lovely colonies.' Lady Ashbrook has added many new features; some are a rationalization of earlier designs, such as covering the old rock garden area with a mixture of hardy shrubs and perennials to great effect, and the substitution of shrub roses for the artificial

Hybrid Teas of earlier times. She has instigated a change of use in the main area of the kitchen garden, where now, instead of rows of vegetables, climbers, shrubs and smaller flowering plants surround a central well of lawn framed in fastigiate beech, *Fagus sylvatica* 'Dawyck'. In other parts of the garden her planting schemes are new but she maintains the spirit of her great-grandparents' grand design, assimilated through three more generations. In appreciation 35–40,000 visitors come yearly to Arley. Today her son and his wife, The Hon. Mr and Mrs Michael Flower, maintain her traditions, and a new garden is being planned to occupy the site of Nesfield's vanished parterre.

Perhaps Miss Jekyll should have the last word, as her

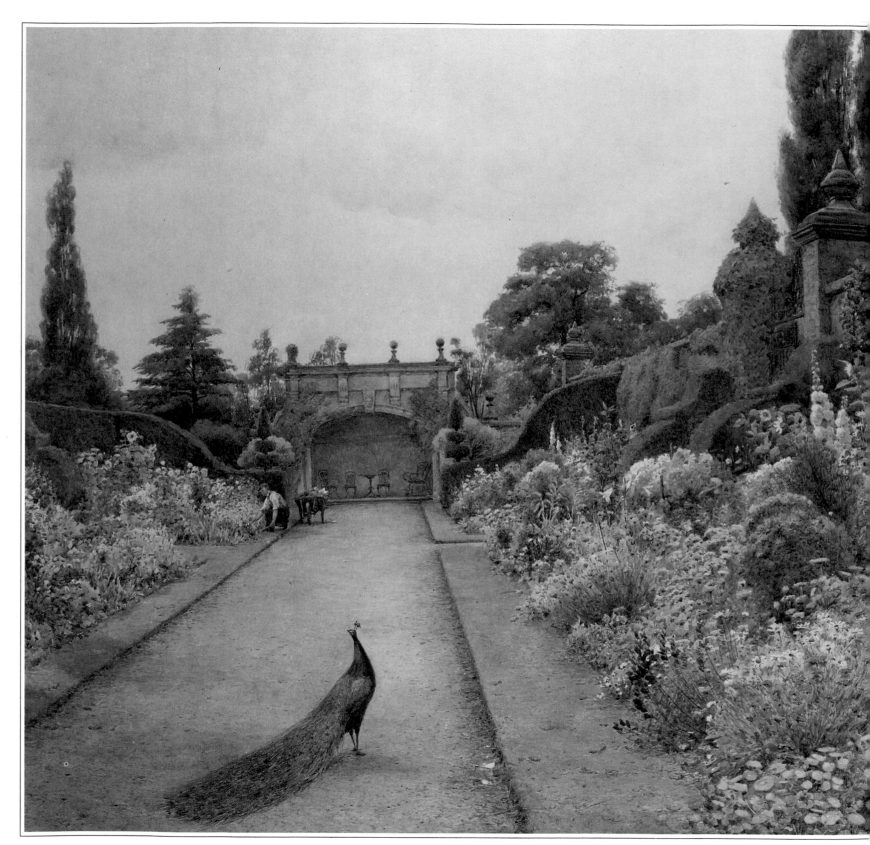

58. Ernest Arthur Rowe. *The Herbaceous Border, Arley Hall*, Cheshire, 1896.

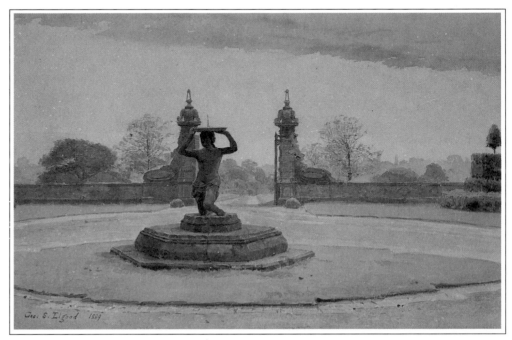

59. George Samuel Elgood. *Statue at Arley Hall*, Cheshire, 1889.

perception reveals the essential characteristics of the garden's atmosphere as well today as it did in 1900: 'Here we see the spirit of the old Italian gardening, in no way slavishly imitated, but wholesomely assimilated and sanely interpreted to fit the needs of the best kind of English garden . . . how happily mated are formality and freedom; the former in the garden's comfortable walls of living greenery, with their own appropriate ornaments, and the latter in the grandly grown borders of hardy flowers.' How many gardens today would still so surely receive Miss Jekyll's approval?

BALCASKIE

Fife

Balcaskie in Fife lies within a mile and a half of the shore, north and east of Edinburgh. Its south-facing terraces, part of Sir William Bruce's extension and remodelling of an old castle at the end of the seventeenth century, are aligned on the Bass Rock rising out of the Firth of Forth twelve miles away; today, as well as providing a fine vista, the high terrace walls give shelter to exotic tender shrubs and climbers. Bruce, the greatest Scottish architect of his day and builder of Charles II's Holyrood Palace, acquired the castle from John Moncrieff in 1665. During his thirty-three years of ownership the castle was transformed from little more than a defensive tower into an elegant mansion. Before the Restoration Bruce travelled in France where he had opportunities to study houses and gardens of Renaissance inspiration; he was the first architect to introduce this 'modern' style to Scotland. Kinross not far away is probably his masterpiece. There is no record of a visit to Italy; yet, especially at Balcaskie, the garden terraces seem more Italian than French in spirit, and it is hard to believe he had not either visited the Villa D'Este at Tivoli, or at least seen du Perac's drawing of the garden made in 1573 even before it was completely finished. John Evelyn had visited D'Este in 1645 and Bruce could have had contact with him. This can only be surmise. Certainly on the steep slope at the back of the house he laid out majestic terraces. The first, reached from the house by a double flight of descending steps, its eighteen-foot wall supported from below by great buttresses on which busts of Roman emperors were set, was laid out for ornamentals; on the two levels below only orchards were planted.

It remained for Sir Ralph Anstruther, descendant of Balcaskie's purchaser in 1698 and grandfather of the present owner, to exploit the garden's potential more fully. Sir Ralph took advice during the 1820s from William Sawrey Gilpin. The two upper terraces were linked at either end with wide balustraded staircases. On the second terrace a central sunken bowling green with parterres to east and west were part of the new design, and advantage was taken of the wall beds made at the base of the wall and the projecting buttresses to plant with luxuriant shrubs and climbers. Gilpin, the nephew of the Rev. William Gilpin (author of *Essay on The Picturesque*) was himself the author of *Practical Hints upon Landscape Gardening* (1832) and was influential in Scotland where he advised at Bargany, Whittingehame and many other estates. With Sir Henry Stewart of Allanton and Sir Walter Scott, he encouraged a return from the fashionable eighteenth-century landscape to a more formal style derived from earlier times, yet softening the effects of geometry where it collided with a wild and picturesque countryside. In 1827 Sir Walter Scott praises the improvements at Balcaskie where Gilpin had restored the gardens 'in good old style with its terraces and yew hedges. The beastly fashion of bringing a bare ill-sheared park up to your very door seems going down.' However in *The Gardener's Magazine* (1834) Loudon criticizes Gilpin's work at Balcaskie, especially in relation to 'laboriously twisted and turned about' plantations with which he screened an approach road from the north-west that joined a formal avenue aligned on the north forecourt of the castle.

Sir Ralph Anstruther had married a Hussey from Scotney Castle in Kent (where Gilpin in the 1830s adjusted the romantic landscape round a ruined moated castle to be viewed from the site of a contemporary castle on the hill above). W. A. Nesfield, who developed Gilpin's parterre designs at Balcaskie in 1848, was the prime exponent of the Italianate geometric style; he was brother-in-law to Anthony Salvin, who designed the new castle at Scotney for the Husseys. The gardens were certainly altered again in 1857 but no designer is named. The upper terrace had been divided by Gilpin into three sections separated by holly hedges. A central parterre surrounded a sundial; to the east was a shrubbery (which later became an American Garden), and the west section was ornamented with statuary. A rose garden was added in 1870. By Miss Jekyll's and Elgood's visits at the end of the nineteenth century, Gilpin's planting of pines, cedars and ilex which make projecting wings to frame the view to the sea had grown mature. Fine old cedars, which may date to the 1830s when

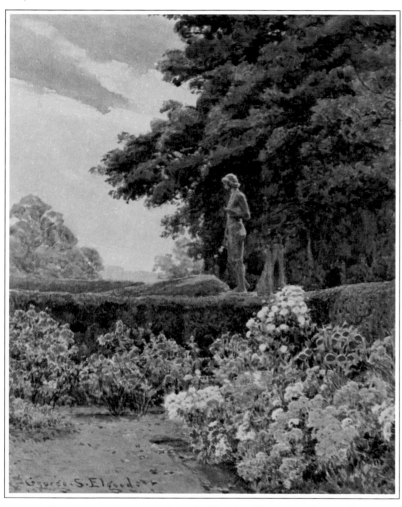

60. George Samuel Elgood. *The Apollo, Balcaskie*, Fife.

deodars were first introduced, remain and dominate the garden today. Miss Jekyll found the top terrace divided by yew hedges; probably by this time yew had been added to give a mixed tapestry effect which still exists today. She describes a broad gravel walk running its whole length, at one end centred on a lead statue of Apollo, at the other on one of Diana. One of George Elgood's paintings (1899) is of the rose garden (plate 60), enclosed with yew hedges adjacent to the west end of the house, below turrets added in 1869 when the architect Bryce worked here. The Apollo is visible above the five-foot hedge. Today this rose garden still exists in substantially the same format. Elgood's second painting (plate 61) shows the lower terrace and creeper-clad eighteen-foot wall and buttresses topped with Roman busts. A sunken lawn occupies the central space and in the four corners roses grow in box-edged beds. In another Elgood watercolour painted a few years afterwards and published in Sir Herbert Maxwell's *Scottish Gardens* (1908), the young monkey-puzzle tree barely visible in 1899 has grown considerably, to become an important feature on the west portion of the lawn. It is not easy to identify individual plants in the paintings.

Sir Herbert Maxwell's description of the planting in 1908, a decade later than the painting illustrated, is vivid. A large wisteria covers the south wall of the house, where a tender evergreen myrtle grows to twenty feet. On the lower terrace an immense *Cornus capitata*, with a fine flowering record but now weak with age, occupied the space between two high buttresses. *Phygelius capensis*, in most British gardens a sub-shrub dying back to ground level each season, had reached twenty feet against a wall. The stonework was pleasantly mellowed with moss and lichen and the little daisy-flowered *Erigeron mucronatus* (now *E. karvinskianus*) had seeded in every nook and cranny. Of horticultural interest was a colony of a Christmas rose, *Helleborus niger macranthus*, developed from a root given by Miss Frances Hope of Wardie Lodge near Edinburgh, who first obtained it in 1862. In *Gardens and Woodlands* (1881) she describes a method of increasing it from

root cuttings. Today the garden planting still takes advantage of the sheltering walls – sophoras from New Zealand, Chilean *Crinodendron hookerianum*, a vast *Garrya elliptica*, magnolias and hoherias extend the range.

Lawrence Weaver arranged for Sir Robert Lorimer of Kellie Castle (see page 153) to make accurate drawings of the house and gardens at Balcaskie for an article in an issue of *Country Life* in 1912. The garden terraces appear after they had been adapted in the nineteenth century, and the design of the garden remains much the same today.

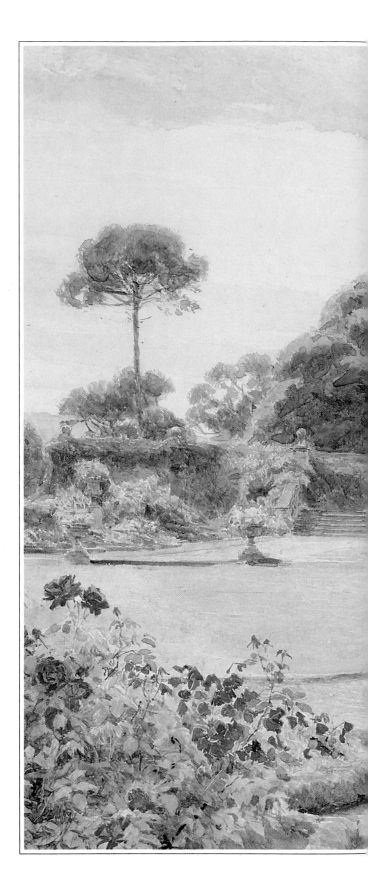

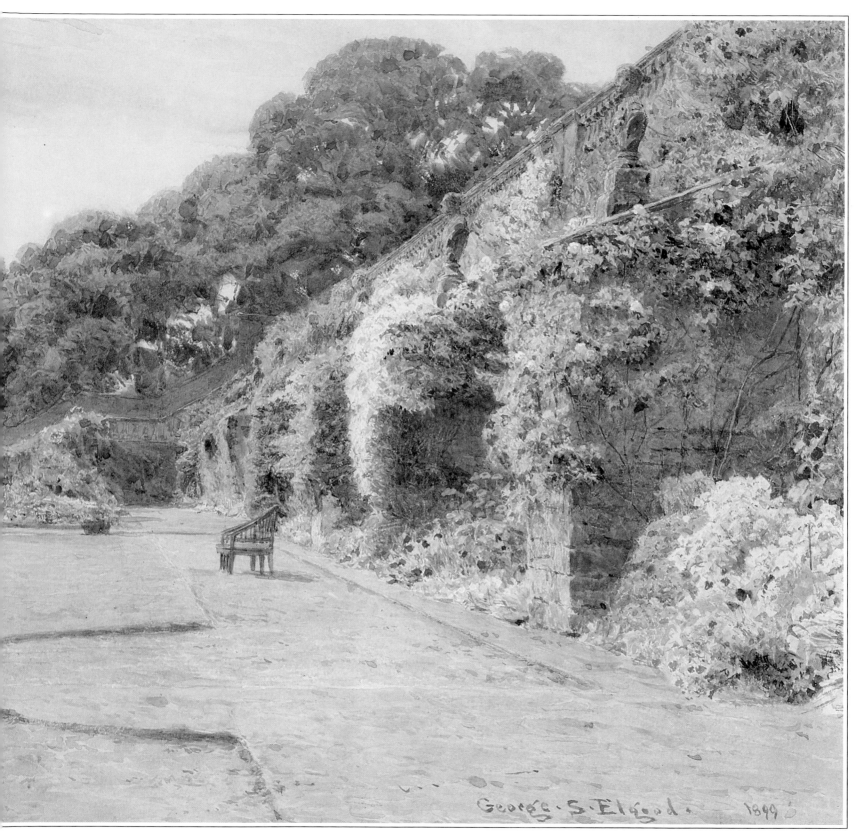

George S. Elgood. 1899.

61. George Samuel Elgood. *Balcaskie*, Fife, 1899.

BERKELEY CASTLE

Gloucestershire

Miss Jekyll's description of Berkeley Castle can hardly be improved upon: 'Seen from the meadows . . . it looks like some great fortress roughly hewn out of natural rock. Nature would seem to have taken back to herself the masses of stone reared seven and half centuries ago. The giant walls and mighty buttresses look as if they have been carved by wind and weather . . . rather than wrought by human handiwork . . . When the day is coming to its close, and the light becomes a little dim, and thin mist-films arise from the meadows, it might be an enchanted castle, for in some tricks of evening light it cheats the eye into something ethereal – sublimate – without substance – as if were some passing mirage, built up of the moment into towering masses of pearly vapour.'

The garden now, as then, when Miss Jekyll described it, lay to the south where the wall fortifications fall steeply in three great terraces; a grassy space sloping away a further hundred paces to make space for an ancient tiltyard before the open landscape and meadow land. An old Bowling Alley and a rectangular lily pond reached by broad steps extend the garden to the west. The layout is simple and uncluttered; plants grow in logical places and grass pathways follow the base of the high walls, which are curtained with climbers and shrubs needing protection from wind. At their base narrow flower-beds provide good drainage and a home for bulbs and plants which love to be baked in hot sun. The walls are of blocks of pink-flecked sandstone brought from the valley of the Severn, interlayered with cool grey tufa, blending to make a rosy background to clumps of pink valerian which seed across the surfaces.

Berkeley Castle, the building of which began before the Norman conquest, was erected on solid hard rock, encased by the local stone. Most of its present appearance reflects Norman influence, its main strategic purpose to hold the south flank of the Welsh marches. Its history, intimately and horrifyingly connected with the death there of Edward II in 1327, includes a siege and capture of Royalist forces by the Parliamentarians, as well as the more peaceful establishment in the eighteenth

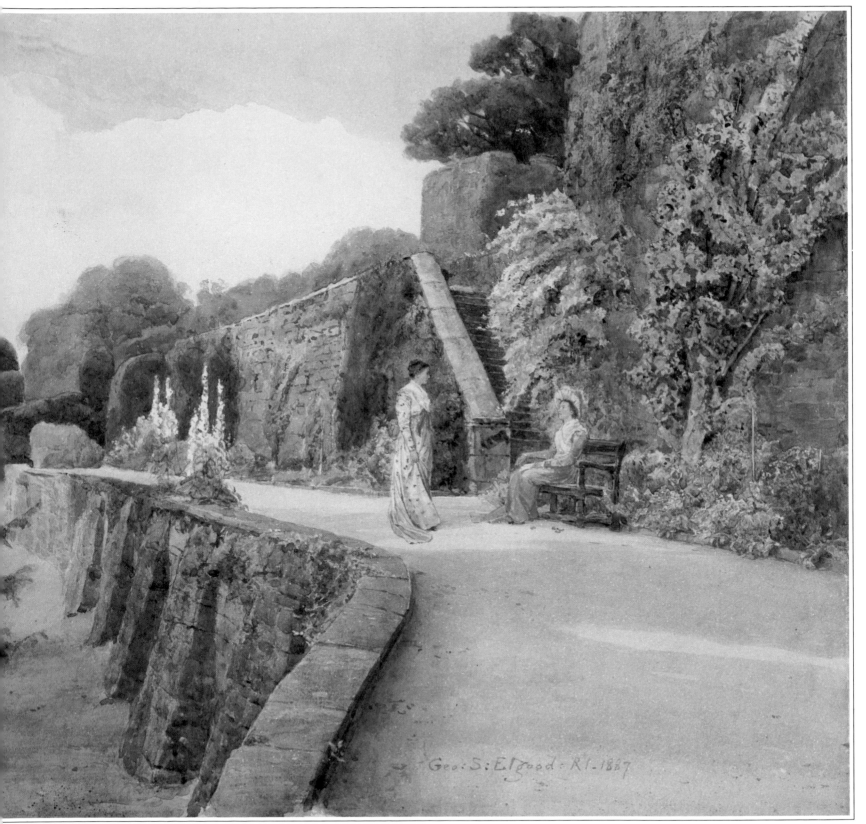

Geo: S: Elgood: R.I. 1887

62. George Samuel Elgood. *Berkeley Castle*, Gloucestershire, 1887.

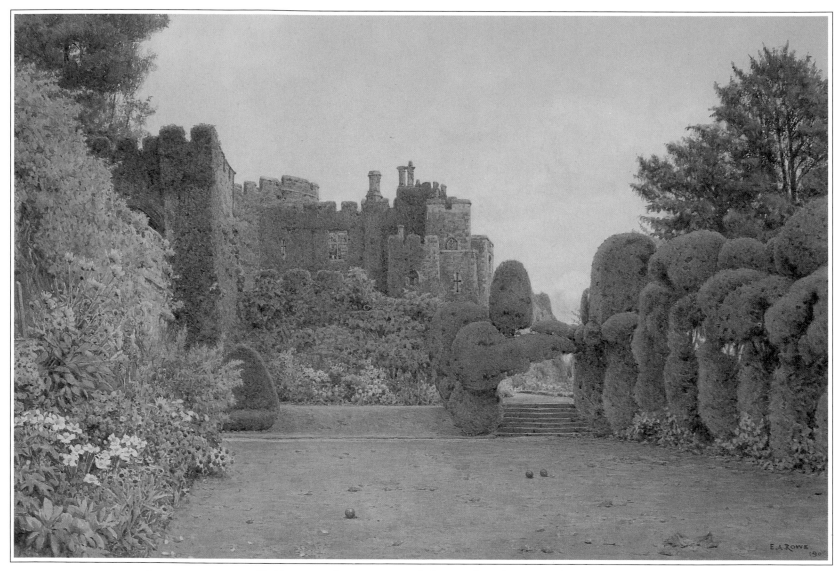

63. Ernest Arthur Rowe. *Berkeley Castle*, Gloucestershire.

century of the Berkeley Hunt, whose Gothic stables can be glimpsed beyond the water meadows.

The painting by Elgood (plate 62) shows steep steps leading down to the second of the terraces which lie directly below the battlemented forecourt. Rowe's painting (plate 63) frames the western view of the castle and its ramparts from the Bowling Alley, where strange yew shapes, clipped, I believe, to resemble elephants, reflect aged planting. Broad steps under an arch of yew lead up to Elgood's grassy walk. Much of today's garden planting was only completed by the present owner's father, Major Robert Berkeley, who inherited in 1942. Clearly a wider range of exotics now thrives against the warm heat-reflecting walls, but it is obvious from both illustrations that gardening was not neglected in earlier years. Georgina, Lady Fitzhardinge, was responsible for many 'of the best hardy plants and shrubby things' which, with an array of white lilies which 'grow like weeds', were described by Miss Jekyll. The scene portrayed is timeless, except for the Edwardian costumes of the visitors.

The illustration of Elgood's view shows the high wall of the castle. Miss Jekyll identifies a 'bowery clematis' (this may well be fragrant Virgin's bower, Clematis flammula, one of her own favourites) tumbling out from the wall and steps, and she mentions the structure of the great pear tree trained against the main stone surface. The painting reproduced and described in Some English Gardens in 1904 is identical in format, but it seems that later Elgood (or another artist) further embellished the original with blue flowers. Some of these appear to belong to the ancient espaliered pear and are therefore unlikely to have been faithfully portrayed. Today this section of the wall is bare. Further touches of blue among the border plants are more realistic and could be annuals; it is likely that they were also added later. The white bell-flower Campanula pyramidalis has seeded in a crack on top of the lower wall; this biennial, commonly grown as a pot plant, will survive harsh winters if drainage is good and soil poor. It flowers in August and September and establishes beyond doubt the season in which the painting was done. Rowe also painted here in late summer; in a border under the high wall Michaelmas daisies, tall golden helianthus and black-eyed Susan or cone-flower (Rudbeckia fulgida) are grouped with white Japanese anemone. What might be a Banksian rose clothes the wall and a blue-flowered ceanothus is tightly pruned against the high stone; this was probably Ceanothus azureus, the only hardy late-flowering member of this genus available in the early 1900s. Today the yew has been rejuvenated to make a more conventional hedge, and new planting emphasizes the microclimatic conditions. There are pineapple-scented broom, Cytisus battandieri, with silvery foliage and yellow flowers in July, modern ceanothus garden cultivars which bloom in spring and late summer, Carpenteria californica with white flower saucers in mid-season, and a spring-flowering yellow Banksian rose (Rosa banksiae) tangles with a vigorous vine, Vitis coignetiae, which colours scarlet in autumn. Wisteria and climbing hydrangeas (Hydrangea petiolaris) cover buttresses and corners of the old walls. In the border the hardy orange (Poncirus trifoliata), the yellow-flowered evergreen shrub Piptanthus laburnifolius, dwarf pomegranate (Punica granatum 'Nana') give structure among assorted perennials but do not change the essential spirit of the scene captured by Rowe.

Today Berkeley Castle and its gardens are open regularly and are well planted and maintained. Major Robert Berkeley (1898–1969) was a nephew of Miss Ellen Willmott of Warley Place (see page 195) and a friend of Gertrude Jekyll and Vita Sackville-West, and his modern planting as well as his son's care reflects true horticultural interest. He lived mainly at the other Berkeley property, Spetchley Park in Worcestershire, where he created a fine garden of rare trees and shrubs in an eighteenth-century parkland setting. The gardens at Berkeley, while still retaining old and venerable fig-trees fruiting against the hot terrace walls, are enriched by buttresses of evergreen magnolias trained between vast wisteria, and a good assortment of ceanothus and cistus which do well here. Yuccas, kniphofias and acanthus have sculptural leaves which seem appropriate against the background of massive stonework.

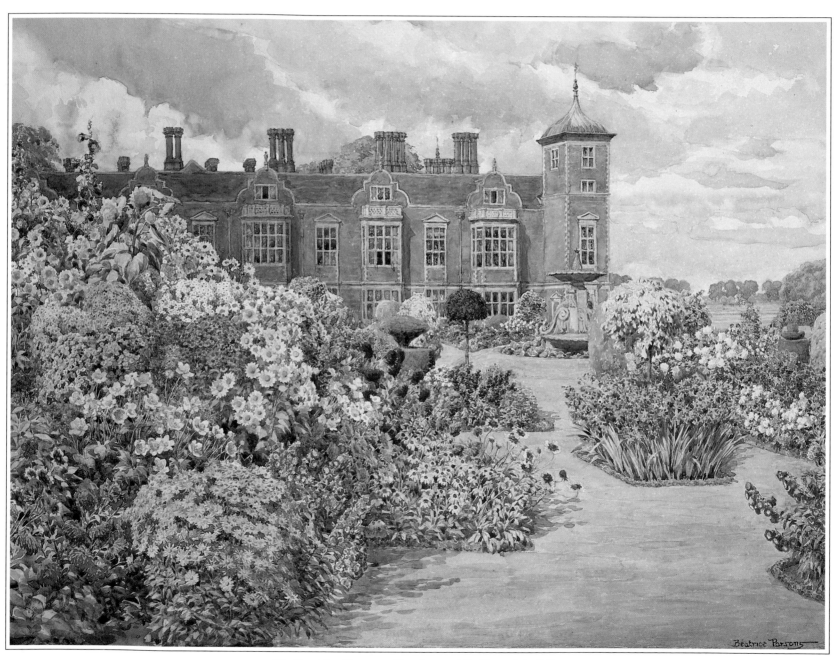

64. Beatrice Parsons. *Borders at Blickling*, Norfolk.

BLICKLING HALL

Norfolk

The seventeenth-century house at Blickling looks to the east over a flat, almost square, area of lawn. This is enclosed by terraced banks parallel to the outer edge of the house walls and terminated by a wall and central steps which lead to a distant classical temple. The terraced walls and banks are nineteenth-century and the temple was built in 1760. The acre and a half of flat lawn will probably have been originally laid out as a parterre in a style contemporary with the house; most probably also this design was swept away in the eighteenth century, when the lake to the north (just visible in the painting) was made. In 1872 W. A. Nesfield was called in by the Countess of Lothian to lay out a new parterre, at the same time that Sir Digby Wyatt completed the walled terrace and steps to the east, and the central fountain basin and statues were brought from the ruined Elizabethan mansion, Oxnead Hall, near by. Nesfield, brother-in-law of the architect Anthony Salvin, often collaborated with Sir James Barry in so-called Italianate garden style, using elaborate patterns of low box hedging to enclose beds of coloured gravels or annuals. At Blickling his instructions were unusual; indeed it is possible that he either did not complete a plan or that Lady Lothian did much of the design herself. Lady Lothian wished for an elaborate array of flower-beds, but much of the planting was to be of hardy plants with vertical conifers, standard clipped trees and roses giving symmetry and formality. Plants were to include pinks, carnations, lilies and other bulbs. Four large outer beds had their corners marked with sentinel yews; today these, visible in the painting as small elaborate clipped topiary specimens, remain but, grown large, are shaped as acorns. Strange solid yew blocks, like strips of isolated hedging, framed the further steps to the east (not visible in the painting, which shows the view westward towards the house); today these are called 'grand pianos'.

Beatrice Parsons painted Lady Lothian's parterre (plate 64) in the first years of this century. The painting shows foreground plants which are easily identified: a judicious mixture of hardy perennials and colourful annuals, obviously chosen for late-summer effects. Plants are tightly packed, leaving little obvious space for earlier spring of summer-flowering plants. Perhaps by now original planting schemes have been modified to suit periods in which the family are in residence. Alternatively, earlier-flowering bulbs and herbaceous plants are removed to a storage bed after finishing flowering in June, leaving space for dahlias and annuals which have been brought on under glass. Late in the autumn the original plants are replaced in the beds for next season's display, when flowering plants treated as annuals are taken up. This sort of very intensive gardening allows areas of the beds to be dug and richly manured twice in a season, an important consideration in a low-rainfall area such as East Anglia. The large planting block in the painting has an elaborate shaped outline edged with low box plants. Tall hollyhocks, Michaelmas daisies, heliopsis, helianthus and Japanese anemones, all permanent plant groups which need dividing only every few years, are graded in height from the centre of the bed. Annual sunflowers match the hollyhocks in height, and medium and lower-growing dahlias extend the flowering season well into the autumn. In the farther beds colour schemes seem simpler; in one, massed *Curtonus paniculatus* (then known as *Antholyza paniculata*) with grooved sword-like leaves and orange-red trumpet flowers, contained by dwarf edging box, frames a standard mop-headed tree. This invasive colourful perennial is completely hardy.

In the 1930s the parterre was simplified. Mrs Norah Lindsay, a well-known amateur designer, retained the four square corner beds, slightly sloping the soil up towards the centres. In them she planted hardy perennials arranged in strict colour schemes. The two nearest the house had flowers in blue, mauve, pink and white with a touch of crimson. The beds farthest away have flowers in yellow, orange and a touch of red. Narrow beds of roses and catmint surrounded with clipped hedges of erica match the main colour schemes. Today the National Trust maintain this planting.

BRICKWALL

East Sussex

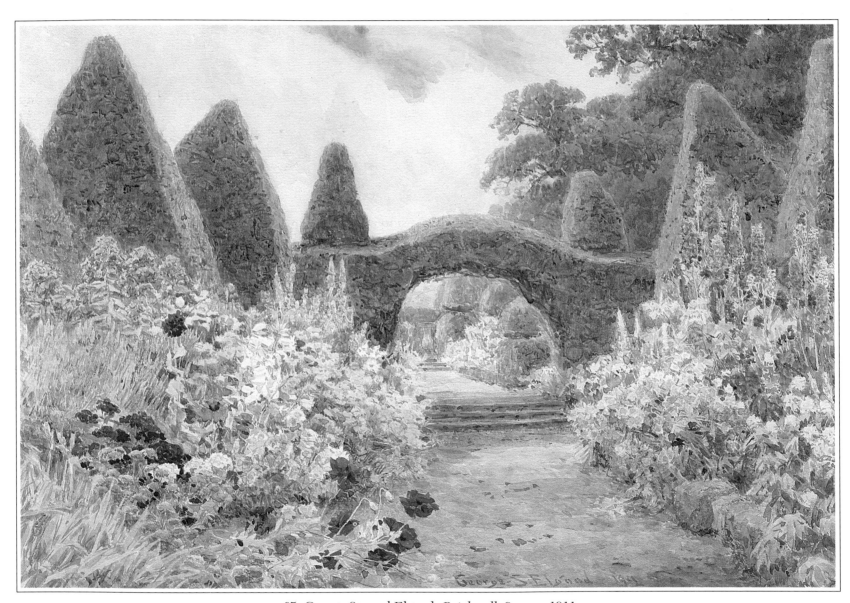

65. George Samuel Elgood. *Brickwall*, Sussex, 1911.

In 1900 the Tudor and Jacobean house at Brickwall, the Sussex seat of the Frewen family, was surrounded by a garden which retained a seventeenth-century aspect; in fact it had been sympathetically restored by George Devey, who also worked at Penshurst Place (see page 179) in the mid-1800s, after Mr Thomas Frewen returned to live here from the Leicestershire and Yorkshire seats preferred by the family between 1766 and 1830. The fine pyramids and cones of yew were probably planted after this date, but Dante Gabriel Rossetti is already inspired by the antiquity of the garden in the 1860s. As at Penshurst, it seems likely that the original formal and functional layout will have been preserved much as it was first planned, the garden remaining outside the mainstream of eighteenth-century landscape fashion.

It is possible that yews as hedging or topiary did survive here from planting in the late seventeenth century, to be tidied and trimmed by Mr Frewen and Devey. The popularity of yew was at its height in James II's reign, during the time we know the house was being embellished and improved. Writing in 1676, John Evelyn claimed to be the first to bring yew hedging and topiary into fashion 'as a succedaneum for cypress, whether in hedges or pyramids, conic spires, bowls, or what other shapes; adorning the parks or larger avenues with their lofty tops, thirty feet high, and braving all the effects of the most rigid winter which cypress cannot weather . . . I do again name the yew, for hedges, preferable for beauty and a stiff defence, to any plant I have ever seen.' At the same time he suggests that 'everyone who has the least pretension to taste must always prefer a tree in its natural growth to those monstrous figures.'

By the last half of the seventeenth century, yew was generally accepted, on account of the smallness of its leaves, as a better plant for clipping into shapes than broad-leaved hollies or other deciduous bushes. In 1838 Loudon recalls that a few old gardens such as Levens Grove in Cumberland still retained yew 'cut into singular shapes as ornaments to regularly clipped hedges, and to ancient flower-gardens'. Alterations at Brickwall date to 1685, after Thomas Frewen was knighted by James II; Levens was laid out after 1688 by Guillaume Beaumont for Colonel Grahme, the Keeper of James II's Privy Purse, who was a friend of Evelyn. Whether yews survived from earlier times or were a nineteenth-century addition is only of historic interest; at Brickwall in 1900 they seemed entirely suitable to the period of the house and garden, and provided a perfect frame for the hardy perennial borders which Elgood painted and Gertrude Jekyll described.

In 1900 the gardens were described in *Country Life*; a few years later Gertrude Jekyll's account included more plant detail. From these two descriptions a clear picture emerges of an old-style garden. Inside a walled enclosure to the south of the house, hedges of yew and pleached beech (various accounts say lime or hornbeam) further subdivide the garden into three; a fishpond lies east of the main yew walk and a bowling green alley forms a boundary with the park. Yews are trimmed into precise pyramids or triangular cones and are framed by colourful flower-beds; a further area contained a kitchen and fruit garden of roughly the same dimensions. Grass walks, raised six steps above the paving outside the south front and three steps above the garden level, are nine feet wide and each 130 feet long. They enclose three sides of the garden, on one side above the bowling green separating it from the park.

George Elgood painted here in 1903, in late June and again in August; the painting illustrated (plate 65) shows a view of the double borders which – framed by neatly cut yew pyramids – run south from the main garden entrance. Steps under a curved yew archway lead to the upper level further south. A wide brick path runs along the south side of the house. In the area to the east, but near the house, a large steep-sided fishpond lies in the lawn; of this Miss Jekyll is frankly critical. Because the ground rises away from the house the water level has to be set low; she would have preferred to have seen a brick or paved path on the level of the water with shallow steps leading up to lawn. To the west, just to be glimpsed from the house windows, a beech walk pleached above a five-foot brick wall (in *The Formal Garden in England* Blomfield says it is a lime palisade) runs across to meet the central pathway.

The borders are planted with an array of good hardy perennials planned to give a long season of performance. Scarlet oriental poppies, delphiniums in full glory of flower (in the second picture with decorative seed-heads), pink phloxes, both early-flowering *Phlox maculata* and the later *P. aniculata*, soaring verbascums, lilac-flowered erigerons and spiky thistle-flowers of echinops, rudbeckias and lavender and white daisy-flowered *Chrysanthemum uliginosum* are planted in generous groups. In the foreground Miss Jekyll notices 'the grand red-ringed Sweet William called "Holborn Glory".'

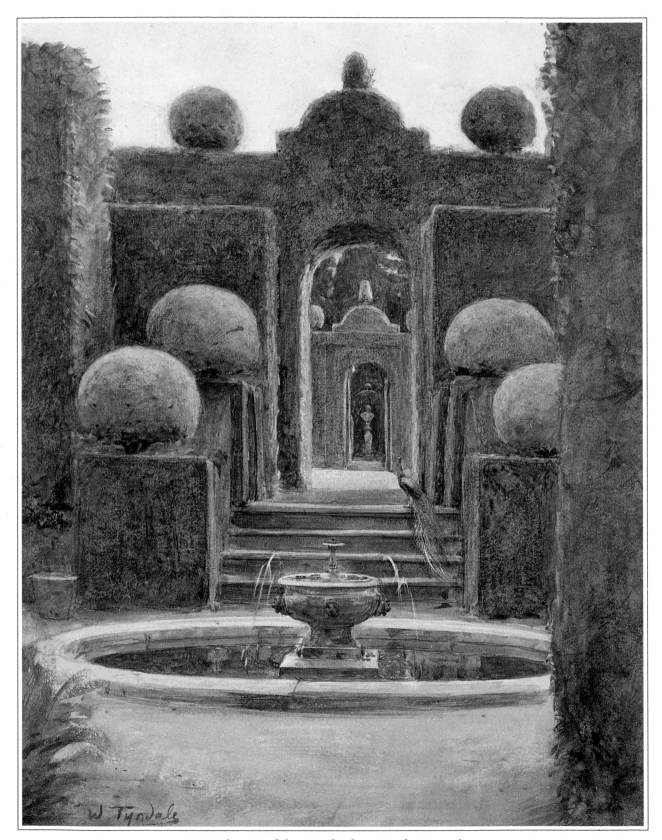

66. Walter Tyndale. *Brockenhurst Park*, Hampshire.

BROCKENHURST PARK

Hampshire

The garden at Brockenhurst Park in the New Forest is little known, but its discovery makes a dramatic impact on any visitor. Today the approach drive arrives in a walled forecourt; across the corner a fortress-like modern house built in 1960 hides the formal garden from view. When Gertrude Jekyll came to Brockenhurst at the turn of the century the layout was hardly thirty years old and must have been dominated by the French-style house built for John Morant by Thomas Wyatt some years before to replace a classical mansion. This house was finally pulled down in 1960. The garden seems to have been designed by Mr Morant himself; its size and proportion resembled more closely the simplicity of a sixteenth-century Italian Renaissance design rather than the more elaborate French Baroque which would have matched the Wyatt house. Indeed, Miss Jekyll considers Mr Morant to have 'absorbed the true spirit of the pure Italian gardens, and his fine taste knew how to bring it forth again, and place it with a sure hand on English soil . . . it is none the less beautiful because it is a garden almost without flowers, so important are its permanent forms of living green walls, with their proper enrichment of ball and spire, bracket and buttress, and so fine is the design of the actual masonry and sculpture.' The Italian-style garden was surrounded on three sides by fine eighteenth- and nineteenth-century plantings of trees – Scots pines, six magnificent cedars of Lebanon, a group of *Sequoia sempervirens*, wellingtonias and a *Cedrus deodara*, all of which survived into the second half of the twentieth century.

Both George Elgood in 1897 (plate 68) and Walter Tyndale in the early 1900s (plates 66 and 67) painted the formal garden at its peak. The illustrations show the eastern garden, where a series of geometric enclosures leading off a main stage are hemmed in by tall hedges and decorated with sharply cut topiary shapes, almost as fine in clipped detail as the statues which ornament them. The stage, raised above the end of a long canal which stretched south from the house, had wings and arches in sculptured bay; the garden 'rooms' were surrounded by clipped hedges of *Quercus ilex*, cherry laurel and green and golden yew; these living walls framed fine statuary. Archways elaborately cut as classical pediments and steps up or down provided access and linked confusing changes of level.

Neither artist portrayed the finest feature in the garden; fortunately it is one which remains today in all its detail just as it was conceived a hundred years ago. A long canal, set in grass panels, is the focal point of the garden, as important now to the modern house as it was when dominated by Thomas Wyatt's château. Topiary shapes – alternating domes and squares cut in green and golden yew and box – stand as sentinels in the grass beside the canal, while outer hedges of clipped bay are backed by tall Luccombe oaks and ancient cedars to make a further dark frame to the still reflecting water. The stone edges of the pool are softened by spreading bushes of herringbone cotoneaster.

Today the garden survives, but only just; the formal hedges and topiary have been simplified to save labour without destroying the feeling of intimacy and structure. The Hon. Mrs Denis Berry, who died in 1987, restored the garden after 1960 using professional help only for dredging and repair work to the canal and pools, and for annual periods of hedge and topiary trimming. Although when she and her husband came in 1960 most of the fine ornaments had vanished, they were replaced with urns and statuary of equal quality brought from Mr Berry's own home at Dropmore. Mrs Berry did much of the maintenance work herself, planting new and often rare trees in the outer garden for future generations to enjoy. Without her love and care this garden would certainly have vanished; we must hope for its survival into another century. After her death the hurricane of October 1987 brought down many of the old and the more recently planted trees.

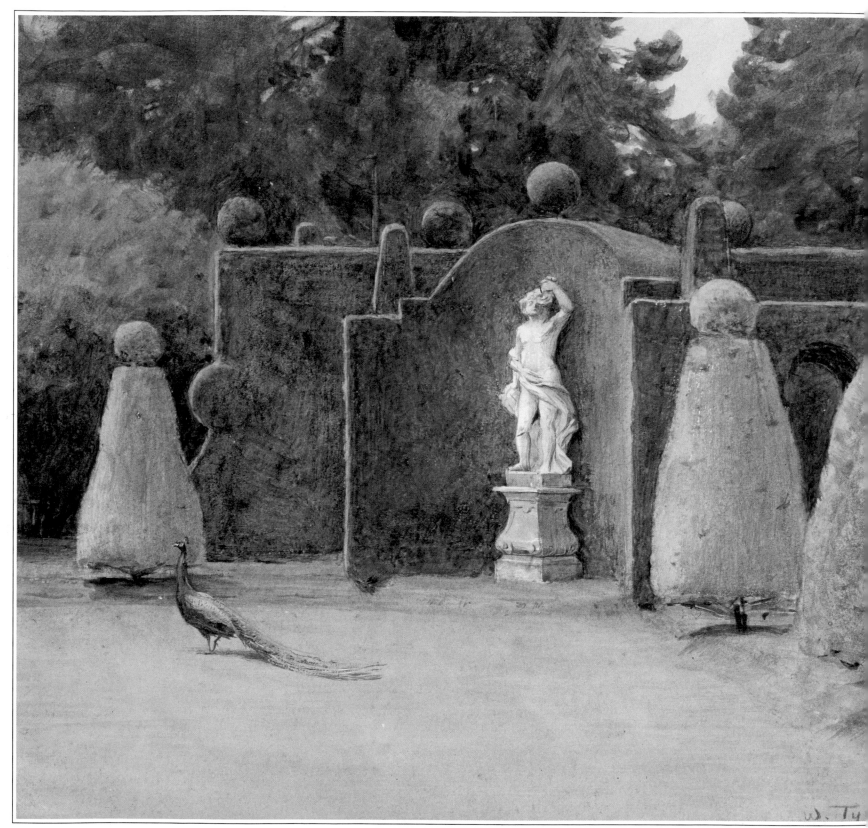

67. Walter Tyndale. *Brockenhurst Park*, Hampshire.

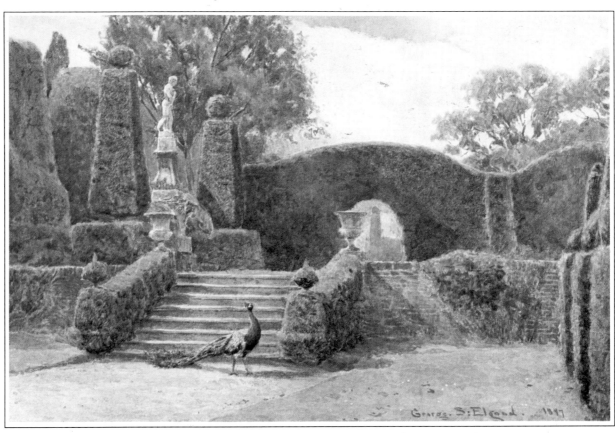

68. George Samuel Elgood. *The Terrace, Brockenhurst Park,*
Hampshire, 1897.

CAMPSEA ASHE

Suffolk

Campsea Ashe lies a few miles from the Suffolk coast near Wickham Market and seven miles from Aldeburgh; its land originally marched with that of Rendlesham Hall, where Repton advised in the last years of the eighteenth century. The garden layout, probably dating to *circa* 1680, was extremely impressive; with vast radiating avenues in French style, a series of parallel canals (resembling those at Westbury Court, and of a scale and grandeur particularly appropriate to the flat East Anglian landscape), and an elliptically shaped bowling green hedged around with fantastic yew shapes. The latter feature remained intact in the early 1900s, and one long canal, stretching 150 yards south and east of the house, survived the centuries. Rowe captured the dark stillness of the canal and the towering yew walk which dominated it. Elgood, typically, chose to work in the flower garden, where perennials, biennials and annuals were shown to great pictorial effect, their bright hues backed by strange yew topiary shapes, the recurring features in this garden.

An extract from *The Suffolk Traveller* (2nd ed. London 1764) sets the historical context: 'The High House at Campsey is a good seat and was built by John Glover, Esq., sometime servant to Thomas Howard, Earl of Norfolk, whose successor, removing to Frostenden in the county, sold it to the Sheppards, one of which Family now possesses it.' An engraving in a topographical guide to the County of Suffolk published in 1819 shows a house with tall gables and 'curiously ornamented chimneys' framed by a pair of cedars. In front, to the southwest, is an elliptical lawn, almost enclosed by hedge, where a game of croquet or bowls is in progress. The pleasure grounds are described as extensive and 'kept in their original style, exhibiting a singular contrast with the present mode of gardening'; this presumably means the gardens kept their seventeenth-century formal layout and had not been converted to the Landscape Style.

Today no house occupies the original site, yet the hedged bowling green remains and a lime avenue still stretches northwards. On old maps a cross-avenue, its axis through the house, stretched two and a half miles from east to west; few trees remain of this early planting. We know that the Sheppard family held the house from 1648 to 1883 and then sold to the Hon. William Lowther who owned it at the time that Elgood and Rowe painted it and Gertrude Jekyll paid a visit. The Sheppards were probably responsible for laying out the avenues and canals at the end of the seventeenth century. The house was remodelled by Salvin in about 1870. In 1908 the well-timbered park of 144 acres is described as stocked with deer, while the grounds contained wonderful cedars, one of which was 110 feet, long avenues of limes, terrace gardens and an almost unique bowling green with its yew fences clipped into fantastic forms.

There is much more documentation about the great radiating avenues and their alignment, but it is with the canals, yew colonnade and inner gardens that we are concerned. Miss Jekyll describes the gardens in Lowther's time. Later Viscount Ullswater (a son-in-law) gives a more historical description in the *Journal of the Royal Horticultural Society* for January 1928. Miss Jekyll saw the raised broad walk which lay some ten feet above the eastern canal as illustrated by Rowe in his painting of 1905–6 (plate 71) a few years later; the terrace walk runs north, allowing a glimpse of Salvin's remodelled house. In her time the yew was twenty feet high and ran for 150 yards above the bank of the canal. She notices the punt where steps lead down to the water just as it is in the painting: it is a ferry-punt propelled by an endless rope such as was commonly used in the fenlands. Rowe shows the busts set between the yews; these had been collected from an old Italian villa by Lord Lonsdale (father of the Hon. William Lowther) in 1850; by 1928 they had vanished and in 1988 the canal itself has dried up.

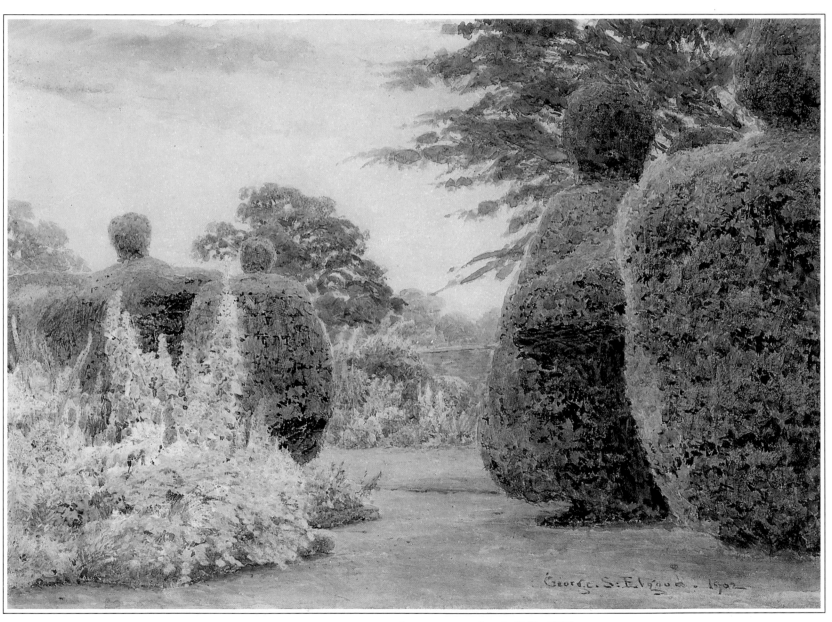

69. George Samuel Elgood. *Campsea Ashe*, Suffolk, 1902.

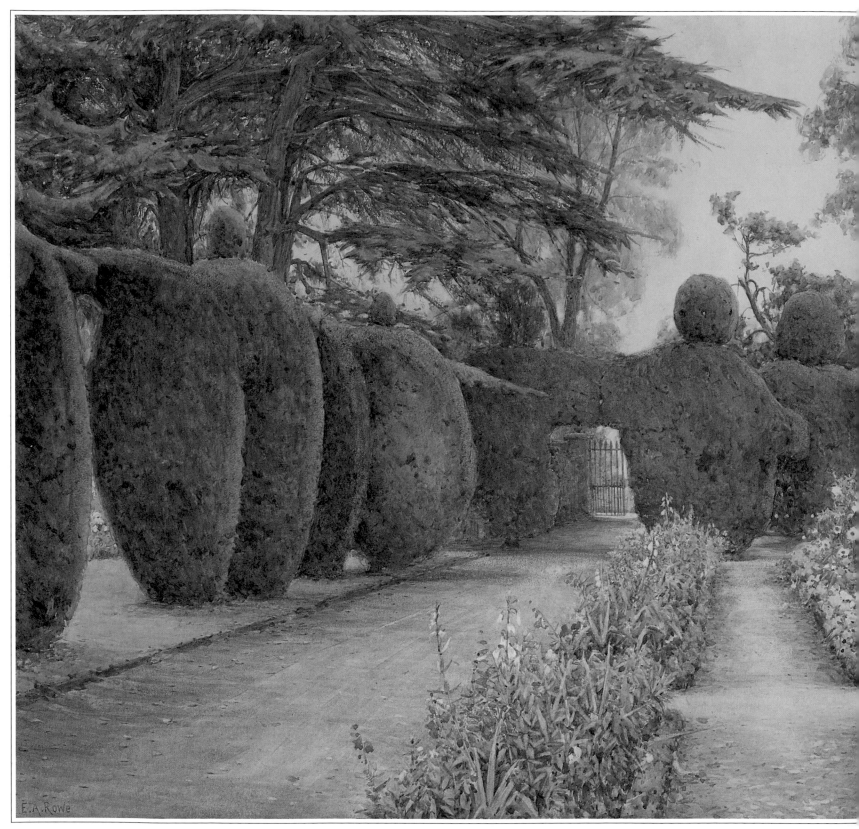

70. Ernest Arthur Rowe. *Campsea Ashe*, Suffolk.

Even in 1900 Miss Jekyll found the topography of the garden hard to understand; at times traces of older features appeared but were not sufficient to give cohesion. Elgood's painting in *Some English Gardens* shows a small parterre of box-edged beds, packed with tall perennials and backed by a row of old clipped yews. Rowe's second painting (plate 70) portrays the further end of the same parterre, where box-edged beds are much more neatly planted with annuals, less boisterous in effect. Miss Jekyll describes this part of the garden, where the main paths are bordered with flowers; this colonnade of yews lies at the southern end of the garden. These topographical details are confirmed by Lord Ullswater in 1928. He writes of the old yew 'fences', at that time '15 to 25 feet high and 8 to 10 feet thick'; in the whole garden they stretched 600 yards, 'a formidable proposition when the time comes for their annual shingling'. Ullswater also describes the yew colonnade and stone garden; these were set in the walled garden south of the house and beyond the canals. Both Miss Jekyll and he also comment on the ancient bowling green: a pity neither artist attempted to paint it. Elgood's painting (plate 69) shows a further corner of the same row of top-knot yews, now showing their age with patches of dead wood; beside them planting in the beds seems more permanent, hollyhocks which he loved to paint, tower above lower growing yellow-flowered perennials. As Miss Jekyll says, 'Good hardy plants are everywhere in abundance. Specially beautiful in the late summer is a grand pink Hollyhock of strong free habit, with flowers of that best of shapes – with wide, frilled outer petals and centres not too tightly packed.'

An entry in *The Gardener's Chronicle* of 19 August 1933 has accompanying black and white plates showing the Long Water Pool (Rowe 1905–6), still virtually as it was, and a view of a sunken pool and rose garden. This central pool was once the northern part of a long western canal, a pair to that illustrated

to the east. A further canal once lay north-west of the house but has long since disappeared. This garden, an Italian Garden and a Speaker's Garden (named for Lord Ullswater, who was Speaker in the House of Commons from 1905–1921) were twentieth-century additions to the seventeenth-century layout.

By the end of the 1970s, Mr P. F. Springett had worked out much of the detail of the early seventeenth-century layout, his task complicated by additional garden features added since Rowe and Elgood painted here but now also vanished through neglect. Garden archaeology and historical research can solve many riddles; where Miss Jekyll only surmised, knowing that the garden which she saw represented hidden layers of history, more definite conclusions can now be reached. Alas, only scholarship and the paintings remain: the grand and complicated layout has disappeared forever.

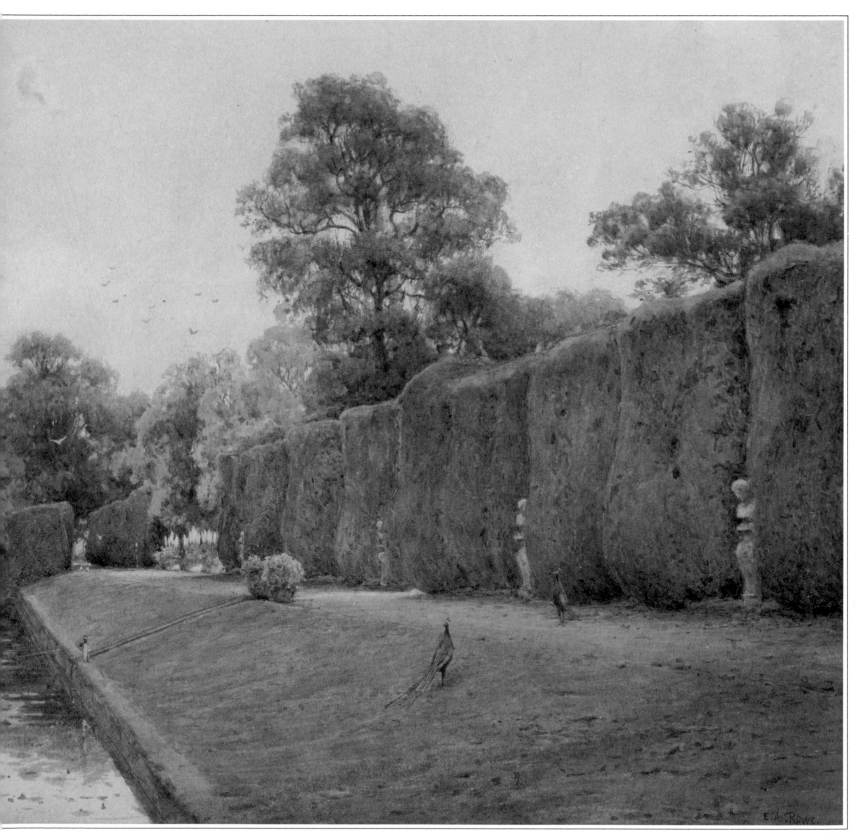

71. Ernest Arthur Rowe. *Campsea Ashe*, Suffolk.

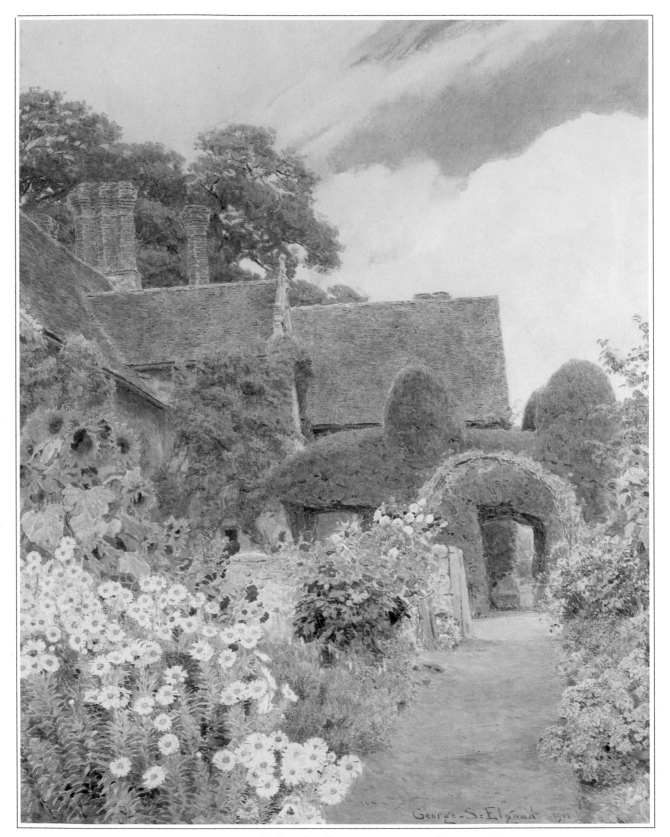

72. George Samuel Elgood. *Cleeve Prior*, Warwickshire, 1901.

CLEEVE PRIOR

Worcestershire

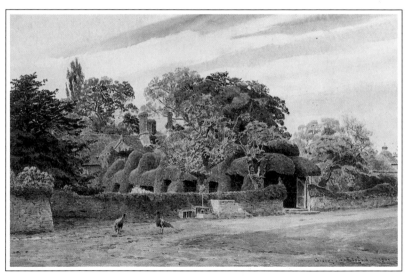

73. George Samuel Elgood. *The Twelve Apostles, Cleeve Prior, Warwickshire*, 1901.

The old manor at Cleeve Prior, near the Warwickshire border, was first granted to the Dean and Chapter of Worcester after the dissolution of the monasteries by Henry VIII. With a break in ownership during the Commonwealth, it remained in their hands until 1859, when the Ecclesiastical Commission became Lords of the Manor. In 1901, when George Elgood painted the garden, it was still their property, and Mrs Holtum their tenant. The manor itself and accompanying farm buildings, standing on rising ground above the River Avon, dates to the seventeenth century, and by the early 1900s the essential features of the garden layout had probably changed little during nearly three centuries. Occupiers of a tenanted farm had little incentive to follow the vagaries of gardening fashion. Old yew hedges typical of seventeenth-century style were allowed to remain *in situ*, and nearby fruit orchards and vegetable areas were kept in use on a working farm when grander mansions were surrounded by elegant parkland during the eighteenth century. The approach, framing a projecting porch at the centre of the manor house, is lined with ancient yews clipped into arches flanked with taller sentinel domes, spaces between each pair on either side of the stone-flagged path allowing views to the simple flower-beds described by Gertrude Jekyll in *Some English Gardens*. Eight yews stand on either side, sixteen in all – together known as the twelve Apostles and four Evangelists (plate 73). Tall mushroom-domed yew heads frame the 'wooden handgate, with its acorn-topped posts, that stands upon two semi-circular steps'. Their shape and title recall the famous topiary Sermon on the Mount at Packwood House not far away. Interestingly, much of the yew planting at Packwood is only nineteenth-century; it is possible that the mature yews at Cleeve Prior were its inspiration. Beyond the gate a circular stone dovecote with tiled roof is just visible; it may date to the period when Cleeve Prior was the property of Evesham Abbey; that is, before the Reformation.

Gertrude Jekyll writes: 'To the left of the Apostles' garden, as you stand facing the house, a little gate leads into the vegetable garden. It has narrow grass paths bordered with old-fashioned flowers . . . how grandly the flowers grow in these old manor and farm gardens. How finely the great masses of bloom compose, and how beautifully they harmonize with the grey of the limestone wall and the wonderful colour of the old tiled roof; both of them weather and lichen-stained; each tile a picture in itself of grey and orange and tenderest pink.' Elgood's painting (plate 72) shows these unsophisticated borders where a vigorous clump of trouble-free hardy Shasta daisies (*Chrysanthemum maximum*) flowers in front of the great annual sunflower (*Helianthus annuus*), which reaches to eight or ten feet in a season. Beyond a pale-flowered lavender bush (probably old English – *Lavandula angustifolia*) on the left in the picture and a group of mauve perennial Michaelmas daisies opposite, dahlias are massed to frame an archway on which a climbing rose is trained. French marigolds (*Tagetes patula*), an annual from Mexico grown since the sixteenth century, edge the roughly mown grass path. Beyond the Apostles' Walk a further gate leads into a traditional farm orchard. By 1900 no passing fashion in landscape design nor schemes of Victorian carpet-bedding had altered this garden, which remained virtually timeless and very English in style. Grander in scale than a cottage garden, it retained its functional character where flowers for pleasure and picking mingle with scented lavender and kitchen herbs, making a foreground frame to orchards and pasture. Until recently the garden features have been well maintained; in 1988, although the clipped yews and pretty eighteenth-century style wooden gateway are still there, the outlines of Elgood's Apostles can only be imagined, and the rest of the garden is a wilderness.

COMPTON WYNYATES

Warwickshire

The great house at Compton Wynyates, one of the finest Tudor buildings in England (parts of it dating to before 1520) lies in a hollow just out of sight of the minor road which brings a traveller from Banbury. Neither house nor garden is often open to the visiting public; instead, until recently, many of the curious were able to gaze down on the square shaped building and the strange topiary patterns, known as the Best Garden, from the slopes above. Today for reasons of privacy this is no longer possible; if it were, the view is much altered. The elaborate sculptural shapes in yew and box were cut down in 1980; they are no longer there to be admired and pondered over. Even the flowerbeds in which the pieces grew have vanished and smooth lawns now frame the house. The early building was moated on three sides for defence (the south and west portions of the moat were drained during the Civil War). It seems unlikely that any contemporary period garden of topiary or knots would have existed beyond the line of the moat, although topiary gardens are recorded as being in construction in Northumberland and Oxfordshire in the early Tudor period. After the Civil War Compton Wynyates was virtually abandoned; the late Victorian topiary parterre was laid out in 1895 and, with flower borders to the west, seems to have been a first attempt at providing the house with any sort of garden setting. The new intention is to reopen the dry channels of the moat and to restore the garden to a simple format – one which, unadorned by intricate ornament, would be in keeping with the defensive role of the original buildings.

In fact the clipped pieces in the Best Garden, removed in 1980, had been there for less than one hundred years; certainly none dated to the early Tudor period or even to the end of the seventeenth-century when so-called Dutch gardening was all the rage. Although Sir Matthew Digby Wyatt had been employed on restoration of the house in 1867, it seems likely that when the Fourth Marquis inherited in 1884 the garden hardly existed. Plans indicate some planting of yew hedging to the south of the house in the succeeding decade, and the Best Garden, named for the field in which it lay and not in any comparative sense, was completed in 1895. The new topiary, cut in shapes to resemble statuary, was a product of the late Victorian cult of period revivalism, essentially the search for a style from an historical context, which would satisfactorily link house and garden as one unit. Like the labyrinth and golden-yew chessmen at Hever Castle (see page 148) the degree of accuracy in projects and planting detail was unimportant; what mattered was to convey an 'antique' atmosphere, an association with the distant past.

Curtis and Gibson, the latter head-gardener at Levens, published *The Book of Topiary* in the same year that *Some English Gardens* was produced; in it photographs appear of various curious rustic shapes taken from Compton Wynyates; in the text Curtis refers to an 'old' example of box topiary in the garden. It seems likely that some of the clipped box were indeed of considerable age but may have been planted as mature specimens; peacocks were in yew, a pig, a farmyard fowl, 'a leathern bottel', a swan and an armchair are all portrayed in box. The 'pieces' could have been bought 'ready made' to reinforce one or two bushes already *in situ*. Two firms specialized in their production; Joseph Cheal of Crawley who also worked at Hever Castle, and the aptly named Herbert J. Cutbush of Highgate.

When Gertrude Jekyll came to Compton Wynyates grass lawns occupied the site of the old moat on the south and west; the water still remained on the northern side of the house. The topiary parterre lay beyond a yew hedge; it occupied a flat area the width of the southern facade of the house. More garden beds lay on the south-west. We know from Elgood's painting of 1903 (plate 75) that the topiary looked established and mature; clipped cones set on a hemispherical base, each with a button finial, dominate the foreground in the painting. Miss Jekyll praises the good hardy flowers in the main borders but hardly mentions the topiary which was to make this garden famous for the next eighty years. She notices ornaments of peacocks cut in the principal openings of the yew hedge which surrounds the parterre, and 'of ball and such-like forms at other apertures'. One feels an undercurrent of disapproval; obviously she would have preferred the flower-beds unadorned with such orna-

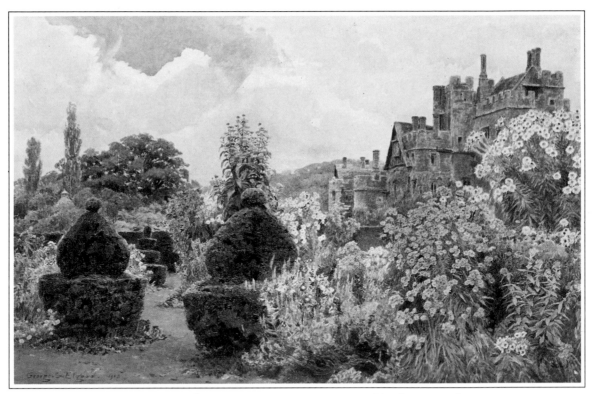

74. Ernest Arthur Rowe. *Compton Wynyates*, Northamptonshire.

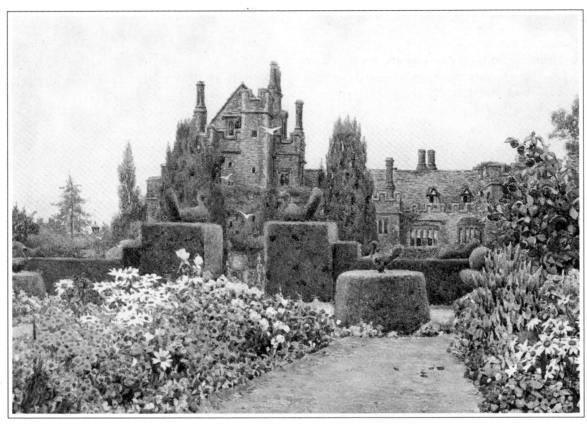

75. George Samuel Elgood. *Compton Wynyates*, Northamptonshire, 1903.

ment. Whereas at Levens Hall she accepts the strange forms of yew and box, as showing 'perhaps the whimsical humour of some one of a line of owners, preserved, with careful pains-taking, by his descendants', because she believes the topiary genuinely old, she knows that at Compton Wynates it may be dismissed as a passing and distracting fashion, hardly worthy of mention.

Elgood's painting accompanies Miss Jekyll's prose, which gives admirable detail of the planting he portrays. 'Here are some of the tall perennial Sunflowers, eight feet high; the great autumn Daisy (*Pyrethrum uliginosum*) [now *Chrystanthemum uliginosum*]; bushes of lavender with Pentstemon growing through them – a capital combination, doing away with the need of staking the Pentstemons; the last of the Phloxes; for the time of the picture, which was painted in this part of the garden, is September' (Elgood did other paintings of the garden but their whereabouts is not known.) 'This bold use of autumnal border flowers invites the exercise of invention and ingenuity; for instance, August is the main time for the flowering of Lavender . . . Clematises, purple, lilac and white, can be planted among them, and can easily be guided, by an occasional touch of the hand, to run over the lavender bushes' and so she runs on; Miss Jekyll rides her usual hobby horse. 'The working out of such simple problems is one of the many joys of the good gardener; and every year, with its increased experience, brings with it a greater readiness in the invention of such happy combinations'. In 1904 she seemed in critical mood; although appreciative of the ambience of the house itself, she found faults in garden detail. She declared the sundial plinth too small; the pyramid fruit trees 'an experiment of doubtful value', the pergola 'which is well-placed at the eastern end of the parterre, deserves better piers than its posts of fir'. It is hard to believe the Marquess was pleased to find his garden taste so much and publicly in question.

Ernest Arthur Rowe painted at Compton Wynyates in 1889, 1892, 1895 and again in 1913. It seems almost certain that the illustration here (plate 74) was done in 1913. By that year the peacocks have grown huge; the borders are in riotous colour and it is possible that some annuals have crept in to prolong the seasonal flowering peak. A few years after Rowe's visit the flowerbeds were removed and the topiary shapes sat alone in smooth grass; today they have vanished altogether. Although the Best Garden had little real historical justification many today find the empty lawns and tarmacadam driveway unsympathetic. A projected garden develoment in an appropriate but much earlier style should please the scholars and placate the horticulturists; the preservationists will continue to regret the vanished Victorian garden.

CRATHES CASTLE

Kincardineshire

The building of Crathes Castle, on the north bank of the Dee, was begun in 1553 by Alexander Burnett of Leys; it was finished in 1596. The east wing was added in the early eighteenth century and the garden terraced; by tradition the great yew hedges were planted in 1702 in an area to the east of the castle, where today seven acres are contained within a rectangular wall. Sometime in the same century two lime

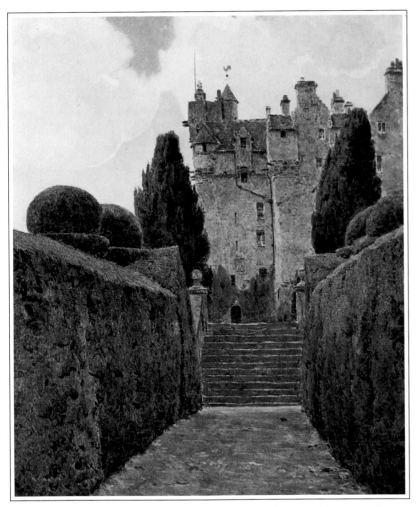

76. George Samuel Elgood. *Yew Walk, Crathes Castle*, Kincardine.

walks were planted leading southwards from the castle walls towards the river. A further wing was added to the building in Victorian times.

The walled gardens at Crathes rank amongst the finest in Great Britain. Although the planting schemes visible today owe much to the taste and interest of Sir James and Lady Burnett of Leys after the 1920s, George Elgood's paintings, completed before the turn of the century, show garden scenes which could illustrate the modern garden. Today, as in Elgood's time, the walls of the grey stone castle, yew hedging and vast topiary specimens still dominate the whole garden layout; axial and cross-axial paths further divide the garden into compartments. The mature alley of yews, each ten feet high 'with roof-shaped tops' in 1895, providing a hidden walkway, seems hardly to have changed in the ninety or so years since it was painted. In the more flowery picture illustrated (plate 77), a wide border under the clipped topiary (he also painted a double border arched over with rambling roses where the main herbaceous borders are today) although of different composition seems to capture the spirit of the thickly planted perennial borders which are such a feature of the modern Crathes garden.

Since 1900 the scope of the ornamental garden has been much extended; in particular in the lower garden, where four main divisions are reserved for separate colour and plant themes. The top terraces of the garden have changed comparatively little; the croquet lawn at the garden entrance remains uncluttered as it has for centuries, while the formal Fountain Garden east of the tall yew hedge is still in Victorian style with blue-flowered annuals giving a long summer display. The Colour Garden, directly under the east walls of the castle and above the croquet lawn, was designed by Lady Burnett in 1932; it is a spectacular formal layout with purple and bronze foliage plants, scarlet, crimson and brightest yellow flowers all symmetrically arranged in beds to surround a small central pool. In 1875 this garden was mainly of herbaceous plants, roses and lilies; a hundred years later the strong distinctive colour blocks are new, as are many of the 'improved' herbaceous plants, but the border styles are not essentially different.

At the time of Elgood's visit, the lower garden had a main gravel path as a central axis, but most of the beds were reserved for kitchen produce – including the crops of gooseberries praised by Miss Jekyll; wide flower-beds lay along the walks and under some of the walls as in the illustration. The lower garden's divisions were reinforced by the Burnetts, hedges were planted to divide the area up into concealed compartments; in all of these separate 'rooms' colour or seasonal themes are dominant. There are white borders, June borders, a 'cottage' garden with informally shaped beds, a Golden Garden and a Red Garden as well as the centrally placed perennial double borders over which the grey castle seems to tower. Where an ancient mulberry was encircled by a seat, a Portugal laurel makes a focal point today. These thematic gardens owe much to Lady Burnett's flair for composition; Gertrude Jekyll, writing about Crathes in *Some English Gardens* after a visit to Sir Robert Burnett in 1895, could hardly have guessed that a new garden-artist set in a firm Jekyllian tradition would soon extend and embellish the scenes she enjoyed and praised. It is easy to believe that Lady Burnett will have referred to Miss Jekyll's books during the years she was making the gardens; it is recorded that the Golden Garden, planted in 1973 after Lady Burnett's death, was inspired by Miss Jekyll's *Colour Schemes For The Flower Garden*, written in 1908. Miss Jekyll's works, especially those containing colour pronouncements, were never intended to provide planting examples to be exactly copied; instead she opened a reader's eyes to the grammar of colour theory, leaving it to each of them to plan and plant their own original designs, new interpretations of plant harmonies.

When George Elgood and Gertrude Jekyll visited Crathes, the garden seemed to have been recently planted. 'The flower garden . . . is quite modern. The finest of the hardy flowers are well grown in bold groups. Luxuriant are the masses of Phlox and tall pyrethrums, of towering Rudbeckia, of Bocconia, now in seed pod but scarcely less handsome than when in bloom; of the bold yellow Tansy and Japan Anemones; all telling by their size and vigour, of a strong loamy soil.' George Elgood painted the garden scenes in October. Miss Jekyll visited in late August; she writes after her visit: 'The brilliancy of colour masses in these Scottish gardens is something remarkable. Whether it is attributable to soil or climate one cannot say; possibly the greater length of day, and therefore of daily sunshine, may account for it . . . The flowers of our July gardens, Delphiniums, Achilleas, Coreopsis, Eryngiums, Geums, Lupines, Scarlet Lychnis, Bergamot, early Phloxes and many others and the hosts of spring-sown annuals, are just in beauty.' These northern gardens, with long daylight hours in summer and cooler temperatures, provide perfect growing conditions for hardy perennials; borders come to their peak later than in lower latitudes, but plants grow taller and colours seem more vivid, as at Kildonan Lodge (see page 156).

Although best known for its perennial colour schemes, Crathes is not only a flower garden; Sir James contributed a collection of interesting trees, shrubs and climbers which make an extra framework inside the walls and hedges, softening right-angled corners and formality with flowing branches, flowers and foliage. To many visitors the tender specimens come as a surprise, but the protected garden provides sites with favourable microclimatic conditions and Sir James loved to experiment, often protecting young woody plants until they were well established. In 1951, two years before his death, Sir James Burnett handed over Crathes Castle to the National Trust for Scotland.

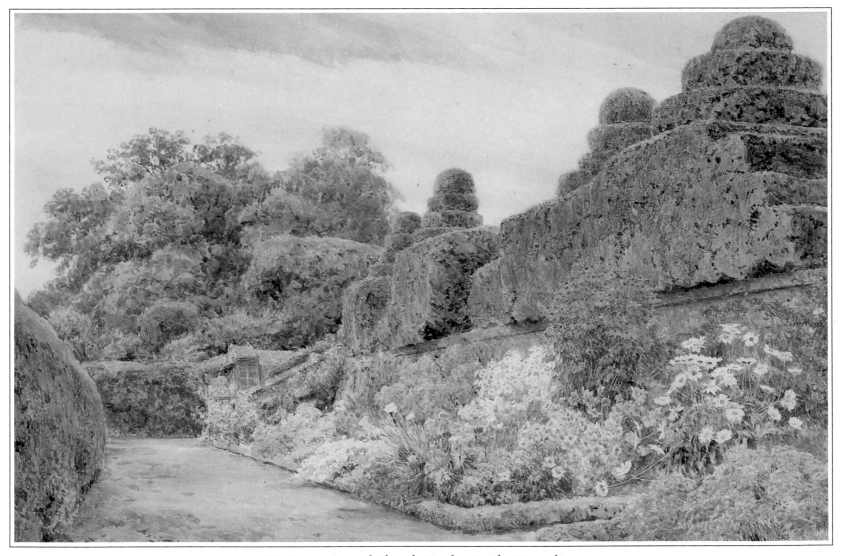

77. George Samuel Elgood. *Crathes Castle*, Kincardine.

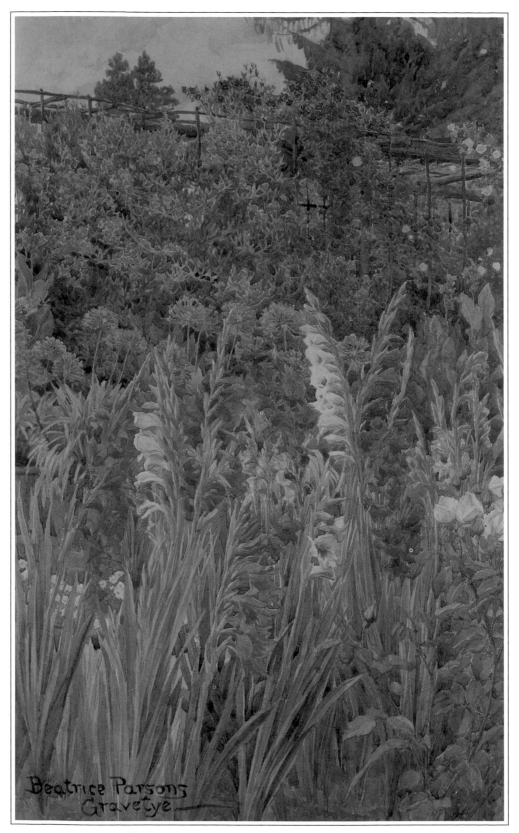

78. Beatrice Parsons. *Gravetye Manor*, Sussex.

GRAVETYE MANOR

West Sussex

Any man who sets a trend and, as in William Robinson's case, becomes eponymously associated with a style, must expect his protagonists as well as his detractors to exaggerate his edict somewhat. Indeed, many of William Robinson's writings and remarks that are quoted in favour or disfavour in the battle between two schools of gardening practice are outrageous. Robinson, on close examination of both his writing and his practice, proves as conventional a man as the next when considering the terraces immediately about a house. We do not have to seek far to find extracts from his own writings which confirm his appreciation of some sort of a geometrical layout: 'Formality is often essential in the plan of a flower garden near the house – *never* as regards the arrangements of its flowers or shrubs. To array these in lines or rings or patterns can only be ugly wherever done.' Thus in his review of *The Formal Garden in England* by Reginald Blomfield and F. Inigo Thomas (1892) he makes it quite clear that it is the *plants'* not being set in patterns that is important; the layout should be so planned as to make the plant arrangement most artistic.

A visit by any of his contemporaries to Gravetye, his Tudor manor set in a fold of the Sussex hills between East Grinstead and Turner's Hill, revealed a conventional garden layout which framed the grey stone house in flowers; stone steps, paving and terraces, pergolas, trelliswork and rectangular flower-beds were set out in a design his critics Blomfield and Sedding could only have approved. One might have expected the gardens to show only the 'naturalistic' treatment of design and plant arrangement which we associate with Robinson's teaching. In fact the symmetrical layout was perfectly attuned to the architecture of the house and its situation. Mr Robinson himself made a clear distinction between the flower garden, which should frame a house – so that 'with one foot over the threshold one should enter a realm of flowers, garland and mosaic, wreathed and perfumed around one' – and the outer wilder garden, where Robinsonian laws ruled. This edict never conflicted with his broader thesis concerning growing hardy plants in a 'natural' way; nor with his controversial views that

the role of the architect of a house should remain distinct from the gardener. In the outer wilder garden at Gravetye planting was truly 'Robinsonian': bulbs were naturalized on steep slopes under tall pines, as we can see in one of the illustrations. Both the paintings are of the paved garden near the house, and the date of their execution by Beatrice Parsons fortunately coincides approximately with the publication in *Country Life* (28 September 1912) of a detailed plan and description of Robinson's flower garden drawn and written by himself. Equally valuable are articles in April and October 1913, where he describes his 'wilder' garden in the same journal. There is no better guide to a garden than the experienced owner, especially one whose teachings and influence are still relevant today, more than a hundred years since first expounded. One watercolour (plate 79) shows a broad view of the paved garden showing flower-beds and the pergola which marks its farther north-west edge. The style is cottage-garden; campanulas, daisies, roses and carnations scramble together in arranged disorder. Beyond, roses and clematis are draped over the pergola, beneath which there is a fine array of agapanthus. The other view is a close-up of the pergola corner (plate 78). A mauve clematis – perhaps a *viticella* form, white roses and pink sweet peas make a backdrop for agapanthus, gladioli and, in the foreground, more roses. Let us quote directly from the *Country Life* article: 'The editor took a fancy to have a plan of my garden . . . but plans should be made on the ground to fit the place and not the place made to suit some plan out of a book . . . in this case I thought of nothing but the ground itself, its relation to the house and what I wanted to grow in it . . . I am a flower gardener and not a mere spreader about of bad carpets done in reluctant flowers, and when I had a garden of my own to make, I meant it to contain the greatest number of favourite plants in the simplest way. I threw the ground into simple beds, suiting the space for convenience of working and planting, not losing an inch more than was necessary for walks. . . . No plan of any kind was used nor any suggestion sought from any garden, the question being decided in relation to the space. Any talk about "styles" in relation to such a thing

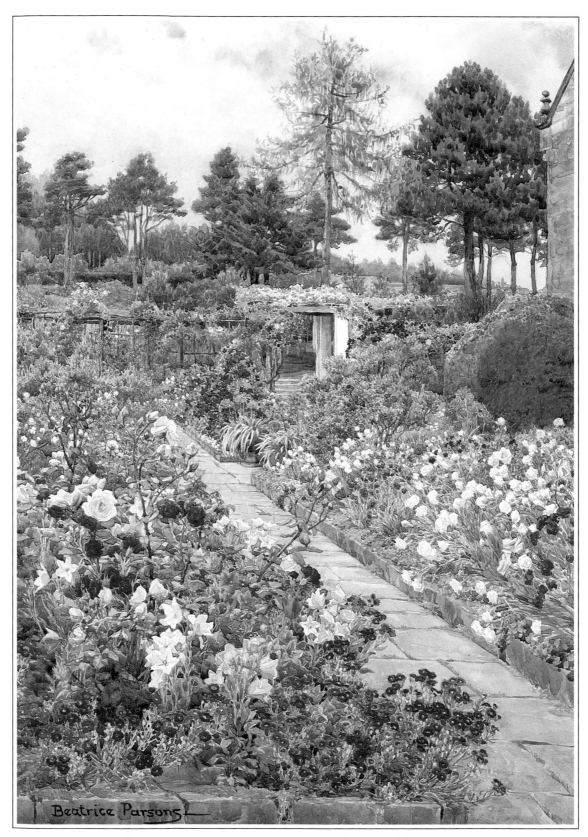

79. Beatrice Parsons. *The Paved Garden, Gravetye Manor*, Sussex.

is absurd. Having made my garden, one day a young lady who had been reading one of those mystifying books about formalities and informalities came in, and, instead of warming her eyes at my Roses and Carnations, said, "Oh, you too have a formal garden." Just imagine what Nebuchadnezzar or the medieval Lady in their small patches of garden would think of any silly person who made such a remark instead of looking at the flowers.' Elsewhere he expands his theme: 'The real flower garden near the house is for the ceaseless care and culture of many and diverse things often tender and in need of protection in varied and artificial soils, staking, cleaning, trials of novelties, study of colour effects lasting many weeks, sowing and mowing at all seasons. The *wild garden* on the other hand, is for things that take care of themselves in the soil of the place . . . like Narcissi on a rich orchard bottom, or blue anemone in a grove on the limestone soil.' He goes on to sort out the confusion caused by the term 'formal' in gardening. He calls formal only those gardens 'where the plants . . . are rigidly set out in geometric design, as in carpet gardening and bedding-out'. This is much the same point as he made, as already quoted, in his review of 1892.

In his own garden these pictures show how the available space has been divided up to make a simple layout. Robinson used old half-worn London York stone pavings instead of gravel for the paths, which he edged with pieces of broken stone about ten inches deep. These are clearly visible in one of the paintings. The tripod plant supports are of chestnut, the trellises of oak and chestnut, the small fixings being of rattan. The uprights are of iron with oak or bamboo stakes tied over them.

The gardens of Gravetye have been partially restored by present day owners. Unfortunately the gales of October 1987 have almost completely destroyed Robinson's woods.

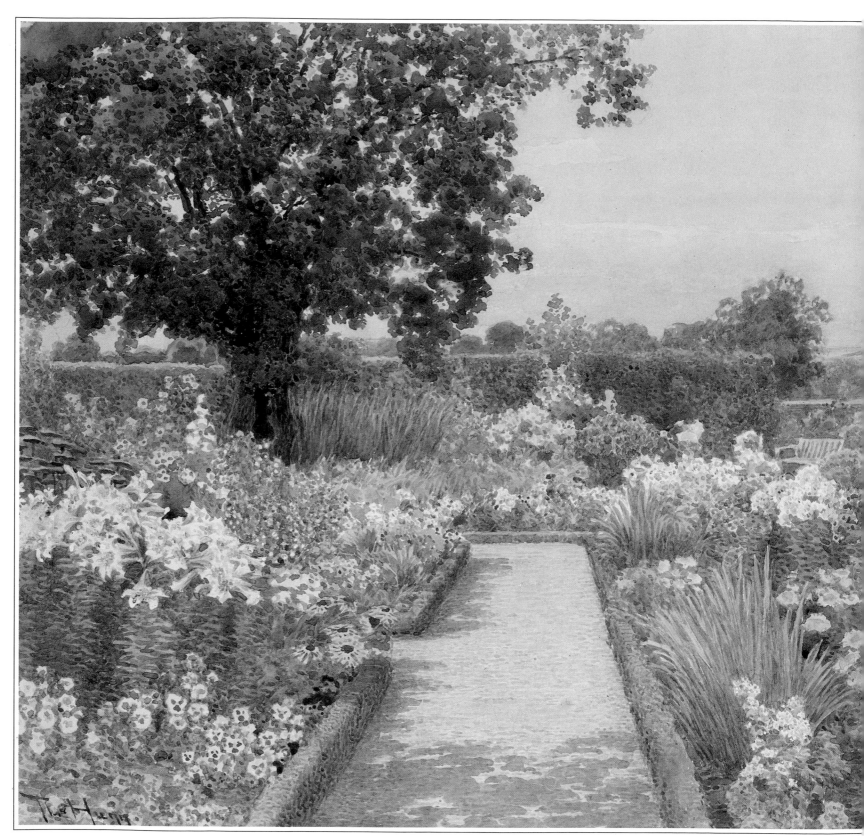

80. Thomas Hunn. *Borders at Great Tangley Manor*, Surrey

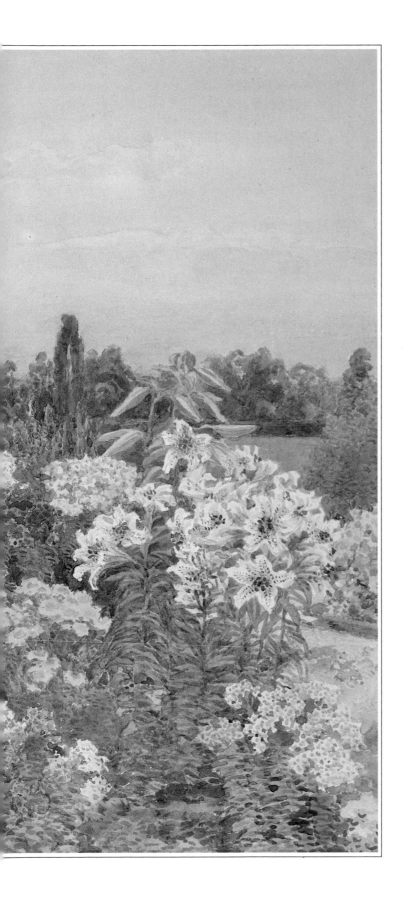

GREAT TANGLEY MANOR

Surrey

The gardens of Great Tangley Manor, lying about three miles east of Guildford and today vanished inside urban sprawl, were laid out for Mr Wickham Flower in the 1880s in much the same spirit as were those at Gravetye Manor by the great William Robinson. Near the house a garden framework of simple geometry permitted beds to be filled to overflowing with a mixture of shrubs and hardy plants all 'arranged' in an informal cottage-garden style. Nearly forty years earlier, hidden down a remote lane near Wonersh Common, the virtually derelict manor and its gardens were already known by Gertrude Jekyll, who was still a young girl and living three miles away at Bramley House. Against a background setting of chestnuts, elms and poplars with old orchard fruit trees, the gardens were a mass of tangled thorns and elders with ground-elder strangling the remaining flowers in the farmhouse garden. The moat was dry and could hardly be traced as a continuous water-course.

This sleeping beauty was awakened in 1884; then the manor house and farm was bought by Mr and Mrs Wickham Flower when the whole property, of which it was a part, came to be sold. The house, built on the site of a hunting lodge of King John, had had its half-timbered front added in 1582 when owned by the Caryl family. The old manor house itself was redesigned and extended for Mr Flower by the architect Philip Webb between 1886 and 1897. At first the west end was extended and a covered way over the moat was built; a library and rooms over it were added in 1897.

The actual gardens at Tangley, except for an orchard area inside the moat to the west and an enclosed courtyard on the southern face, were made on the old farmyard site and laid out under the guidance of Mr Whiteman in 1884. During a six-month period eighteen labourers worked at the development of the six- to seven-acre garden. Their labours included digging out the old dry moat, using the excavated soil to level the adjoining land, and directing water from an existing pond to supply it. Yew and beech hedges were planted to divide the garden areas into sections, further emphasized by a covered way over the moat, the moat itself and a rustic pergola for

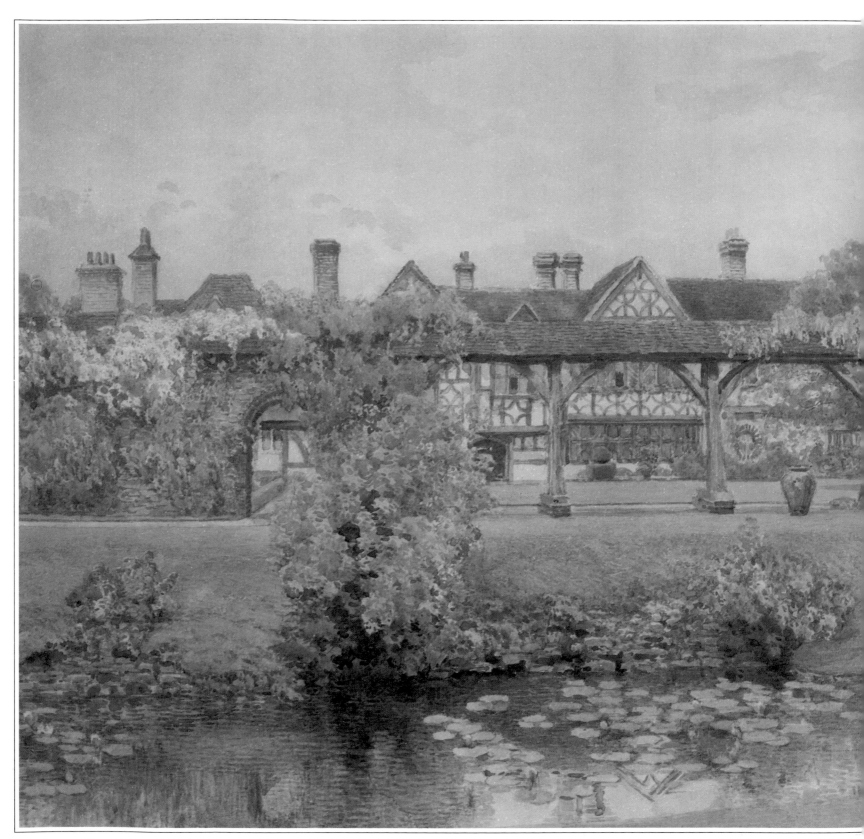

81. Thomas Hunn. *Great Tangley Manor*, Surrey.

climbing roses and vines, very much in Gertrude Jekyll's style. The old courtyard provided walls for more climbers and a sheltered microclimate for tender plants through all the seasons. In *Gardens, Old and New* planting here is described in detail. George Elgood's watercolour of 1899 is the frontispiece to *The Gardens of England in the Southern and Western Counties* (ed. Charles Holmes Studio 1908). Forms of *Iris reticulata* come into flower in very early spring, sometimes with snow still on the ground; myrtle and rosemary flourish; *Iris pumila*, fritillaries, windflowers, asphodels, white and yellow tulips, roses and peonies, with jasmine and wisteria on the walls. Thomas Hunn's painting (plate 80) shows a yew enclosure with one of the old fruit trees still exant. Here box-edged beds contain lilies, irises, larkspurs and Japanese anemones – all hardy perennial plants packed together in Robinsonian style. Beyond the rustic pergola (plate 81) a dell-like rock garden formed from local Bargate stone was further hidden behind thick plantings of shrubs, to come as a complete surprise after the cottage beds of the garden area nearer the house had been explored. A pond to the south-east, parallel to the pergola, fed the moat. In *Some English Gardens* Miss Jekyll describes the planting on its margins as 'now a paradise for flower-lovers, with its masses of water irises and many other beautiful aquatic and sub-aquatic plants; while water-lilies and . . . great groups rising from the water of the white calla, commonly called Arum lily, give the pond a quite unusual interest. To the left is an admirable bog-garden with many a good damp-loving plant, and, best of all in their flowering time, some glorious clumps of Moccasin flower (*Cypripedium spectabile*), largest, brightest and most beautiful of hardy orchids.'

Elgood's watercolour, printed in 1897, and illustrating *Some English Gardens*, showed yews flanking the entrance to the covered way, now after more than a decade covered in twining plants. The yews make a strong background to autumnal flowering of Michaelmas daisies, French marigolds, pink Japanese anemone and white chrysanthemum.

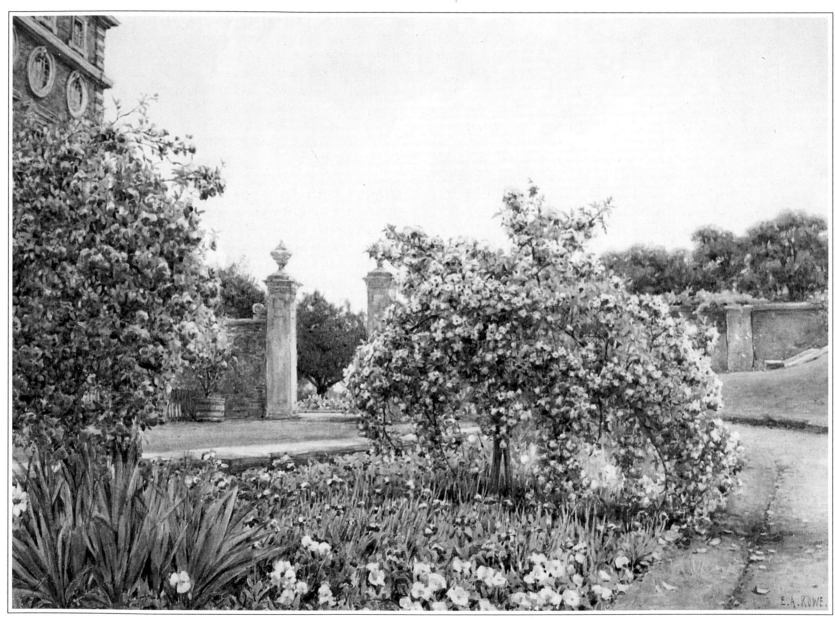

82. Ernest Arthur Rowe. *Walton Rambler and Dorothy Perkins, Hampton Court*, Middlesex.

HAMPTON COURT PALACE

Middlesex

In 1525 Hampton Court on the river Thames, newly acquired from Cardinal Wolsey, became Henry VIII's link with Whitehall. Landing at the Water Gallery on the south-west the King could make his way through the herb gardens to the entrance on the south front. During his first year of possession Henry planted a flower garden, a kitchen garden and two orchards. An arched alley of hornbeams was named Queen Anne's Bower after Anne Boleyn; later the hornbeam was exchanged for wych-elms and the walk renamed for William III's Queen Mary who liked to sew there with her court ladies, overlooking what had become by then the Privy Garden. In this latter garden Henry VIII almost certainly planted evergreens to be trained in topiary shapes. Account books from the 1530s show purchases of 'quicks' and willow-branches and osiers which were used as training frames. By 1599 a German visitor, Thomas Platter, can describe some of the fanciful architectural forms which included 'all manner of shapes, men and women, half men and half horse, sirens, serving maids with baskets, French lilies and delicate crenella-tions all round made from dry twigs bound together . . . and evergreen quick-set shrubs'. Queen Elizabeth visited here first as a princess being imprisoned in the Water Gallery by her sister Queen Mary; later as Queen she enjoyed walking in the grounds in winter 'to catch a heat' and made a knot garden under the south front. In 1638 Charles I diverted the river Colne through Bushy Park to make the Longford river and commissioned Francesco Fanelli to sculpt the Diana Fountain which at first stood in the Privy Garden until moved by Wren to Bushy Park in Queen Anne's reign.

The *patte-d'oie*, the three great avenues of lime trees imported from Holland radiating from the semi-circle before the east front of the palace, were planted by Charles II. He also built the long canal flanked by the central avenue. Evelyn, visiting the park in June 1662, describes the 'sweet rows of lime trees, and the canal water now nearly perfected.' It was William and Mary who made Hampton their chief residence; the south garden near the river was remodelled to become the *parterre* Privy Garden and smaller Pond Gardens; a new Wilderness and Kitchen Gardens were made to the north. Dwarf box hedging, newly available from Holland, was used everywhere in the new Pleasure Gardens. In 1689 Wren was commissioned to rebuild the east front and the King embel-lished Charles II's semi-circle, now to be known as the Great Fountain Garden. Box scroll works in French *broderie* designs, probably by Daniel Marot, with thirteen symmetrically placed fountains all playing vigorously, were set in crushed brick. Yew trees trimmed as obelisks and white hollies trained as globes edged the beds. Jean Tijou made wrought-iron gates for the entrance to the east avenues and a thirteen-foot screen for the southern end of the Privy Garden; the latter was sent to the Victoria and Albert Museum in 1865 but by 1902 was reinstated at Hampton Court where it still remains. Wren also built an Orangery on the south front. Mary died in 1694 and work stopped until the last two year's of William's reign, 1700–72; then the Water Gallery was demolished and replaced by the elegant Banqueting Hall on the riverside and the whole of the Privy Garden was lowered by ten feet to allow a better view of the Thames from the palace. A walk above allowed views over the Broad Walk, which stretched from the Thames across the east façade of the Palace a full half-mile to the Kingston road, as well as down over the Privy Garden itself.

William III also invited Wren to rebuild to the north, but the King died in 1702 before plans were executed; the long northern chestnut avenue stretching from Teddington was planted. The Wilderness between the avenue and the façade had been planned and planted by George London and Henry Wise (see Melbourne Hall, page 169). Yew, holly and box were planted in a geometric pattern. Later, in Queen Anne's time, Wise laid out a labyrinth in hornbeam – the famous Hampton Court Maze (now in yew)—which was planted near the Lion Gate, where it is today. Earlier labyrinths were symbolic rather than designed deliberately to confuse with head-high plants or motives but at Hampton Court 'figure hedge work of large plants' was used from the beginning.

Queen Anne, having taken a resolution 'to restrain the expense of the gardens' and disliking the smell of box,

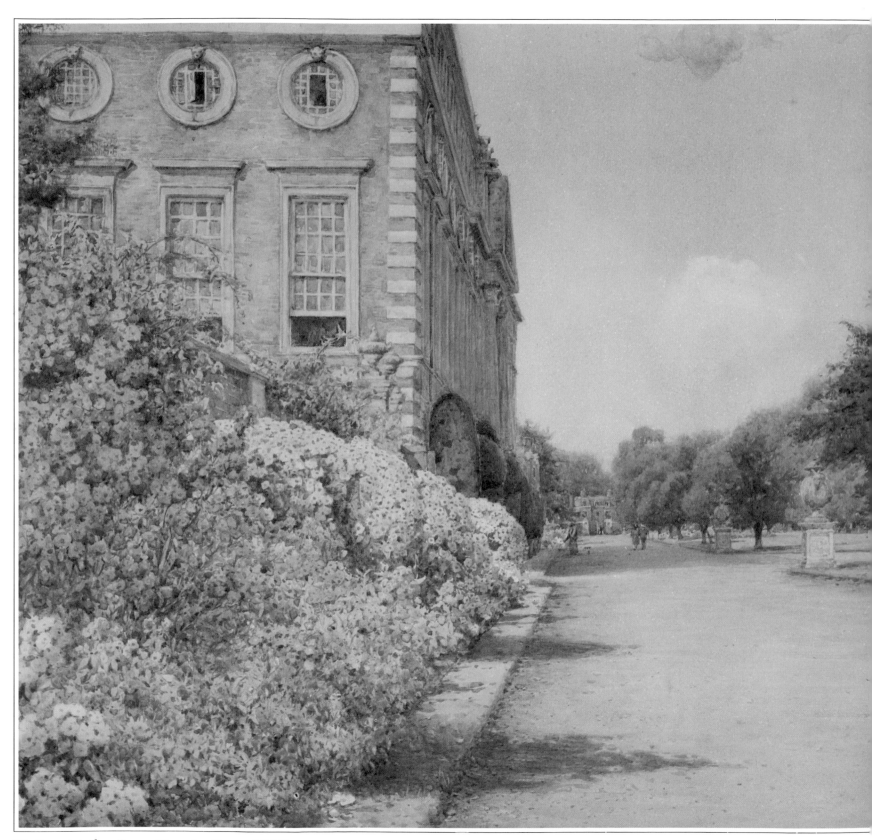

83. Ernest Arthur Rowe. *Hampton Court*, Middlesex.

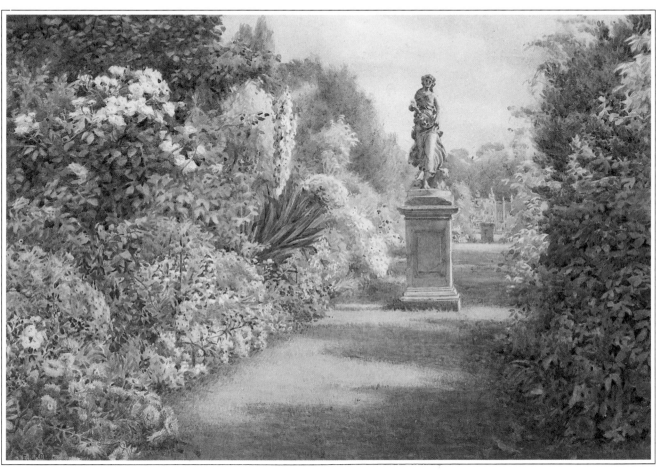

84. Edith Helena Adie. *Hampton Court*, Middlesex.

commenced on alterations to the Great Fountain Garden. The outer ring of fountains was removed, lime trees brought nearer and grass plots, still edged with the original yews and hollies, replaced the box scrollwork. King George II's Queen Caroline introduced more lawns, and, in particular, simplified the elaborate scrolls in the Privy Garden, replacing gravel with grass. In 1764 George III invited Capability Brown to improve the grounds, but he preferred to be excused 'out of respect to himself and his profession.' Instead, in the Privy Garden, steps were removed and replaced with sloping grass banks; the Great Vine was planted near to Queen Anne's Orangery, at the edge of the Pond Gardens. This Black Hamburg vine was taken as a cutting from one at Wanstead in Essex.

By 1838 Queen Victoria threw open Hampton Court and Bushy Park to the public; in 1890 carpet bedding embellished the Great Fountain Garden. J. A. Gardiner, curator from 1897 to 1907, ably encouraged by Ernest Law, an early Robinsonian disciple, tried to introduce more naturalistic planting in the beds. Law, writing early in the twentieth century, deplores the insistence of the public in showing a preference for the formal style: 'attempts to follow fluctuating follies of successive fashions in gardening ... by efforts to vie with the costly pretentiousness of the modern style', condemning it as extravagant as well as incongruous to 'the character of the place'. Later in 1924 Law himself planned and planted a Knot Garden in appropriate Tudor style beyond the Pond Garden near Queen Anne's red brick Orangery. By 1923 Law was able to praise new schemes along the Broad Walk, where William Robinson's influence had triumphed. Hardy herbaceous plants, with grouping for height and colour, had been introduced into the wide borders. These schemes had been in place for some years already; the border between the south-east corner of the palace and the Water Gallery above the river was called the Herbaceous Border and was planted only with hardy perennials; the wider border, leading from the north-east to the 'Flower Pot' Gate on the Kingston Road, was 'mixed' with annuals still used to augment the perennials, so partly satisfying the formalist and those of more 'natural' school. William Cobbett, the fiery pamphleteer, wrote in 1819 in *The American Gardener* of golden rod growing in the rich soil of the Hampton Court borders to the height of five or six feet: 'it nods over the whole length of the edge of a walk, three quarters of a mile long and perhaps thirty feet wide – the most magnificent border, perhaps, in Europe.' *Solidago*, a wild flower in the eastern American states, was regarded, especially by American farmers, as a torment: 'that accursed stinking thing, with a yellow flower, called the "Plain Weed".' Perhaps Mr Law shared the prejudice; by 1923 there is only one clump of golden rod in the whole length of the border.

Rowe's painting (plate 83), probably executed in about 1921, shows a section of the Herbaceous Border in front of the eight-foot wall which separates the Privy Garden raised walk from the Broad Walk. In his other picture (plate 82) he looks out on to the Broad Walk from inside the Privy Garden. Wren's original wall of crimson and purple bricks with Portland stone coping was replaced in the nineteenth century with one of the same height built in the less attractive yellow London stock. Law gives detailed planting plans which more or less tally with Rowe's almost contemporary painting. A group of tall blue Michaelmas daisy, *Aster* 'Feltham Blue' (a garden cultivar of the north American *A. novi-belgii*), clumps of pink dahlias, scarlet and white phlox and the magnificent yellow *Coreopsis grandiflora*, with the smaller European *Aster amellus* at the further end, are all identifiable and can be checked with Law's list. Planting in 1988 is very similar in theme. Rowe's painting from inside the Privy Garden shows standard roses 'Dorothy Perkins' and 'Waltham Rambler' flowering above dianthus and iris in a bed just below the raised walk. The popular rambling rose, 'Dorothy Perkins', a hybrid *wichuraiana*, was introduced in 1901. 'Waltham Rambler', a multiflora hybrid from William Paul's nursery, was in commerce by 1903. E. H. Adie's painting (plate 84) of the garden in the 1900s shows an inner view of the Privy Garden, where grass alleys separate beds filled with shrubs and perennials appropriate to the four seasons. Statues of the Seasons, partly concealed behind the luxuriant planting allow views the length of the garden to Tijou's screen by the riverside. Four statues were commissioned from the sculptor R. Jackson in 1866 but only those of Spring and Summer were ever completed. The painting shows 'Summer' raised on a plinth. Roses, delphiniums, *Erigeron*, a yucca and a late-flowering rhododendron give much the same effects as are still observed and enjoyed in the 1980s.

HARDWICK HALL

Derbyshire

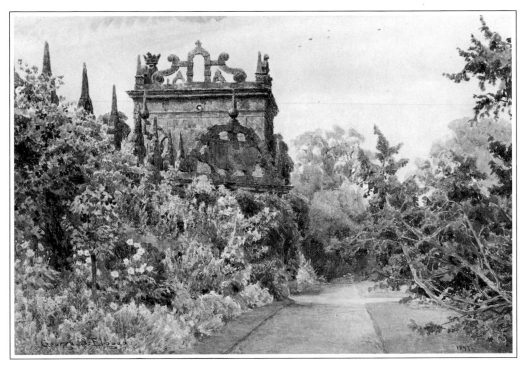

85. George Samuel Elgood. *The Forecourt, Hardwick Hall*, Derbyshire.

The masterful Countess of Shrewsbury, known as 'Bess of Hardwick', left a legacy of fine houses to posterity. The old house at Chatsworth, Bolsover on the same high ridge as Hardwick looking westward to the Matlock Hills, the less imposing manor house of Oldcotes and Hardwick itself, completed in 1597, with her initials 'ES' carved in stone, blazoned across the balustrading of the roof line. Inevitably, by the mid-1800s the same initials appeared as a massive monogram in bedding on the lawn in the west court.

In the nineteenth century the basic garden framework remained much as it was laid out in the sixteenth century (see also Montacute House, page 171); it still remains so. The imposing gatehouse and walls which surround the forecourt are contemporary with the house; the latter topped with elaborate carved finials. In 1832 Lady Blanche Howard planted the

Lebanon cedars and it was she who made the parterre, incorporating the monogram of the famous Bess to match the stonework on the roof. This bedding scheme remained at least until the early 1900s. By the late 1860s garden fashion dictated a return to some sort of internal division of space more closely related to sixteenth- and seventeenth-century designs, whether Italian or French inspired – in this case entirely appropriate to the style of the late Elizabethan house. Flat areas could become a series of alleys and enclosures to give a sense of privacy and mystery quite lacking from the English idea of the Italianate parterre usually set on an open terrace before a house. At Hardwick, of course, the parterre, in front of the main entrance and visible from the upper floors, was already in a walled forecourt. Lady Louisa Egerton, daughter of the Seventh Duke of Devonshire, laid out the eight-acre enclosure

to the south. An article in the *Journal of Horticulture* of 1875 describes this new design: 'It is divided into four parts by avenues of Yew and Hornbeam hedges running north and south and east and west, the grass walks between them being 20 feet wide and in excellent condition. The first part contains the croquet ground, surrounded by fine evergreens and conifers . . . The second part, which is in close proximity to the house, is a fruit orchard, and Apples, Pears, and plums are well presented. The third is chiefly taken up with Filberts and other fruit trees; the fourth is entirely devoted to vegetables.'

By 1892 Blomfield can write of the life-size lead figures which, framed in niches cut in the yew, stand on pedestals at the *rond-point*, where hornbeam and yew hedges intersect: 'one figure represents painting, another a young man playing a shepherd's pipe, the third a female figure with a violin, the fourth a figure with a trumpet.' It is a corner of the *rond-point* in the south garden which is portrayed by George Elgood (plate 85) in 1897. The view to the north looks back along the yew alley to the Hall (plate 86).

Today at Hardwick Hall, given to the National Trust in 1959, this part of the garden looks identical. The lead figures still rest on their pediments, and tall fruit trees – old varieties which could have been there in the nineteenth century – break the line of the hedge to the east. By the 1950s the hedges, after some war years of comparative neglect, were in need of severe pruning. The yews were tackled first; each plant was 'stumped' back to its main trunk, the base cleaned of weeds and given rich feeding. By 1961 it was possible to give the hornbeams similar treatment. By this time the hedges had not only grown too wide and high but leaned over the green alley, ruining much of the grass and altering perspective and scale. Within a few years of fresh growth the hedges look mature and healthy, and resown grass has restored the long alleys to the way they appeared in the 1890s. To the west the nuttery, with an increased range of filberts and some young walnuts, still exists. In this area the Trust have enriched the garden with an ornamental herb garden, designed as a geometric pattern. Corners are accentuated by hop plants, both green and golden-leaved forms, growing on tall tripods.

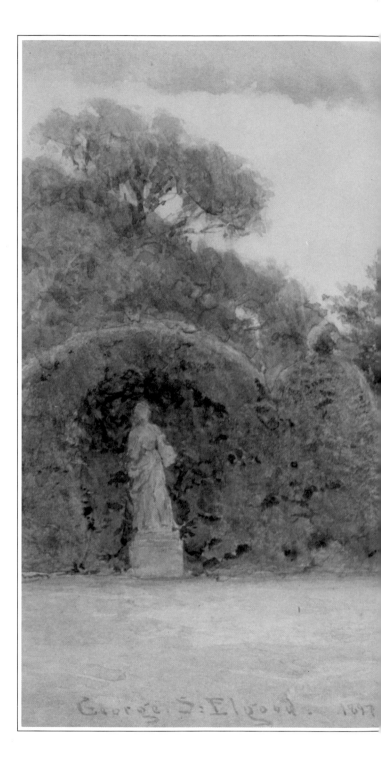

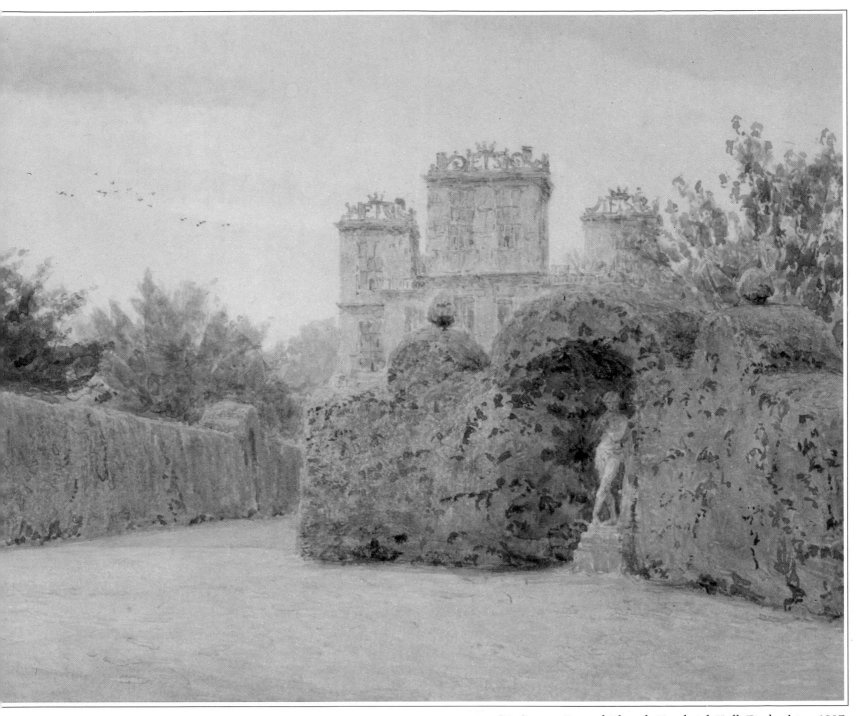

86. George Samuel Elgood. *Hardwick Hall*, Derbyshire, 1897.

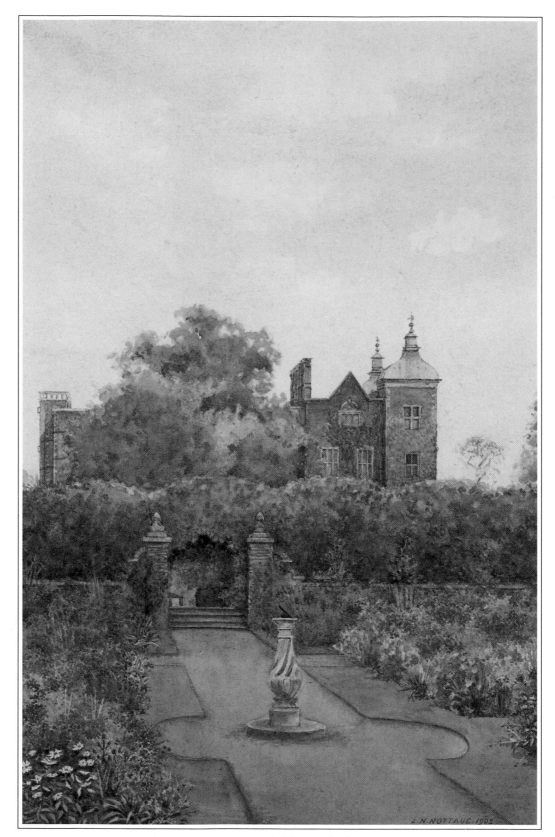

87. L.N. Nottage. *Hatfield*, Hertfordshire, 1902.

HATFIELD HOUSE

Hertfordshire

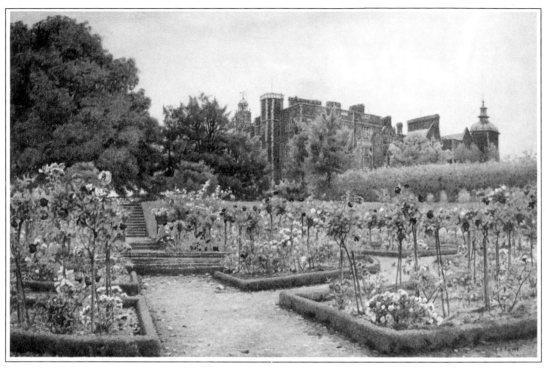

88. Ernest Arthur Rowe. *The Rose Garden, Hatfield*, Hertfordshire.

Hatfield House was built in 1607, when Robert Cecil, Earl of Salisbury, exchanged his London house at Theobalds for the old Tudor palace where the young Princess Elizabeth had been held a prisoner until her succession in 1558. The site of the new house was on an eminence above the earlier palace. On its eastern side, which contained the private apartments, a series of terraces were constructed; below these a water parterre and fountains provided a theatrical spectacle for *fêtes-champêtres*. Unfortunately, although the artificial 'puddled' lake remains at the bottom of the slope, no trace of the more elaborate waterworks survived the century. On the west, quite differently, the gardens were enclosed, inward-looking and of more domestic style; orchards and kitchen areas had extended from and surrounded the Tudor

buildings. These areas far below the level of the new house were kept more or less unchanged in layout and in atmosphere. The three paintings illustrated, dating to the early 1900s, were all done in this part of the garden where one of the four mulberry trees planted by King James I survives to this day.

In the early Victorian period, garden owners and architects became interested in recreating layouts appropriate to the period of the house; this was especially true for Tudor and Jacobean houses, for which plenty of contemporary literature and descriptions existed. If no plans were extant for a particular house, enough was known of the style for gardens to be terraced and compartmentalized to forms which existed before the Landscape movement had obliterated all traces of formality; if necessary a knot, a maze or French *broderie de parterre*

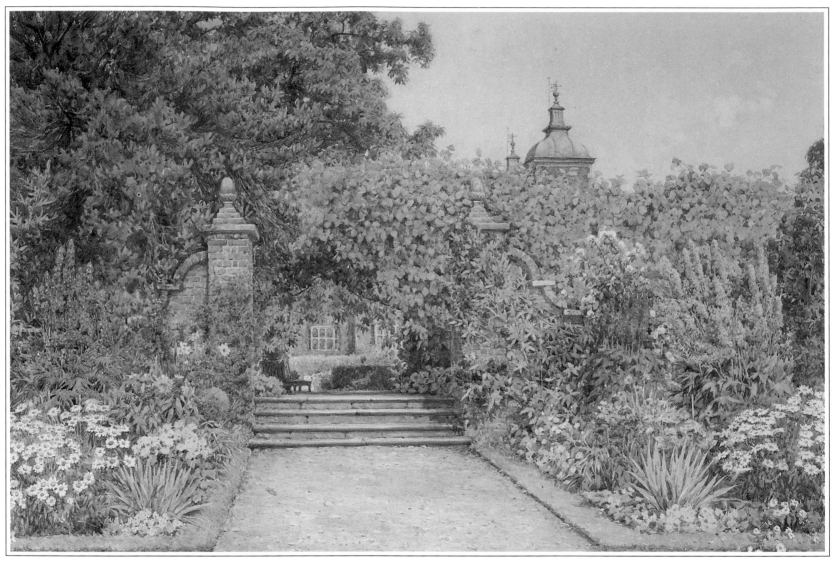

89. Ernest Arthur Rowe. *July, Hatfield*, Hertfordshire.

could be copied from sixteenth- and seventeenth-century pattern books. Often genuinely old features existed which were incorporated in the restoration work. At Trentham, Cliveden and Shrubland architects such as Charles Barry looked farther afield for inspiration and interpreted Italian Renaissance garden styles with monumental stonework and vast parterres to match the enlarged mansions after they had been done over in Italianate style. In these there would be no attempt to pretend a garden actually dated to an earlier time.

In the eighteenth century the grounds at Hatfield were landscaped up to the walls of the house and by the 1840s little remained of any garden layout except old lime avenues which stretched from the north and south façades. The Second Marquess of Salisbury restored the east and west terraces in the 1840s. North and south courtyards were extended with elaborate balustrading and gateways. On the main terrace to the east he laid out box-edged beds in a formal pattern; the maze of yew below was planted in time for a visit of the young Queen Victoria in 1848; by the end of the century it was being taken for genuine seventeenth-century design. The Second Marquess widened the west terrace and below it, the Privy Garden. Where pleached alleys of lime (seen by Loudon in 1825) surrounded the privy garden, he planted a hedge of yew to enclose a central sundial and flower-beds. This is the view painted by L. N. Nottage (plate 87) in 1902. To the north-west, below the chestnut trees, a sunken rose garden was laid out in front of the old Tudor palace. Roses, standard and lush, probably old hybrid perpetuals and teas, were set in box-edged beds. Rowe painted this rose garden (plate 88) and a further view to the west of the Privy Garden (plate 89) in 1908.

The main layout at Hatfield has changed little in the last hundred years, but the present Marchioness of Salisbury has radically restored the planting patterns and plants to schemes which retain a link with the historical context of both Tudor palace and Jacobean house. Today a knot garden and labyrinth lie beside the Tudor building and a fragrant garden is laid out in the area below the Privy Garden. Interest in the seventeenth-century garden is stimulated by its importance as the place where many plants newly introduced by both the elder John Tradescant and his son, John the Younger, were first grown in England. The elder John was head-gardener at Hatfield, later Royal gardener and finally the first Curator of the newly founded Botanic Gardens at Oxford. He and his son travelled widely, the elder in Europe and as far as Russia, the younger in the eastern states of America. Tulips and anemones came from Holland, pomegranates, figs and rare shrubs from Monsieur Robin in Paris and lilies from Constantinople. From America John the Younger brought back 'ferns and reeds, cypress, jasmine and columbine.' By the 1980s Lady Salisbury had once more collected many of the Tradescant plants at Hatfield; this adds considerable botanical interest to the garden. The gardens now, appropriately linked with history, are also a superb example of a modern or almost timeless English planting style where beds and borders, formally hemmed in by low box hedges and a firm design, are filled with vigorous hardy plants which bring colour and scent throughout the summer months; against the walls fruit trees, trained in cordon and espaliered shapes, serve to extend the formal element in the same way that they will have done in the seventeenth-century garden.

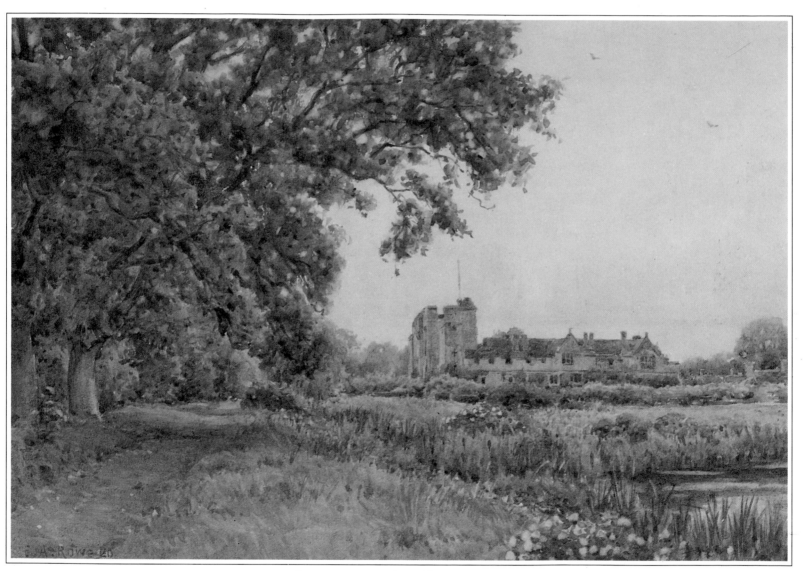

90. Ernest Arthur Rowe. *Diana's Walk, Hever Castle*, Kent, 1920.

HEVER CASTLE

Kent

Hever Castle has had three main periods of building. In 1280 the massive Gatehouse and walled bailey, surrounded by a moat crossed by a wooden drawbridge, was a fortified refuge. By 1500 the Bullen family felt secure enough to add a comfortable dwelling house within the curtain walls. Its last expansion dates to William Waldorf Astor's acquisition in 1903; at that time both castle buildings and garden were lavishly extended; it is Mr Astor's mature garden that visitors can see today. Ernest Arthur Rowe, who lived near by, painted scenes from it soon after it was laid out; those illustrated were done in 1920.

From 1749 until 1903 the castle was nothing but an almost derelict ruin, its sandstone walls and moated setting appealing to painters of romantic landscapes and lovers of the picturesque. For Mr Astor the empty garden canvas provided the perfect background to his ideas: to build an intimate Tudor-style garden, appropriate in date to its connection with Henry VIII and Anne Boleyn, near the castle; to provide a suitable Italianized site for his collection of Classical Roman and later Italian antiquities; and to frame the romantic castle with a great landscape in which exotic and native trees and plants could thrive and be displayed as specimens. Mr Astor became Viscount Astor in 1917 and his younger son was given the title of Lord Astor of Hever in 1956.

William Waldorf Astor developed a passionate love of Europe during a period as American Minister in Rome, from 1882 to 1885; finally he became a naturalized British subject and moved his vast fortune from America to England. He bought Cliveden on the Thames at Taplow first; ten years later he bought Hever. He employed F. L. Pearson to build him a Tudor-style village just across the moat to the north-west, and connected with the castle by a covered way. Eight hundred workmen took three years to build the replica village; a further 748 labourers dug the new lake and made the garden over three years. Mr Astor employed Joseph Cheal from Crawley, nurseryman and landscaper, for this work. This firm had created a formal garden round the ruins of Kirkstall Abbey in 1893.

The new Tudor-style gardens south-east of the castle moat were appropriately divided into intimate compartments partly surrounded and linked by a pergola draped in wisteria. Planting was period but not entirely accurate. Golden yews unknown until the middle of the nineteenth century were planted to be clipped as topiary chessmen (the actual pieces copied in design from a sixteenth-century chess set in the British Museum). By today, in Anne Boleyn's garden, herbs and roses, augmented by pelargoniums, grow in box-edged beds; in another area orange gazanias, cannas and heliotrope are more garish. A fine maze in English yew, laid out in 1906, represents an eclectic Victorian and Edwardian taste for a historical style rather than the more accurate planting restoration which would be undertaken today. Orchards by the moat are filled with golden daffodils in spring. Farther away across the outer moat to the south-west, the Italian garden with distant colonnaded loggia and piazza terraced above the lake recalled Mr Astor's visions of Renaissance Italy, and provided sites for antiquities acquired during his service there. Here the garden seems designed as a museum, not primarily for rare and beautiful plants, but for a display of his collection of stone and marble. A south-facing buttressed wall of golden sandstone, steps, recesses and pergolas, where much of this work was clustered, also provided a framework for wall shrubs and climbing plants, which nearly a century later threaten to engulf the ancient relics. On the southern side of the Italian garden a pergola stretching the length of a shady wall hid secret grottoes, inspired by the Gallery of a Hundred Fountains at the Villa d'Este. The banks of the new thirty-five-acre lake, its water-level replenished from the river Eden (a tributary of the Medway which flows below Penshurst, only a few miles away) were planted with native willows, ash, beech, cherries, lime and poplars. Carpets of spring bulbs, rhododendron walks and rockeries provided sites for interesting and exotic plants and trees. Rowe's paintings are of the garden at Hever in 1920. He shows the Half-moon Pond (plate 92) backed by a ring of columns and an outer high hedge of yew. A statue of Neptune is poised by the water's edge. Today the columns have gone and a Roman

Venus stands more serenely on the wide curving steps. In Rowe's time box-edged beds contained spherical clipped box bushes and the beds on the Cascade Rockery, on the knoll beyond the pond, were backed by native trees. Today the formal beds contain massed planting of the crimson-flowered 'Rosemary Rose' punctuated with standard fuchsias; the Rockery, bright with azaleas in May, is dominated by a fine evergreen oak and other trees which have grown larger in the intervening years.

Behind the Half-moon Pond the oblong Italian garden stretches towards the loggia and lake. Two yew alleys cross its width, the tall dark hedges providing background frames for the antique statues and urns. Rowe painted the ornamental wall (plate 91) on which sit a pair of gigantic oil jars and a central statue, at the back of the first alley. Peacocks stroll on the lawn and the south pergola frames a niche in the wall. The third painting (plate 90) is different; in it Rowe has chosen as his subject the banks of the river Eden to the north of the castle far from the modern Edwardian garden. In this spot nature survives untouched by garden fashion.

The Italian gardens remain much as Cheal devised them. The clean stonework portrayed by Rowe has gathered moss and lichen; among the crumbling columns and the odd Roman sarcophagus, plants – many of them tender and exotic – stray and ramble as they might in real Italian gardens to give an atmosphere of maturity. Today, to please large numbers of visitors (and much as they do in old gardens in Italy), professional gardeners add pockets of bright annuals to grow at the base of the warm walls. The Hever style of 'Italianate' gardening lacks the grandeur and extremes of Trentham and Shrubland; in scale it is much more nearly related to the 'real' thing and concentrated on good proportions and design features rather than providing a vast frame for bedding-out schemes and horticultural ingenuity. The greatest incongruity at Hever remains the lack of a great villa which, linked in scale and alignment to the Italian garden, should form part of the overall conception. In 1904 Edith Wharton published her *Italian Villas and Their Gardens*; in this she reminds a garden-

91. Ernest Arthur Rowe. *Italian Gardens, Hever Castle*, Kent, 1920.

92. Ernest Arthur Rowe. *Half Moon Pond, Hever Castle*, Kent, 1920.

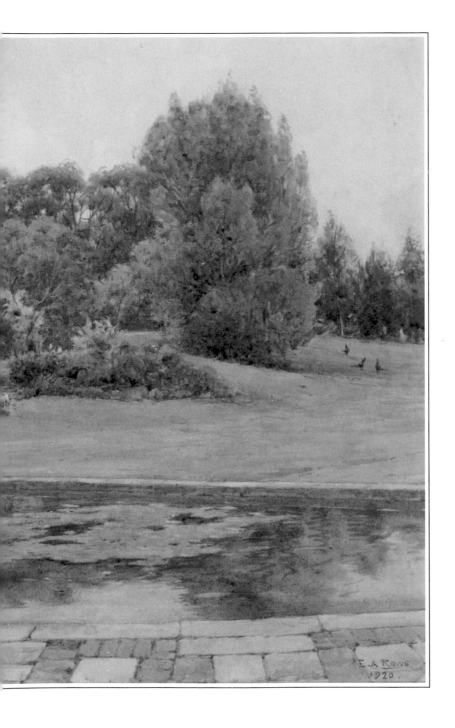

maker of the importance of classical design proportions as well as its adaptation 'to the architectural lines of the house it adjoined'. She offers further guidelines, but writes too late for William Waldorf Astor: 'The Italian garden does not exist for its flowers; its flowers exist for it; they are a late and infrequent adjunct to its beauties' and – still more tellingly – 'a marble sarcophagus and a dozen twisted columns will not make an Italian garden'.

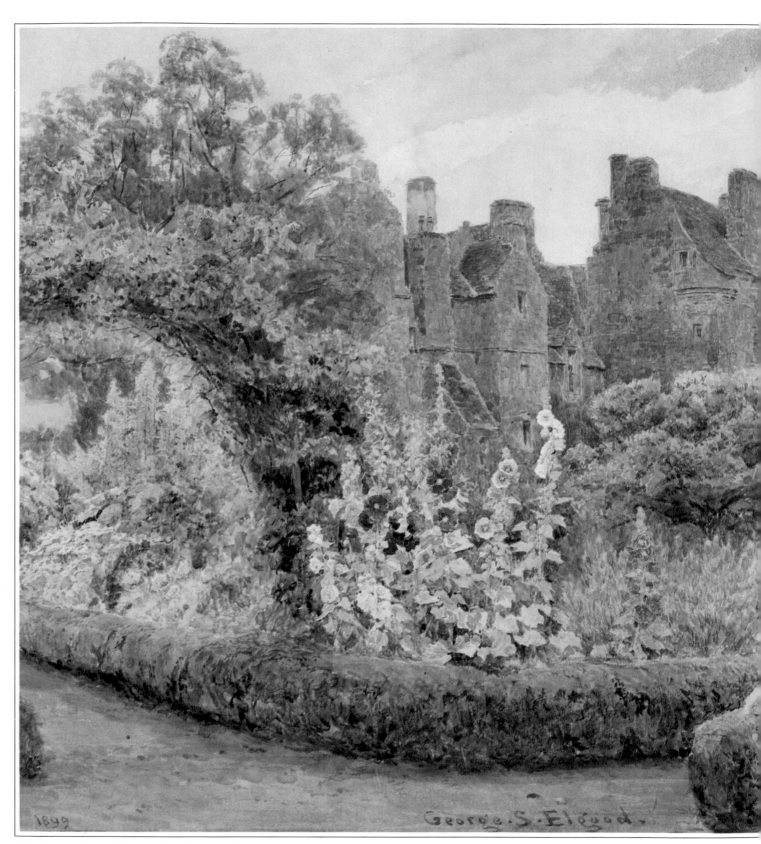

1899 George S. Elgood.

93. George Samuel Elgood. *Kellie Castle*, Fife.

KELLIE CASTLE

Some part of Kellie Castle probably dates from the fourteenth century, its north-west tower having been the original square fortified keep, but much of the rest was completed by the early seventeenth century. It lies very close to Balcaskie, near the fishing village of Pittenweem in the East Neuk of Fife, where a broad chunk of land, bounded by the Firth of Forth to the south and the Tay to the north, projects into the North Sea. The surrounding landscape is bleak. Sky, land and sea give an atmosphere of openness to contrast with the defensive air of the exposed castle and the walled enclosure which is its garden.

First owned by the Seward family, then their Oliphant cousins who were in possession until 1633, Kellie was bought by the Erskines, later created Earls of Kellie; their title passed after 1829 to the Earl of Mar whose family held it until comparatively recently. In that year a great auction, known locally as a 'muckle roup', dispersed all the furniture, tapestries, pictures and other movables, much of them being acquired by the Anstruthers at neighbouring Balcaskie (see page 96). From then for more than forty-five years the castle, treated as a farmhouse or bothy for agricultural labourers, fell into ruin, even the outer garden wall hardly surviving years of neglect and vandalism. In 1878 Professor James Lorimer (father of the artist John Lorimer and the architect Robert Lorimer) became the tenant and started the laborious process of restoration. In 1948 the Lorimers finally bought the castle and in 1971 Hew Lorimer, the sculptor and son of Robert, handed it over to the National Trust for Scotland. He still lives in the castle.

The garden layout at Kellie, lying within a curtilage wall, was never extended to parkland beyond. Only a narrow belt of trees – mainly ash, beech, sycamore and wych-elms – protects the northern boundary of the garden from the winds. To the east, south and west farmland is cultivated up to the property walls. The castle itself lies so that its northern face occupies the south-west corner of the garden which – starting as a rectangular framework – projects eastwards far beyond the width of the house, the walls finally curving round to close off the fields

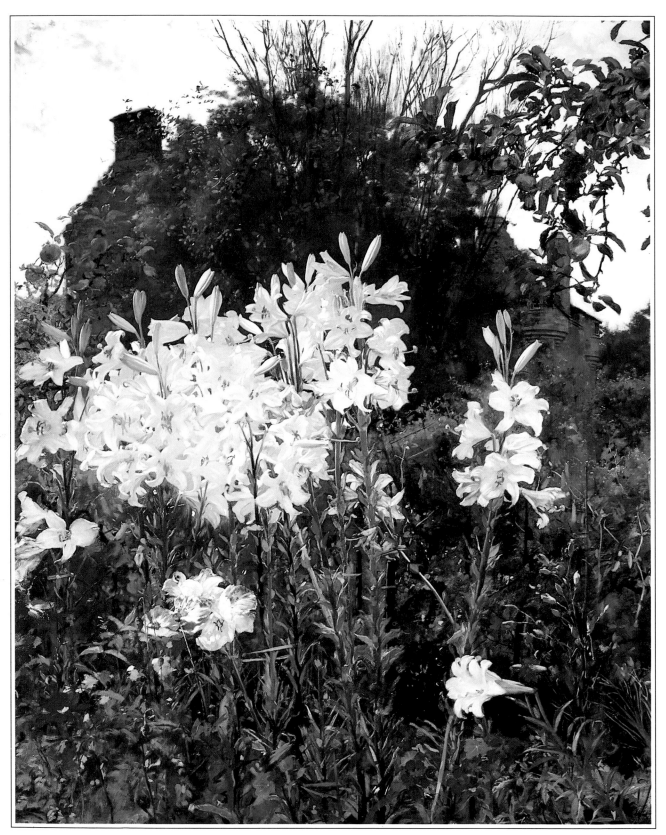

94. John Henry Lorimer. *Kellie Castle*, Fife, 1892.

beyond. Inside this area the garden is divided into compartments, probably closely resembling a seventeenth-century layout where ornamentals and useful plants are pleasantly associated as they would have been when the castle still maintained its fortress-like attributes. As Sir Robert Lorimer wrote 'One of the characteristics of Kellie is the fact that the walled garden enters direct out of the house, and that the flowers, and fruit, and vegetables are all mixed up together.' The Lorimers, having obtained their long lease, set out to recreate the gardens in this spirit. Archways of clipped yew, arches of rambling roses, thick wide box-edging and plenty of 'old-fashioned' plants in borders backed by espaliered fruit turned a wilderness into a garden paradise. Later, after his father's death, Sir Robert emphasized the Victorian characteristics of the garden and made a notable collection of period roses. By 1971 many of the Lorimer garden features were already old and needing replacement; there had been some years' neglect. This involved the Trust in a new restoration programme and it is as a Victorian garden that Kellie Castle is seen today.

John Lorimer's painting of 1892 (plate 94) shows a fine group of *Lilium longiflorum*, the white trumpet lily; it is quite likely to have been started in pots and planted out just before flowering time, in July or August. Given good drainage it is hardy, but if left in the ground it seldom makes such a good show as after the first season. Today the royal lily, *Lilium regale*, only introduced in the first years of this century, would be planted instead. When George Elgood came to paint a corner of the garden a few years later, in 1899 (plate 93), Professor Lorimer was dead and his widow lived in the castle. The picture shows box-edged beds bright with hollyhocks and Shirley poppies; rose bushes, tall plumed poppies, *Macleaya microcarpa* and a rose trained over a metal archway are all seen against the background of the old grey castle. Miss Jekyll describes how elsewhere in the garden vigorous roses, often with *Polyantha* ancestry, are 'balloon'-trained over a framework formed from a central post from which hoops are hung one above the other. Miss Jekyll gives a list of 'other flowers beautiful in such gardens' and also lists roses 'which should be in these good gardens'.

These descriptive lists have been the basis of the National Trust for Scotland's replanting schemes at Kellie. Today *Lavatera* partly replaces the disease-prone hollyhocks, but scented *Dianthus* 'Mrs Sinkins', phlox, sidalceas, oenotheras, *Erigeron*, galtonias and Shasta daisies are all in period and old apple and pear trees make frames for rambling and climbing roses. As in the past the bed at the base of the long south-facing wall is used for vegetables and fruit, including fan-trained 'James Greeve' and Victoria plums. In the south-east corner behind thick yew a hidden garden with pillars of honeysuckle and roses makes a fitting site for a sculpture of a basketwork stone vase by Hew Lorimer.

KILDONAN LODGE
Sutherland

The Duke of Sutherland (see Trentham page 83) built Kildonan as a shooting lodge in 1896. The gardens surrounded by heather-covered hills lie at an altitude of 225 feet in the valley of the River Helmsdale. They were laid out by a later owner, a Mr Hickman, in the early 1900s; a woodland shelter-belt was planted to the east, giving some protection from bitter winds which blow straight off the North Sea barely ten miles distant. The soil is acid but fertile and free of stone outcrop; this valley once supported a thriving agricultural community until sheep farming in the 1820s made cultivation uneconomical for landlords. Winters are cold and last long in the northern part of Scotland – temperatures of as low as 8°F are not uncommon; but long hours of daylight during the summer months compensate for the shorter growing season. Hardy perennials and summer-flowering annuals do well here and their peak flowering performance, at least four weeks later than in an English garden, coincides with the owner's visit in August and September.

The two-acre garden is of formal terraces above a flat square area. Long straight gravel paths run between herbaceous borders and beds of annuals. Rose-beds and a large rock garden provide extra colour. The style of planting today is little different from that in 1914, when George Elgood came to paint here. His picture is an evocative portrayal of a Scottish scene (plate 95); he deliberately contrasts the atmosphere of wild landscape with luxuriant border planting; the misty hills and clouds make a romantic backdrop to groups of pale and dark blue delphiniums. In real life the garden layout at Kildonan is much more formal and restrained, a tame reproduction of Elgood's exuberant planting scene. The success of gardening in this windswept spot depends to a considerable extent on adequate staking and tying, a practical aspect of which there need be no visible trace in a painting. One feels Elgood 'took' this picture at a peak flowering period in July; delphiniums, sweet williams and foxgloves are in bloom; in even a few days flowers will fade and this area of the garden will be over for the season. Fortunately the garden is maintained to a high standard by the present owner, Mrs Anne Claye.

95. George Samuel Elgood. *Kildonan Lodge*, Sutherland, 1914.

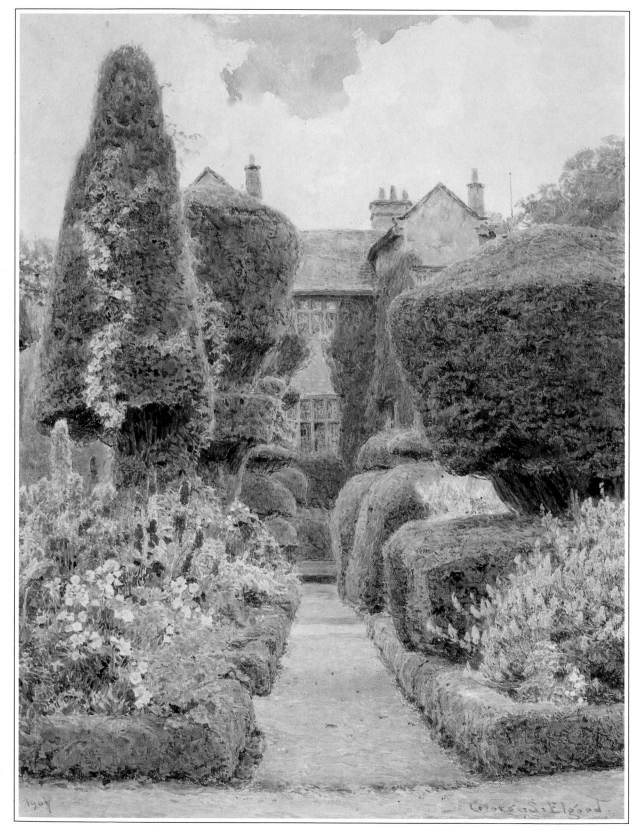

96. George Samuel Elgood. *Avenue at Levens Hall*, Cumbria.

LEVENS HALL

Cumbria

The garden at Levens Hall in Cumbria was designed for Colonel James Grahme in the last decade of the seventeenth century by a Frenchman, Guillaume Beaumont. The making of the garden and the park across the main road to the east is exceptionally well documented; old papers and accounts remain in the house. The garden in 1900 and today is divided by yew walks and is roughly as Beaumont planned it, its layout typical of a seventeenth-century small manor house garden. To the east a broad terraced walk runs the length of the garden. An important feature is a central beech alley, framing an old cedar by the house to the north, and opening out to the south into a roundel, arches allowing vistas east and west. To the west the view over the great Bastion, one of the earliest ha-has in England, stretches to Whitbarrow Scar at the edge of the Lake District. Apart from this the garden was planned to be inward-looking, its elaborately clipped topiary 'furniture' a total contrast to the wild romantic landscape in which it is set.

Levens is the most famous topiary garden in England. No other garden except perhaps Hampton Court has retained so much of its original layout and so many of the originally planted yews for almost three hundred years. Although additional yew and box specimens were added in the early nineteenth century (all the golden yew was planted at this time), and those still existing were reshaped, the essential character of the garden had survived through a hundred years of comparative neglect. By 1892, when Elgood painted the garden, nine miles of trim boxwood still edged flower-beds where fantastic shapes in yew and box remained virtually as first envisaged, although grown and enlarged over the centuries, and added to by Alexander Forbes, head-gardener at Levens from 1810 to 1862. In 1988 there is little obvious change, although planting round the base of the topiary specimens is in a new and simpler style.

In one of the views (plate 96), Elgood portrays a yew- and box-lined alley aligned on the east wall of the L-shaped hall, and a tall yew obscures the thirteenth-century pele tower about which the grey stone house was built. Delphiniums (plants which Elgood loved to paint), yellow tree lupins and other perennials spill over the box hedging. The second painting (plate 97) looks almost in the opposite direction; in it the wall which separates the gardens from the main road and park is clearly visible; its position unaltered since 1690, although now most traffic follows a motorway route on the eastern side of the park. Flower-beds of roses, grey-leaved white-flowering *Dianthus* (could it be the scented 'Mrs Sinkins' introduced in the nineteenth century?) and more delphiniums contrast with massive and spiralling shapes. Planting contemporary with the new garden in 1690, although different in detail, will have been very similar in flowery effect; hardy herbs for culinary use will have jostled rose bushes and plants with scented leaves and flowers. When Miss Jekyll visited Levens the head-gardener was Mr Gibson. In the same year that *Some English Gardens* was published, *The Topiary Garden* by Curtis and Gibson also came out. Gibson writes the end part of the book, which is chiefly about maintenance of yew and box topiary. In this he recommends that massed annuals would be the best foil to the shapes at Levens, particularly suggesting the luminous blue *Salvia patens* – 'the brilliant blue of flower against the dark green of the yew trees has a very striking effect indeed'. He also suggests the scarlet cardinal flower, *Lobelia cardinalis*. Gibson also says that box in his care at Levens, which had not been relaid for nearly one hundred years, was still in good order.

Today the topiary remains and planting in the beds surrounding it is much as Gibson recommended; most effective is massed planting of the annual mauve-blue *Verbena rigida*, which flowers for three summer months and gives an uncluttered setting to the clipped topiary; in winter, tulips or wallflowers serve a similar purpose. These are ephemeral and seasonally fleeting effects; what counts and gives Levens its peculiar atmosphere is the massive shapes which frame and guard the austere grey house. These 'bushes cut into globes and cones, or even Judges' wigs and grotesque birds' in green and golden yew, spirals, umbrellas, chessmen, cottage loaves, high hats on tall trunks and more solid cubes with straight tops

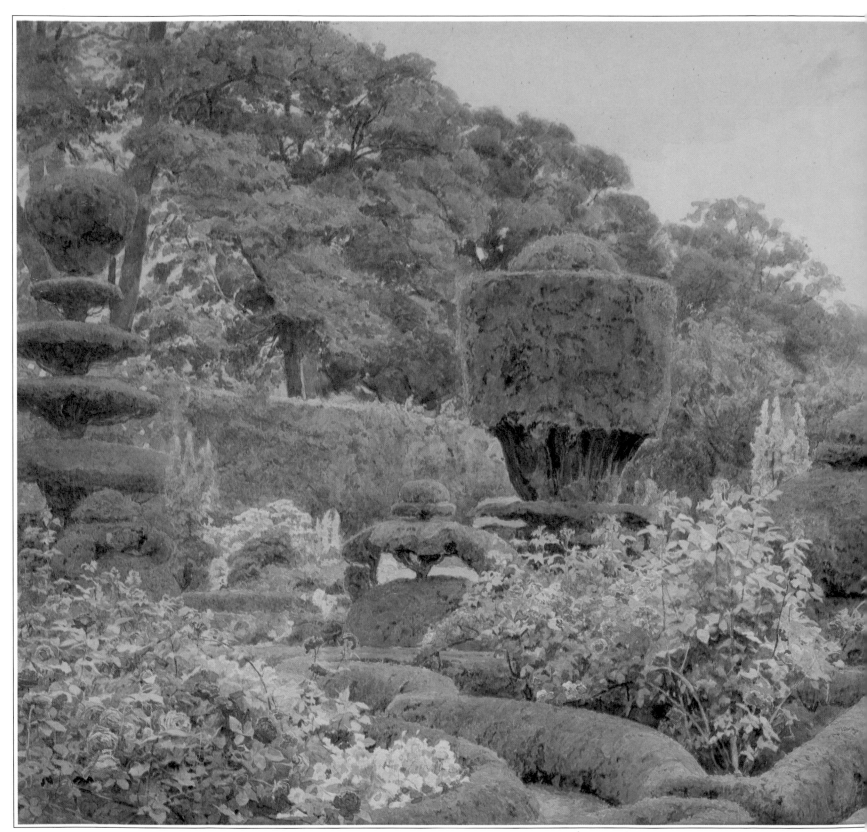

97. George Samuel Elgood. *Roses and Pinks*, *Levens Hall*, Cumbria, 1892.

and sides reveal angles, curves and flat planes of textured foliage all of which reflect light and cast shadows to express the spirit of the garden.

The house and garden are open to the public; successive generations have maintained the geometric symmetry of layout and kept intact the elaborate topiary for almost three centuries. Let us hope the future of this important garden is assured.

LOSELEY PARK

Surrey

Loseley Park lies below the ridge known as the Hog's Back a few miles from Guildford in the valley of the river Wey. The More family, relatives of the famous Sir Thomas More, have lived at Loseley since the sixteenth century. It is recorded that Queen Elizabeth visited Sir William More three times, a mark of peculiar royal favour at the time. A plan with gatehouse turning the house and wings into a quadrangle was prepared for Sir George More after his succession in 1600 by John Thorpe. It includes the west wing, which was demolished in 1820, and an east wing, which was never completed. Sir George's daughter Ann married the poet John Donne and died in childbirth in 1617, after bearing six children. The present occupants, Mr and Mrs James More-Molyneux, with their son and daughter-in-law, run a thriving and expanding business which includes selling dairy products from their Jersey herd, free-range poultry and organically grown corn. The seventeenth-century walled garden, with its contemporary brick-built pigeon gazebos on three corners, where George Elgood painted the ancient yew hedges and borders of hardy flowers, is now planted with organic vegetables. New uses have been found for the ornamental garden, but the main structure of high brick walls, moat and raised terrace walk and much of the yew hedging still exists and clearly indicate the basic layout which dates from John Thorpe's building, if not earlier. It is still possible to identify the areas where teams of industrious gardeners once maintained colourful borders, rose-beds and, by the last years of the nineteenth century, shrubberies planted with new exotics, evidence of the taste and interest of Mr William More-Molyneux (1835–1907), great-uncle of the present owner.

A modern visitor approaches Loseley from the east, the drive swinging round to broad lawns framing the north façade of the Tudor house. No traces of gardens remain here, but a fine branching cedar of Lebanon, and several less mature specimens, dominate the immediate landscape with the northward view to the Hog's Back and the Pilgrims' Way, which runs under its south flank. The façade is impressive, with four main gable projections, a fine classical doorway and carved pediment, and a tall oriel window which illuminates the great hall, where wooden Italian intarsia-work and painted panels, which were rescued from Henry VIII's Palace of Nonsuch during the seventeenth century, now hang.

The main garden with an early moat and seventeenth-century canal lies to the south and east of the house. No plans or knowledge exists of a Tudor garden; the first documents relating to any layout are dated 1704, but these, on a grand scale, are unlikely to have been completed. The More heiress married Sir Thomas Molyneux in 1689; the next decade appears to be the most likely period for the garden work of which traces still remain. Three-hundred-year-old brick terraces above the canal and the three elegant gazebos with pointed conical roofs mark corners of the walled enclosure which stretches east and south to one side of the great house. The almost square area was until recently still divided into compartments, almost certainly much as first envisaged by Sir Thomas and Lady Molyneux, with orchards, vegetables and lawn areas, perhaps at completion decorated with some contemporary maze or topiary patterns which are long-since vanished.

Considering the quality and importance of the house and its contents, we have very few descriptions of the Loseley gardens. Two are useful and important in setting the Elgood paintings of 1898 in context. In *The Garden* (1886) the house stands, as it still does, surrounded on three sides by wide level lawns: 'these fine stretches of grass are for the most part unspoilt by the usual cutting-up effect of flower-beds and injudicious planting, and the grand grey house rises from the level sward with its quiet dignity unmarred by any petty frivolities. The lawn on the south side has not been so fortunate, and is a good deal spoilt by a small sunk rectangular garden of no beauty, with beds set out in heraldic patterns.' The writer would prefer today's simplicity. In 1886 the main or most impressive avenue led from the south-west; magnificent elms, since lost through disease, then dominated the planting; fortunately lime trees reinforced the symmetry and until the gales of October 1987 maintained the avenue effect. The walled

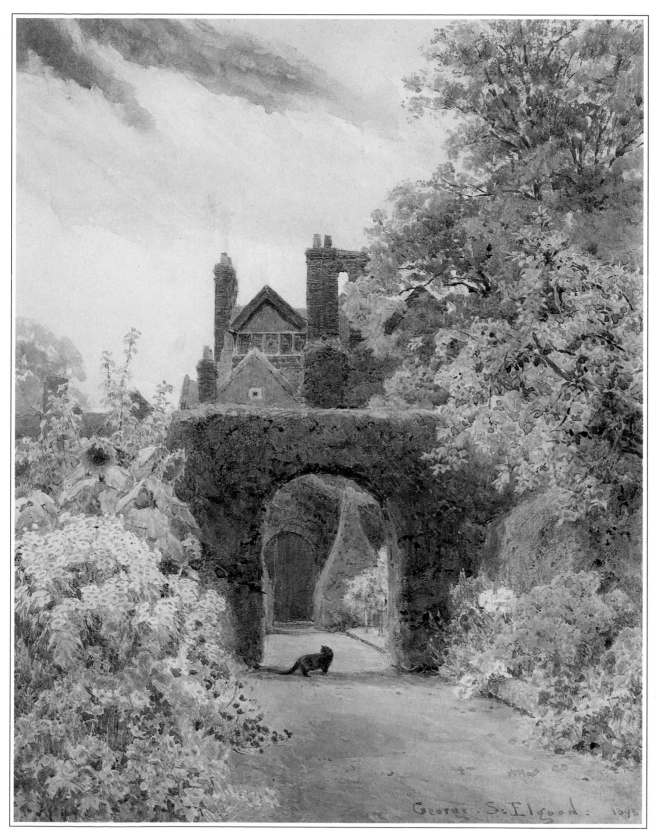

98. George Samuel Elgood. *Loseley Park*, Surrey, 1898.

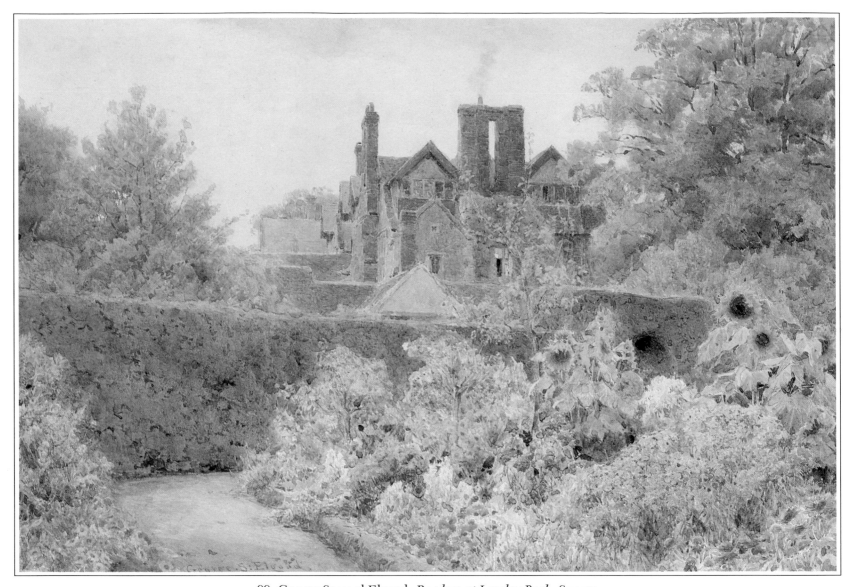

99. George Samuel Elgood. *Borders at Loseley Park*, Surrey.

two-acre garden was both for utility and enjoyment. 'Its large walled space ensures shelter, and as its extent is needlessly great for vegetable and fruit growing, it comprises, in addition to the bowling green, ample grass walks and lawn-like spaces, broad borders of hardy flowers, shady alleys of ancient filberts and fantastic old apple trees.' There is no mention of an old mulberry which must have been a feature in the 1880s.

Mr William More-Molyneux inherited Loseley in 1874; by 1899 his improvements and his planting of bamboos and Chusan palms are commented on in an article in *Country Life*. One of Elgood's paintings (plate 98) shows a yew archway and yew pillars framing a door in the west wall of the great garden. The eastern gables of the house (one housing the Long Gallery) are just visible. Hardy late-summer-flowering perennials fill the borders at the base of the yew. The *Country Life* article describes park and garden as it was at Elgood's visit. The anonymous writer notices the garden plants of interest; hardy bamboos grew on the fringe of thick shrubberies as the entrance approach opens to a sweep by the house. Clumps of *Arundinaria metake* grew luxuriantly beside *Phyllostachys mitis*, black-stemmed *P. nigra*, *P. viridi glaucescens* and *P. aurea*. Tall specimens of the noble Chusan palm (*Trachycarpus*

fortunei) towered above the terraces and, in shade, glossy-leaved *Fatsia japonica* flowered freely. Clearly there was interest in gardening here. The house itself was curtained with creepers; peonies, golden rod and monkshood with specimens of *Yucca gloriosa* grew in strong groups in a border beside the raised south terrace. 'Quaint old hedges, neatly trimmed in the Dutch fashion, and trained Portugal laurels, add pictur-esqueness and distinctive character to the garden, and pre-serve the aspect of former days, well in keeping with the beautiful house itself. Roses flourish . . . on their own roots, the annual shoots being pegged down – a much better condition than when . . . the plants are budded on some unsuitable stock.' Mr More-Molyneux must have been a considerable gardener; it is unfortunate that contemporary photographs show the palm trees but do not show the shapes of hedges or Portugal laurel. By 1905 the famous Miss Jekyll, a near neighbour and almost certainly well known to Mr More-Molyneux (as well as being a regular contributor to both *The Garden* and *Country Life*) was invited to improve parts of the garden with new border schemes both in the walled area and along the terrace above the south-east section of the moat. A plan for a north bed under the kitchen garden wall includes hostas, laurustinus (*Viburnum tinus*), *Yucca filamentosa* and acanthus with her favourite white perennial pea (*Lathyrus latifolius* 'Albus') and golden rayed Auratum lilies from Japan (introduced in 1862), which should have done well in the acidic sandy soil. Rough sketches survive for rose-beds which were probably the basis for the rose garden with box-edged beds which, until recently, existed just east of the borders which George Elgood painted. She made a detailed planting plan for a long border which stretches outside the main wall parallel to the canal. By the middle of this century only lavenders and peonies remained here. On one of her drawings she describes a border against a yew hedge as 'already planted with areas of box and sequoias'. This is difficult to locate with any accuracy and sounds original. It seems likely that a knowledgeable gardener such as Mr William More-Molyneux, by 1905 in his seventy-first year, will have enjoyed the new detailed projects and discussing with Miss Jekyll her recommendations. The gardens at Loseley, with their firm seventeenth-century struc-ture and ancient yew hedges, were exactly the sort of framework in which Miss Jekyll loved to create her colourful planting schemes as is clearly evident in another of Elgood's paintings (plate 99). Sadly Mr More-Molyneux died in 1907: it is doubtful whether he had pleasure in their inauguration, and there is no record of their completion. Today no detailed planting remains at Loseley; instead the land is farmed and gardened organically, providing health foods for a public increasingly aware of the health hazards inherent with artificial fertilizers and herbicides. Miss Jekyll, in her day a pioneer of ecological planting and dedicated to rescuing threatened native and garden flora, would surely have admired and welcomed Loseley's new emphasis on unadulterated foods. The garden round the house, with groves of lime trees and specimen cedars, still makes an appropriate and quiet setting for the fine house; the walled enclosure may have a new purpose, but the overall garden structure, far more important than any ephem-eral flower-beds, remains undisturbed. A few bamboos and a grove of palm trees are a reminder of exotic planting at the turn of the century.

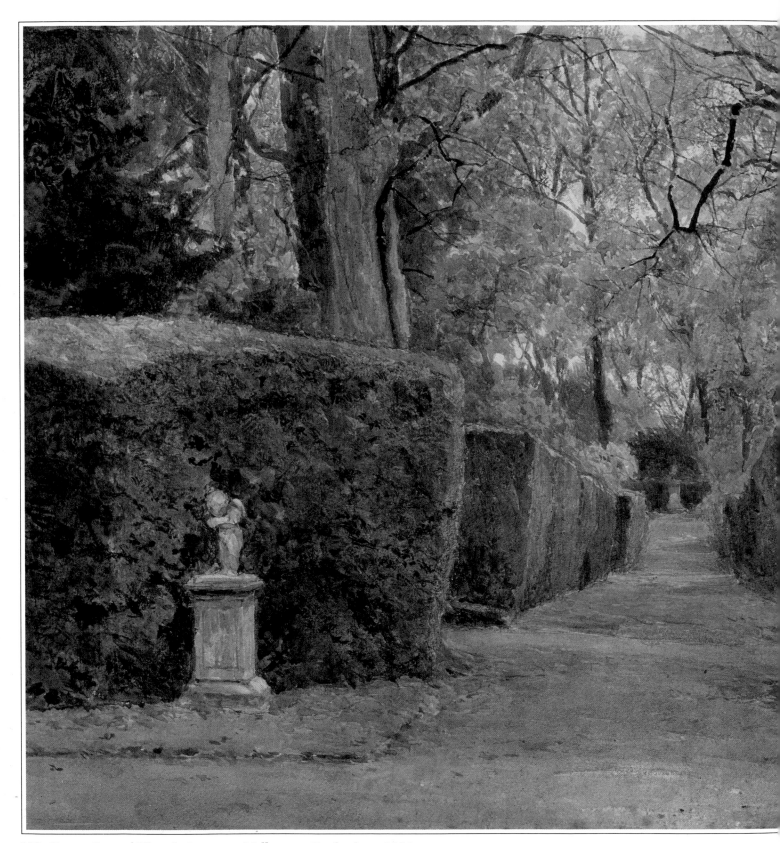

100. George Samuel Elgood. *Statues at Melbourne*, Derbyshire, 1894.

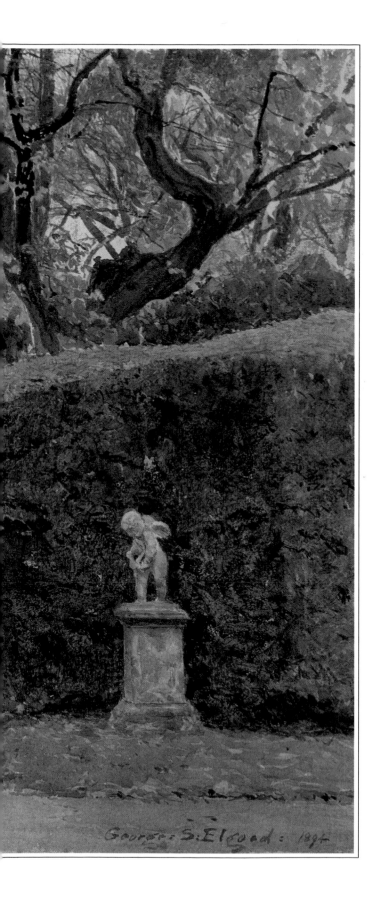

George S: Elgood: 1894

MELBOURNE HALL

Derbyshire

In England few gardens directly attributed to French influence and dating to the latter part of the seventeenth century survive intact. Melbourne Hall, St Pauls Waldenbury and Bramham in Yorkshire are among those immediately springing to mind. Others and many earlier Renaissance-style gardens were swept away during the eighteenth century. Melbourne, with radiating alleys cut in woodland, thick yew hedges and superb statuary, is a French landscape in miniature; although modelled after Versailles, the garden covers only sixteen acres. George Elgood's watercolour, entitled *Amorini* (plate 100) and dated 1894, shows charming winged figures of boys in lead on pedestals framed by a background of green yew and gives a clear indication of the garden style which had remained unaltered from the first years of the eighteenth century. This, and another Elgood (plate 101), are used as illustrations in *Some English Gardens*, where Gertrude Jekyll describes the garden and statues. The second painting shows a circular pool with spouting cherub and a statue of Mercury. This forming an axial point from which more hedged paths radiate.

The Hall was originally the parsonage and owned by the Bishops of Carlisle. In 1629 it was let to Sir John Coke, secretary to Charles I; his grandson, Colonel Coke, greatly enlarged the garden before his son Thomas Coke succeeded in 1696. By that date the garden, from being a small rectangle to the east, had been expanded as a parallelogram on the slope below down to the Blackwell brook, and a wall thrown round almost the entire garden limits. The area next to the house was walled, and in the north-east corner a hexagonal dovecote with ogee roof was built; later this became a library, and today it is known as the muniment room, although onions are stored beneath it. Beyond the wall vegetables grew in another enclosure, and at the bottom of the garden the Colonel had devised two square canalized ponds with central islands planted with trees and shrubs. Along the south side of the garden a yew tunnel, probably planted in the sixteenth century and at first trained over a wooden frame, stretched almost the entire length of the garden. This tunnel, extended by

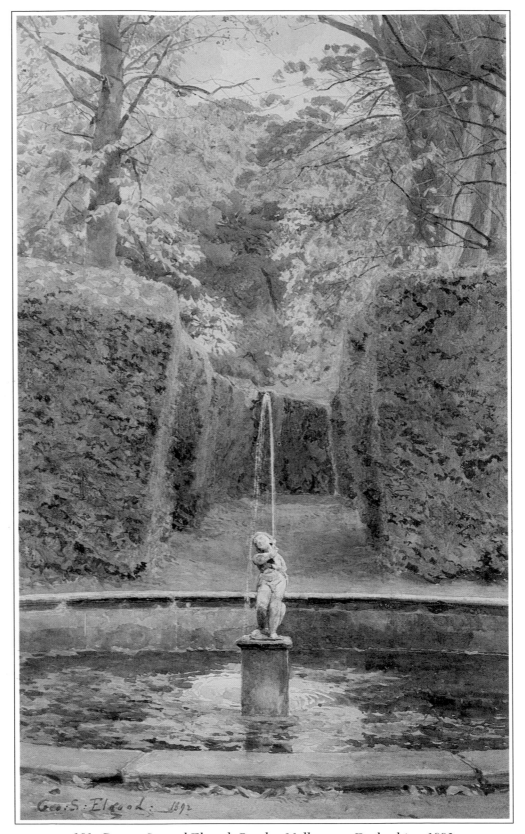

101. George Samuel Elgood. *Pond at Melbourne*, Derbyshire, 1892.

Lord Palmerston in the nineteenth century, remains today.

Thomas Coke, having studied architecture and garden design at first hand in France and Holland and having inherited a sufficient fortune from his mother, commenced an expansion of his garden. At first he ordered plants from London and Wise, the Brompton Park nurserymen. Soon he became more ambitious and in 1699 he forwarded his own design for the garden to Henry Wise, who consulted George London, himself newly returned from a second visit to France where he had studied Le Nôtre's achievements. Plans were approved, but execution was delayed until Coke converted his tenancy of the property into a freehold in 1704 and added six acres to it. The acquisition of a hill beyond the brook to the east and a southern extension allowed more scope. A contract made in May 1704 with a local man, William Cooke of Walcot, concerned transforming the existing flower and kitchen gardens into terraces with parterres. In place of the square moats a great basin occupied the bottom of the slope. Soon Cooke was asked to draw up plans for the newly acquired rather irregular land south of the earlier garden. Here levels ran in all directions; to disguise this groves of thick tree planting were broken up by broad alleys edged by lime and hornbeam. From the far east side of the Great Basin (where Robert Bakewell, a pupil of Tijou, designed a wrought iron arbour in 1706), an avenue – Crow Walk – led up the slope to the south. Centred on an urn representing the Four Seasons, it crosses a subsidiary pool axis from which more *allées* radiate into woodland. From the plateau where the urn rests, lime avenues in turn spread out into deeper forest. At each focal point a statue, pool basin or some garden ornament emphasizes the design. It seems that although London visited Melbourne in 1701, his role in the layout adopted was advisory rather than detailed: plans of Thomas Coke himself or of his contractor Cooke were submitted to London to be 'polished' and approved. Many of the lead figures which remain important features at Melbourne came from the workshop of Van Nost. These were originally painted to resemble stone, and accounts in the house show frequent repair bills over the years. A pair of kneeling slaves, painted black, supported sundials on the main parterre lawn, groups of *amorini* are set in clipped bays in the yew hedges and Cupid spouts water in some of the pools. Perseus and Andromeda, also framed in yew, are placed to face up a north and south walk. A Mercury, modelled after Giambologna, stands in the centre of the lower parterre lawn, where only sloping grass today is seen.

Thomas Coke's daughter Charlotte, married to Sir Mathew Lamb of Brocket Hall, inherited Melbourne on her father's death. Charlotte's grandson, Lord Melbourne – Queen Victoria's Prime Minister – took his title from the place in preference to Brocket. Through inheritance the Hall finally passed to the Kerr family, and it was Lord Walter Kerr who was responsible for refurbishing the garden during the first quarter of the present century. Today house and garden, owned by the Marquess of Lothian, are regularly open to the public. At the time of the paintings, the house was owned by Lord Cowper and tenanted by Mr W. D. Fane. Miss Jekyll describes how some random planting of conifers on the parterre lawn were 'distinctly an intrusion'.

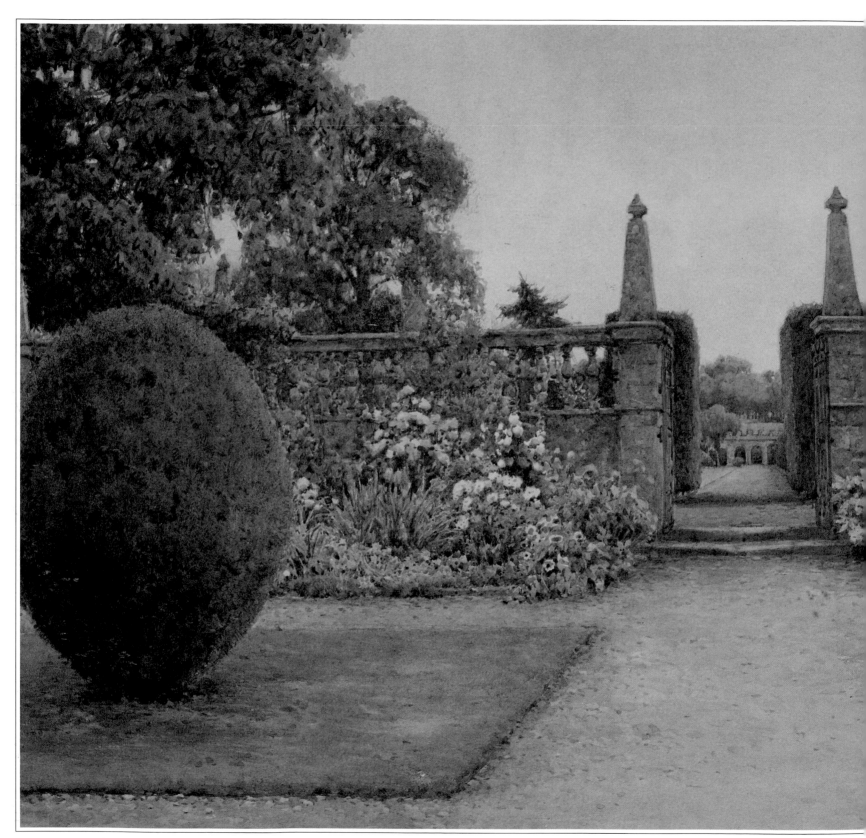

102. Ernest Arthur Rowe. *The Way to the Bowling Green, Montacute*, Somerset, 1908.

MONTACUTE HOUSE

Somerset

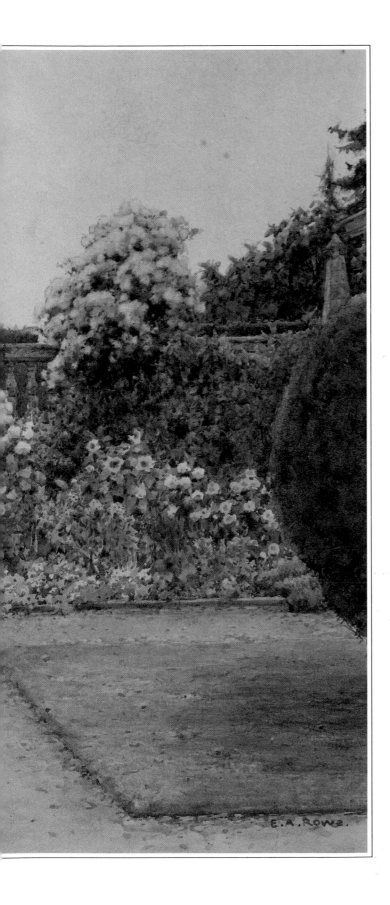

Named for the conical hill *Mons Acutis*, an outcrop of the ridge of Hamdon Hill from which the golden Ham stone is quarried, the great Elizabethan house was built by Sir Edward Phelips at the end of the sixteenth century. Completed by 1601, the house is in the shape of a stunted letter H. The architect was most probably William Arnold whose documented buildings include Cranborne Manor in Dorset and Dunster Castle in west Somerset. The Phelips family, although suffering impoverishment at periods, continued to live at Montacute for over three hundred years. The house was scheduled for demolition in 1931, but was saved by the intervention of Albert Reginald Powys, secretary of the Society for the Protection of Ancient Buildings (SPAB) and son of the vicar of Montacute, who persuaded Mr E. E. Cook to purchase and donate the estate to the society. Ownership was later transferred to the National Trust. Although none of the original contents survived, the Trust has refurnished the house with the help of numerous bequests, gifts and loans and in the Long Gallery there is a permanent exhibition of sixteenth- and seventeenth-century portraits from the National Portrait Gallery in London.

The garden layout round the great mansion remains in essence much as it will have been in the early years of the seventeenth century, although the detail and planting are different. The arrangement of house and grounds conforms to Gervase Markham's dictum of 1615. In the front of the house there should be a forecourt, walled in on every side, with an entrance at the centre. On one side were to be pleasure gardens, with a terrace along the side of the house, all exactly as at Montacute. There the house itself, walls, balustrading, corner gazebos and raised terrace all dominate the site to an extent which makes changes in gardening fashion seem almost irrelevant. Fortunately all were so firmly part of an integrated design that there was no question of these garden compartments being swept away during the eighteenth century. Indeed, the Phelips family probably had little spare income at this time, so found it easy to resist a change in fashion. The forecourt across the east side of the house, the sunken garden

which lies beyond the broad terrace to the north, surrounded by a raised walk, and the outline of the southern garden, at first an orchard area, are unchanged. In the outer corners of the court a pair of stone pavilions are linked to the house by walls topped with elegant balustrading intersected with obelisks above stone piers and complex openwork lanterns or 'crowns'. The west side of the house was completely altered in 1786 when the fifth Edward Phelips brought the façade of delicate Tudor stonework, dating from fifty years earlier than the buildings at Montacute, from Clifton Maybank a few miles away in Dorset. Placing it as a two-storey screen across the west front, he then aligned an avenue on this new entrance. To do this he removed the earlier stables which were redesigned for a site just to the south.

In George Elgood's and Ernest Arthur Rowe's time flower borders lined the forecourt and in addition Irish yews were planted on the edge of grass panels which partially surrounded a gravelled area in the centre of which was a large fountain basin. This exact layout is also illustrated by Inigo Thomas in Blomfield's *Formal Garden in England* (first published in 1892). In this forecourt the stonework dates from the building of the house, although the main carriageway approach to it through a contemporary gatehouse was altered before 1774. By then an old map shows the gatehouse gone and a rectangular Bowling Green, reached through the central gateway, occupies the space between the forecourt and the first avenue trees.

The yew hedging, which surrounds much of the outer

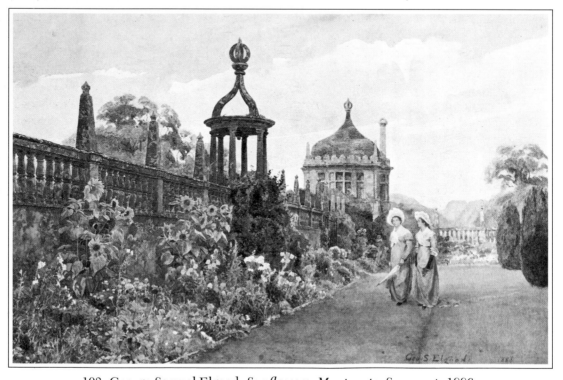

103. George Samuel Elgood. *Sunflowers, Montacute,* Somerset, 1886.

garden area – to a stretch of 895 yards in total, was first planted after 1834 by William Phelips' head-gardener Pridham, who came with William's bride Ellen Helyar from neighbouring Coker Court. One hundred and fifty years later the hedges are ten feet high and broad and have assumed mounded shapes of complexity for neat clipping. The forty-four Irish yews round the sunk north garden were probably also planted by William Phelips (who lived until 1889), for they are included in plans drawn up by R. Shekelton Balfour in 1849, who also made a design for the central fountain and pond, which occupies the site of an original Elizabethan mount. The south garden, still called Pigs Wheatle Orchard in the 1774 map, was also 'improved' during the nineteenth century. The Tudor style garden building in Rowe's painting, or at least its facing, was probably not completed until the end of the nineteenth century. By 1900 a blue Atlas cedar, *Cedrus atlantica* 'Glauca', partnering a more sober cedar of Lebanon, *C. libani*, was already over forty feet in height and a pair of sweet chestnuts, *Castanea sativa*, with their characteristic twisted bark, dated back to before the Victorian era. A yew walk, composed of eleven pairs of Irish yews, invited exploration of the distant end of the garden.

Elgood's painting of 1886 (plate 103) is also reproduced in *Some English Gardens*. It shows planting against the north wall of the forecourt, as well as admirably illustrating the stone finials and openwork lantern. Interestingly, a gateway at the farther end of the border is not there today. Could this be Elgood's artistic licence? Steps through a similar gateway do lead up to the raised terrace at the house end of the wall. The border is described by Gertrude Jekyll. Evergreen shrubs such as *Garrya elliptica* make buttresses under the balustrading and *Clematis flammula* wreathes the pillars. Annual sunflowers and zinnias give bright summer colour. She is critical of much else in the garden, describing the sunken north garden and Irish yews as 'rather dull'. The painting done by E. A. Rowe in 1908 (plate 102) reveals a view on the opposite side of the east forecourt. It is entitled *The Way to the Bowling Green* but its position must not be confused with the original Bowling Green on the east; instead it permits a glimpse of the arcaded garden room in the southern enclosure.

Modern planting at Montacute has a different emphasis, but the basic layout remains as it has always been. The outer borders in the forecourt are wider, the edging paths remain gravelled, but the central area is of mown grass. In the 1950s the National Trust invited Mrs Phyllis Reiss from Tintinhull House near by to redesign the borders, replacing earlier planting plans of Vita Sackville-West. Colours are strong, with planting blocks large enough to remain distinct. Purple-leaved berberis and cotinus contrast with the golden-hued Ham stone and groups of scarlet and yellow dahlias prolong the flowering season. To the north the original terrace, forty-five feet wide, is unchanged; it runs along the width of the house and forecourt; it forms the southern edge of the sunken garden. At its west end an orangery built in 1700 is now unheated but decorative with ivies and maidenhair fern. In the sunken garden in Elgood's and Rowe's time tall cypresses soared behind the pyramid yew shapes; these remained until the 1960s when, much weathered and decimated, they were replaced with broad-headed thorns (*Crataegus* × *lavallei*), which thrive there today. Below the terrace a border of shrub roses underplanted with cool grey-leaved hostas was designed by Graham Stuart Thomas and Vita Sackville-West in the early 1950s. In the south garden the Trust has added a small garden area where, enclosed by yew hedges and framed by a background of Scots pines and evergreen oaks, a pool is flanked by clumps of *Yucca recurvifolia*.

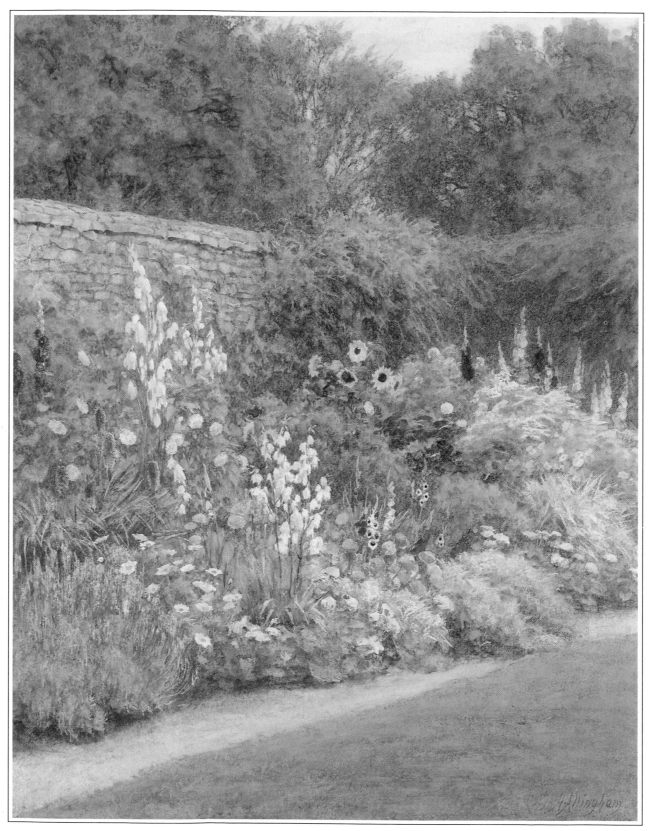

104. Helen Allingham. *Munstead Wood*, Sussex.

MUNSTEAD WOOD

Surrey

Miss Jekyll's own garden at Munstead Wood seems to need little introduction. A large number of the gardens and paintings in this book have been described in Gertrude Jekyll's words as they were when she visited them at the turn of the century. Much of her gardening philosophy emerges from her comments; often praise and even criticism are strengthened by reference to the period and style of the house of which the garden is an adjunct. Most of these gardens were 'old' style and symmetrical, Yew and box hedges made geometric compartments; walls, steps, paving and balustrading provided the architectural elements and framework for borders of hardy plants and neatly laid out parterres. She enjoyed the 'whimsical' topiary at Levens, the atmospheric yew shapes and flowery borders at Brickwall, the romantic terraces at Berkeley Castle and tamer farmhouse sunflowers at Cleeve Prior. All her vivid descriptions take into account the garden's suitability for its great house. In every other description in this book the same is true; the garden – whether restored, recreated or modern – is discussed as an adjunct to a period house.

At Munstead Wood, on the other hand, both garden and house were brand new in the 1890s. The fifteen-acre garden, laid out even before the house was built in 1896, was carved out of natural Surrey woodland and sandy heathland; it was planned so that the 'gardened' area would melt gently into surrounding native woodland, with clumps here and there of introduced exotics looking 'natural' next to native birch, chestnut, holly and junipers. The trunks of a few old Scots pines became features and focal points along grassy walks which, radiating out from the north side of the house, led through glades to thicker woods on the perimeter. The house, built for her by the youthful Edwin Lutyens (almost at the start of their partnership), was envisaged as a functional home and workshop in traditional and vernacular Surrey style. It was the only instance when Lutyens built a house to fit into one of her gardens; in the future she was to design gardens and borders to embellish his architecture. In no way a copy of an old building, Munstead Wood had many of the characteristics of older structures; strength and serviceability without pretension. In a

moment of pique with the young architect Miss Jekyll writes: 'My house is to be built for me to live in and love; it is not to be built as an exposition of architectonic inutility.'

The house faced south-east into the woods; behind it, to the north and adjoining a courtyard, gardening patterns were more traditional with straight paths lining borders, a nut walk, a pergola, a high sandstone wall backing her famous colour border, and walled enclosures for special plant and seasonal themes. A further garden to the south was laid out round a hut which Lutyens had built for her in 1894 to live in while the main house was going up. There she made a cottage-style garden with peonies, June borders and hedges of rosemary.

In the last ten years, but especially since 1982, when fifty years after her death her own works came out of copyright, there has been a spate of new appraisals of Gertrude Jekyll alongside republications of all her main books. Betty Massingham wrote an illuminating biography, Jane Brown discussed her partnership with Lutyens and has recently reassessed her lasting importance as an influence on modern gardening; the present author published a collection of her writings, choosing those which seemed most useful for interpretation and adaptation inside modern gardens. Others have dealt with her skills as artist and craftsman – visual skills which, learned in her early training as an artist, were put into practice in gardening terms after her failing eyesight prevented her continuing to do finer detailed work.

Even if she had not written extensively about the Munstead Wood garden and left detailed planting plans, it would be easy to reconstruct many of her border colour schemes and plant themes from the photographs and paintings which exist. Among her many skills she was an amateur photographer; she took many photographs of her garden at Munstead Wood between 1890 and 1914. As well as these pictures, many of which she used to illustrate her books, both George Elgood and Helen Allingham painted the garden at some of the peak periods of its seasonal performance. Both excelled in painting border plants and colour harmonies; Helen Allingham is well known for her idealized cottage garden scenes, and Elgood for

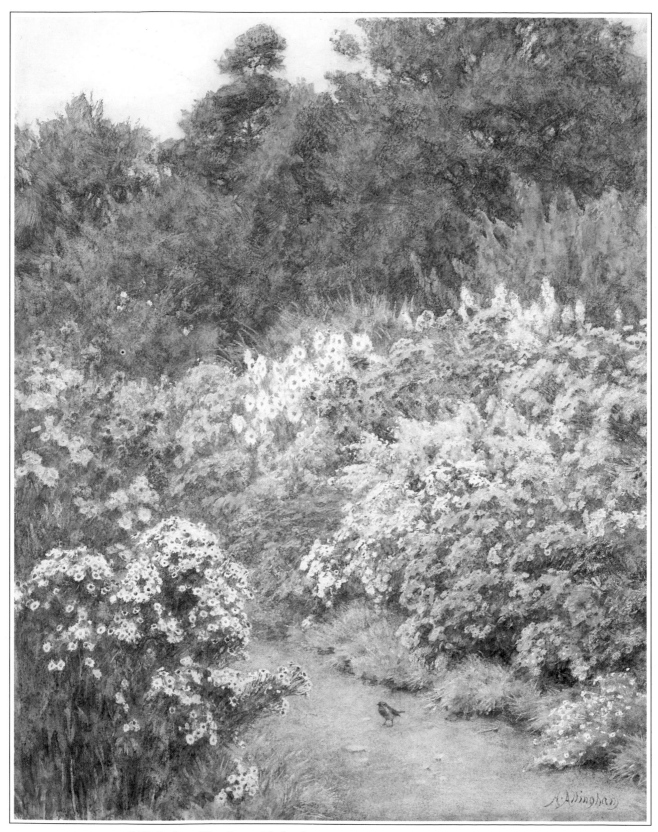

105. Helen Allingham. *Michaelmas Daisies at Munstead Wood*, Sussex.

details of colour combinations and more architectural scenes.

In this book we show two watercolours by Helen Allingham. One is of the north-east section of her long border (plate 104), the other of the double Michaelmas daisy border (plate 105) which lined one of the paths behind the house, in its fullest glory. Helen Allingham probably did these pictures in 1900 in preparation for her *Happy England* (published in 1903). As a painter she was able to grasp the principles behind Gertrude Jekyll's orchestrated colour planning; perhaps, indeed, with her own artistic licence, she improved upon the effects; certainly in the border pictures some of the shrubs, perennials and annuals in the groups were portrayed as overlapping in their flowering period when this was hardly possible. Nor does the planting in the painting exactly coincide with any of the known variations of Miss Jekyll's border plans; orange-flowered bignonia drapes the sandstone wall and from left to right plants are identifiable: dark red hollyhocks, orange kniphofias, creamy spires of *Yucca recurvifolia*, pink dianthus, orange marigolds, cineraria, santolina, marigolds, dahlias and blue-flowered *Geranium ibericum* and more hollyhocks. This main border was designed so that cool flower colours and grey and silvery foliage plants framed the central border area, where 'hot' reds, scarlets, vermilion and orange reached a climax of vivid colour. Colours were carefully and seasonally graded and Miss Jekyll used annuals and pot plants to enhance her effects; there were no 'rules' to impose restrictions on plant choice.

The aster beds were easier to paint, as they were strictly for seasonal enjoyment. Imagination did not have to be stretched; they were planned for a brilliant September performance, the daisies growing in mounded waving massed colour above low-growing grey-leaved dianthus which, used as an edging, became a foil to the pastel flower tints. Most were species aster, some groups were cultivars of *Aster novi-belgii* and clumps of the large Hungarian daisy, *Chrysanthemum uliginosum*, were important. Miss Jekyll herself describes this garden area: 'Where space can be given, it is well to set apart a separate border for these fine plants alone. Here the starworts occupy a double border . . . planted and regulated with the two-fold aim of both form and colour beauty. In these borders of Michaelmas daises, one other plant is admitted, and well deserves its place, namely that fine white daisy, *Chrysanthemum uliginosum*. There is more than usual pleasure in such a daisy garden, kept apart and by itself; because the time of its best beauty is just the time when the rest of the garden is looking tired and overworn . . . the fresh, clear, lively colouring of the lilac, purple and white daisies is like a sudden change from decrepit age to the brightness of youth, from the gloom of late autumn to the joy of full springtide.'

Both these planting schemes have inspired many modern gardeners. Emulation of the great colour border has become almost a spiritual quest for Miss Jekyll's admirers, not an easy task with little labour and restricted space, although careful study of her colour rules and her skill in plant manipulation will amply reward any student. The daisy border had been interpreted more easily and modestly; throughout the summer months flowers in pale blues, pinks and mauves are set off by silvery foliage plants to make gentle compositions entirely appropriate for the grey light and sunless days of England.

Today most of the beds at Munstead Wood have been removed but the site of the main border, banked by the high wall, remains. Walks to the south of the house remain evocative of Miss Jekyll's woodland gardening style.

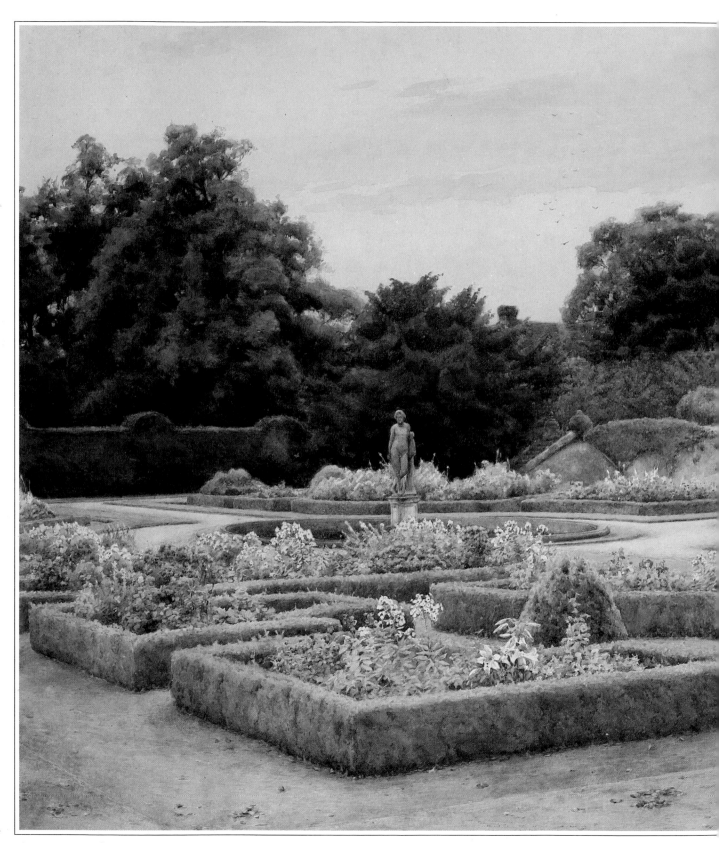

106. Ernest Arthur Rowe. *Penshurst Place*, Kent, 1895.

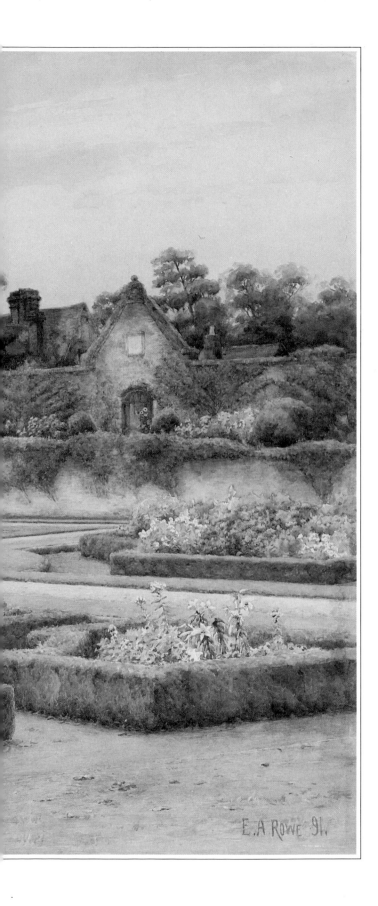

PENSHURST PLACE

Kent

The garden layout at Penshurst, although greatly expanded both in the nineteenth century and in the latter part of the twentieth century by descendants of the Sidneys, still reflects the formal style of the sixteenth and seventeenth centuries. Sir Philip Sidney was born here; in *Arcadia* he describes the garden as it appeared after alterations put in hand by his father in the 1560s, where 'thickets separated enclosures and surrounded pools and fountains'. Perhaps of all our great houses Penshurst, in those years, most closely resembled in atmosphere a Medici villa of the Italian Renaissance, becoming a focal meeting place for writers and brilliant thinkers; house and garden were immortalized by the poetry of Sidney, Spenser, Ben Jonson and Edmund Waller.

Although the north and west fronts were added by the Sidneys, Penshurst dates back to at least the thirteenth century and garden enclosures will correspondingly have their origins in medieval times. The house stands on a raised bank above the Medway valley; it was never fortified or moated, remaining more of a manor house than a castle, although crenellations decorate the walls of the great fourteenth-century hall. The Sidneys acquired the property in 1552, but – as Ben Jonson remarked half a century later – it was never 'set out to envious show'. For all its size and splendour even today, it keeps about it a spirit of modest achievement both in architectural detail and in its garden format which would seem suitable to Sir Philip Sidney's own aura of unostentatious chivalry and honour.

Fortunately the family were impoverished during the eighteenth century and Penshurst escaped the 'romanticizing' landscape hand of Brown or Repton. Instead the gardens remained confined within rectangular boundary walls. It was not until the middle of the nineteenth century that Lord de L'Isle with the architect George Devey, a specialist in Elizabethan revival architecture, embarked on restoration of both house and garden. In the garden their sensitive work confirmed and renewed the old layout. Their approach is described by Miss Jekyll in 1904: 'in part line for line and path for path . . . actuated by sympathy with both house and ground,

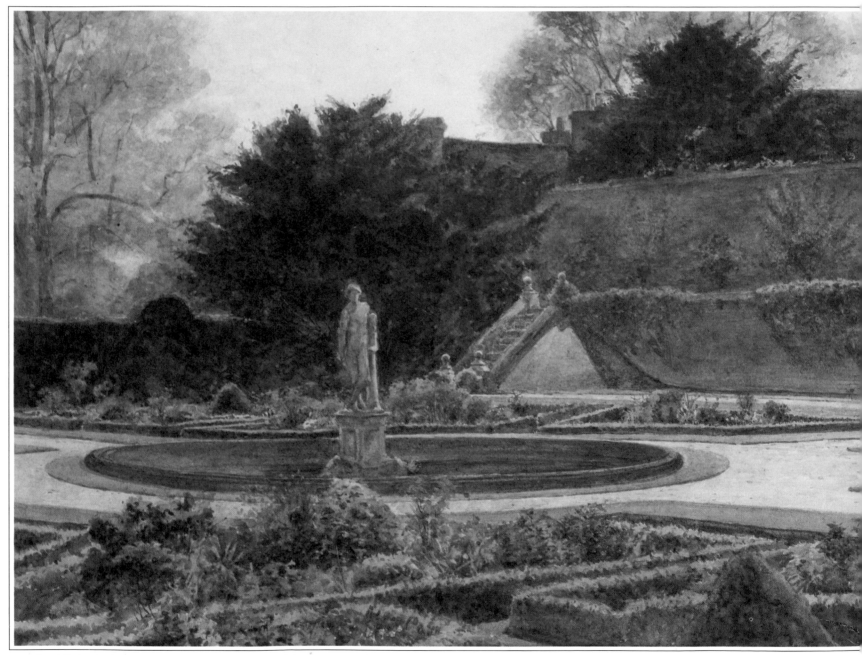

107. Ernest Arthur Rowe. *The Formal Gardens at Penshurst Place*, Kent, 1891.

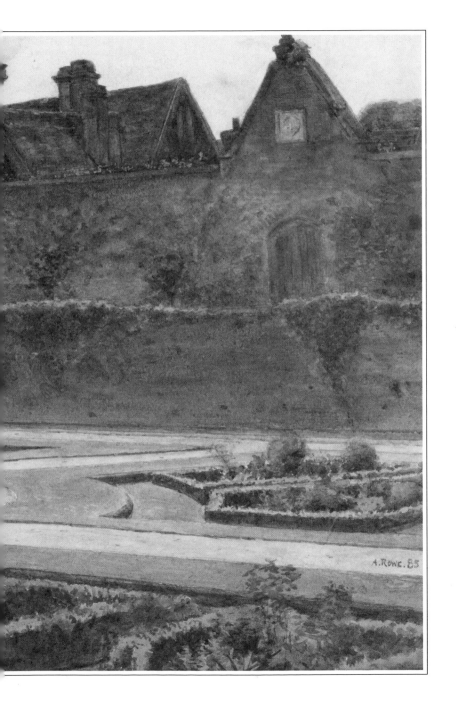

[to] bring forth a result whose character would be the same, whether thought out and planned today or four centuries ago.' Inigo Triggs, writing in *English Homes, Period 1*, is equally laudatory, if rather drier: 'Devey's collaboration with his client in the remaking of the formal gardens on the old lines but with variations and extensions of an exceedingly satisfying kind, must be proclaimed a positive triumph of garden-making.' Fortunately Devey and the young owner, both still in their twenties, had three main sources for their inspiration; Sidney's *Arcadia*, Harris' *History of Kent* (1719) and Kip's *View of the Garden* (1728). The *Arcadia* admirably portrayed the essence of the sixteenth-century garden: 'in separated enclosures flower-beds were canopied by fruit trees' and 'a fine fountain . . . a naked Venus of white marble' and 'in the midst of all a fair pond'. In the 1850s Lord de L'Isle and Devey were able to maintain this 'mixture of orchard and hardy flower garden' using existing walls and terraces as well as new yew hedges to accentuate the garden divisions. The 'fair pond', although undergoing restoration in 1850, still remains as an essential feature, occupying an important site where the main axis of the garden runs from east to west across to the south front of the fourteenth-century hall. Today it is known as Diana's Bath and is enclosed by Devey's vast yew hedges. Harris' *History of Kent* and Kip's *View of the Gardens* were more practical and revealed the main divisions on paper rather than as poetic fantasies. Steps and terraces were shown adjusting levels on the site which sloped perceptibly towards the south-east and the Medway valley. The highest point was the Elizabethan raised walk forming the boundary with the village churchyard; from its height a sunken garden, at first maintained as lawn during the restoration but later becoming a parterre with box-edged geometrical beds, could be overlooked. Another terrace in front of the south front provided a further flat space for the old privy garden; in Kip's sketch it is laid out in a pattern of small beds. In 1855 Devey planted rhododendrons here, but he later converted the area to simple lawn, an improvement maintained today. Kip's plan in essence remained the basis for the nineteenth-century alterations, although the great sunken

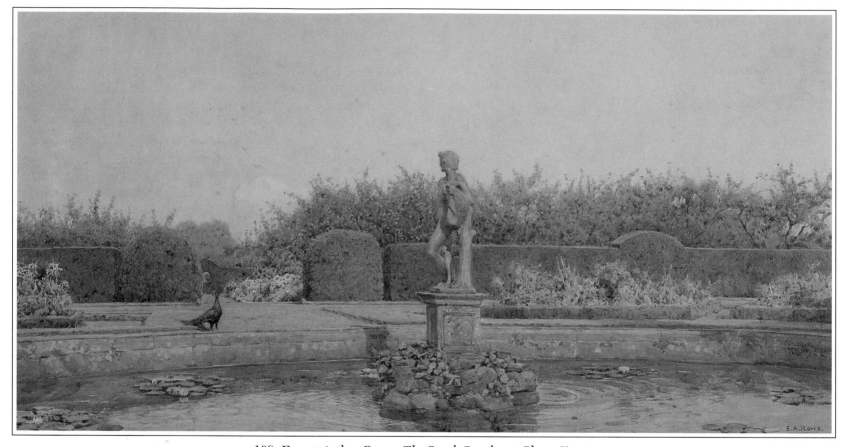

108. Ernest Arthur Rowe. *The Pond, Penshurst Place*, Kent.

west garden was subdivided on the east to provide garden compartments for orchards of nuts and fruit. Further improvements in the second half of the twentieth century maintained the rigid compartmental flavour; the whole garden is still divided by straight hedges and paths parallel and at right angles to each other, very much as Sir Philip Sidney's father first developed it.

Rowe's three paintings show views of the formal sunken garden, today known as the Italian Garden. They are painted in the 1890s, approximately fifty years after Devey's garden restoration. Elgood's views, reproduced in *Some English Gardens*, show the terrace steps and a corner of a stone wall where a fine urn is wreathed in the rose 'Gloire de Dijon'. (This rose was introduced in 1853, its large scented buff-yellow blooms opening continuously through the summer. Dean Reynolds Hole, doyen of Victorian rose growers, preferred this rose to any other, and many modern gardeners would still endorse his opinion.)

Miss Jekyll visited and described the garden as the artists had found it: 'The house stands on a wide space of grass terrace

commanding the garden. On a lower level is a large quadrangular parterre, with cross paths. In each of its square angles is a sunk garden with a five-foot-wide verge of turf and a bordering stone kerb forming a step. The beds within, filled with good hardy plants, have bold box edgings eighteen inches high and a foot thick, that not only set off the bright masses of flowers within, but have in themselves an air of solidity and importance that befits the large scale of the place. They represent in their own position and on their lesser scale somewhat of the same character as the massive yew hedges, twelve feet high and six feet through, that do their own work in other parts of the garden'. She goes on to describe the 'circular' pool (plate 107) (which is in fact on closer observation oval in shape) and statue of Hercules brought from Italy by Lord de L'Isle. In one painting (plate 106) Rowe shows the western raised walk, backed by a group of elms, with its fine Tudor gabled gateway of brick and stone, which leads to the churchyard; another painting (plate 108) shows the eastern edge of the parterre where an entrance in the yew hedge, the top of which is cut as now into scallops, leads to orchards beyond. Today's views are not much different; the box parterres have been simplified to reduce the number of flower-beds. At the outer corners, the plants of box have been massed at different heights as was common in early-sixteenth century Italian gardens, to make a continuous planting pattern. Inside the remaining beds, red roses have been substituted for Rowe's groups of white lilies and phlox – a considerable saving in maintenance.

It seems fortunate that further garden development at Penshurst, mainly since the 1939–45 War, has been as appropriate as that undertaken a hundred years previously. Today the gardens, still divided into compartments in seventeenth-century fashion and with many old features still extant, are among the best in England. New schemes and plant collections are absorbed into the old orchard areas without any inappropriately jarring note. Superbly pruned apple and pear trees and the vast yew hedges still dominate the garden scene; within their framework mixed planting schemes, some designed by Lanning Roper in specific flower and foliage colour themes, and others by John Codrington, give considerable garden interest without disturbing the overall coherence and logicality of the design. At the main entrance double borders of mixed shrubs and perennials line the driveway: their arrangement and upkeep a foretaste of the high standards found throughout the whole garden. Collections of peonies and of shrub roses are worth a special visit in May and June respectively; a new garden in the old kitchen area to the northeast, overlooked by the ancient lime avenue, has been laid out in pink roses and lavender to make a Union Flag, the symbol of English and Scottish unity in 1707. The lime trees are said to have been brought over from Holland by one of the delegates who went to treat with William of Orange. Recently an Elizabethan-style mount has been raised to overlook a gravel and box parterre. All of these and many more garden 'rooms' show an inspired level of horticultural knowledge and taste. Penshurst seems fortunate in having an owner, The Right Hon Viscount de L'Isle VC. KG., who expands and creates while maintaining period features which stretch, in their conception, over four centuries. Renaissance formality and symmetry exist side by side with the equally formal but more massive and ambitious Victorian hedges and schemes. But Penshurst is not a museum of garden styles; a modern garden is alive and growing inside the period frame.

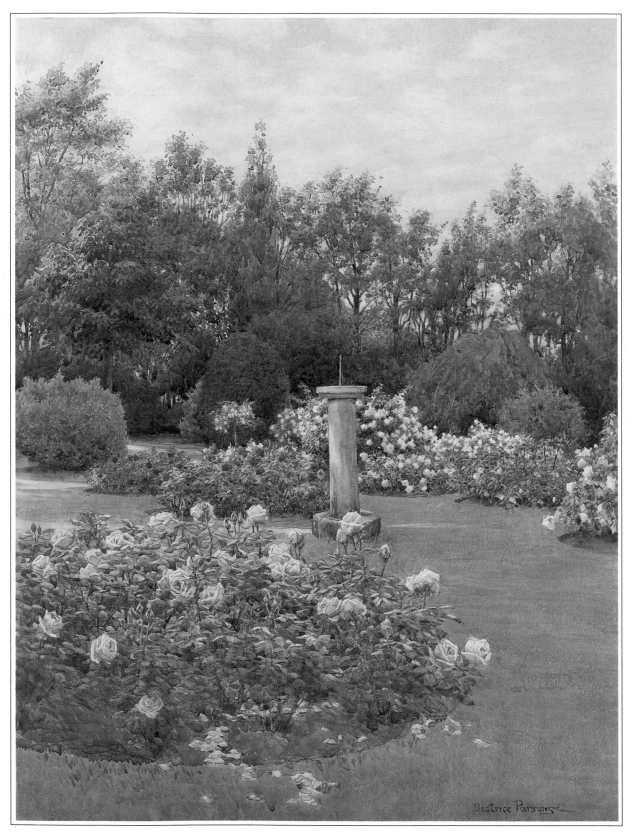

109. Beatrice Parsons. *The Rose Garden, The Pleasaunce, Overstrand*, Norfolk.

THE PLEASAUNCE

Norfolk

In 1888 Lord and Lady Battersea moved into their new home at Overstrand, just outside Cromer on the Norfolk coast. 'The Cottage', as it was then called, consisted of two houses built in red brick and, as Lady Battersea says in her reminiscences, 'was neither romantic or picturesque'. Sir Edwin Lutyens, then a young man and still Mr Lutyens, was called in to make the house more comfortable. It was renamed 'The Pleasaunce'. 'This more important building demanded a more important garden.' Fortunately Lady Battersea's husband 'proved an ardent gardener, a scientific as well as a practical one . . . and after much thought and many essays, a beautiful garden enhanced the pleasure we took in our Overstrand home.'

By 1908 the garden was described in romantic vein in a novel by a close friend (*Ten Degrees Backward* by Ellen Thorneycroft Fowler). Here it became the 'Garden of Dreams'. Situated on the edge of the cliff, it was a garden of infinite variety and of constant surprises. A velvety lawn edged with gay flowers and flowering shrubs preceded a formal garden, with paved paths between the square grass-plots, and a large fountain in the middle lined with sky-blue tiles. Sombre cloisters veiled with creepers led to a sunken garden with flowers of pink and purple. A further section contained a rose garden (plate 109), and beyond there was a Japanese-style garden of streams and pagodas. An orchard of pears and apples led to a cricket pitch; beyond that grassy alleys and shady paths culminated in a huge herbaceous border 'glorious in its riot of colour'. This was the famous 'Tudor' border. Here on either side of a wide eight-to-nine-foot path double borders stretched for nearly a hundred yards.

In 1911 the garden and this border are described in some detail in the *Gardeners' Chronicle* (7 October). The named plants seem to be no longer strictly from Tudor times, if they ever were. During the last two decades of the nineteenth century William Robinson, Inigo Thomas, Gertrude Jekyll and many others encouraged a return to a cult of what were called 'old-fashioned flowers'. Apart from the obvious cottage-garden theme, a major source of vernacular inspiration was found in the works of Shakespeare. Societies were formed for the searching for and recovery of vanished plants dating back to mentions in a Tudor herbal such as Gerard (1597) or in Parkinson's *Paradisi in Sole Paradisus Terrestris* (1629). At The Pleasaunce this was interpreted as a generalization; the border was called 'Tudor' in popular fashion, but in effect advantage was taken of the best herbaceous plants available at the time of planting. These were arranged in bold masses. Many different pyrethrums, and 'veronicas in variety, with anchusas, trollius, centranthus, *Erigeron* "Quakeress" [*E. speciosus* "Quakeress"], some of the best named varieties of *Papaver orientalis*. . . . For later in the summer *Chrysanthemum maximum*, potentillas, *Galtonia candicans*, montbretia [crocosmia], including the newer hybrids, many hybrids of phlox, *Harpalium rigidum* [*Helianthus scaberrimus*], liliums, gypsophilas, statices and other plants for autumn flowering, including a good and choice collection of Michaelmas daisies. The borders were also furnished with dahlias, summer-flowering chrysanthemums, *Eupatorium fraseri* [*E. rugosum*] and many annuals.

In Beatrice Parsons' painting *Overstrand* (plate 110), it is late summer and dahlias, Michaelmas daisies and many different-coloured gladiolus are flowering. It seems she particularly enjoyed depicting the latter, as many of her paintings show them. This must also reflect the taste of the garden owners. By the early 1900s some of the new French or English large-flowered hybrids (mainly hybridized from the South African *Gladiolus brenchleyensis* and crimson *G. gandavensis*) were tolerably inexpensive and were grown extensively in the ornamental garden and for picking. They are not easy to grow successfully in mixed borders, but will thrive between clumps of phlox, roses and dahlias – which enjoy the same rich soil. Corms are either planted in bare but well-manured soil in March or April, or planted in May, will perform late in the summer. In the latter case they can take the place in the border of groups of spring-flowering hardy annuals or tulips.

The method of edging at The Pleasaunce with large stones

over which rock plants scramble is effective. It is described in the article of 1911. 'The edging is composed of irregular low rockwork, in which has been planted a variety of Alpines, among the most conspicuous being *Campanula bavarica, C. pusilla* [*C. cochleariifolia*], *C. c. alba, Gypsophila repens rosea, Armeria maritima,* Aubrietias in variety, *Achillea tomentosa, A. argentea, Dianthus deltoides, Ionopsidium acaule,* Helianthemums in variety, Sedums, Saxifragas (a path of *S. hypnoides* "Kingii" measured 9 feet by 3 feet), *Thymus coccineus* and *T. lanuginosus.* This edging is not only attractive and full of interest but . . . requires little labour to maintain it in a proper order.'

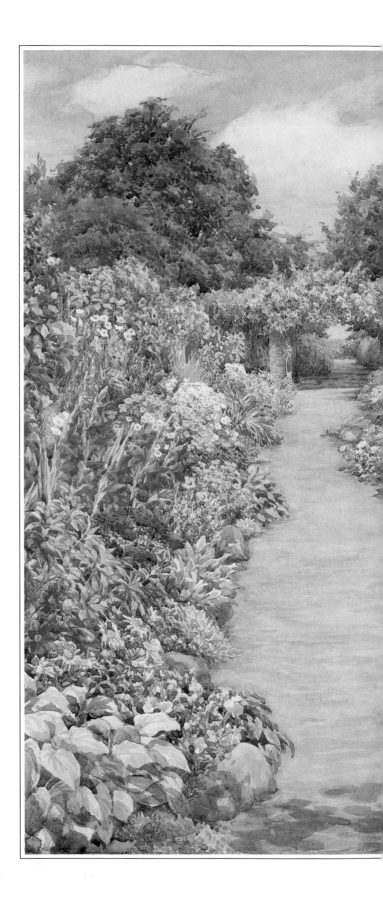

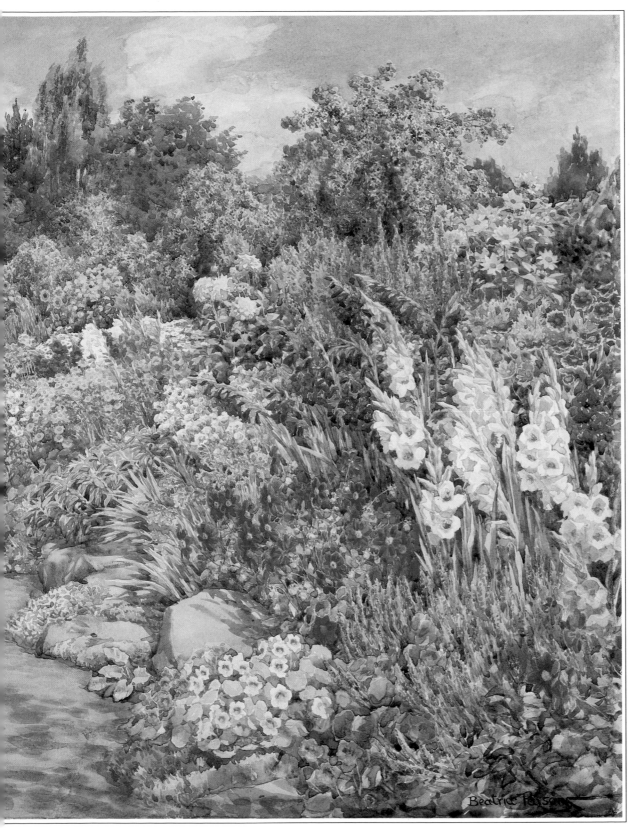

110. Beatrice Parsons. *The Pleasaunce, Overstrand*, Norfolk.

ROCKINGHAM CASTLE

Northamptonshire

111. George Samuel Elgood. *The Yew Alley, Rockingham Castle*, Northamptonshire.

Rockingham Castle, Norman in origin, stands on a high escarpment above the Welland valley. A natural site for fortification, Rockingham has been used for defence since Iron-Age times. Originally a royal residence, the castle was leased in 1544, and later bought outright, by the Watson family, who converted the medieval defensive castle into a domestic home with extensions and alterations which continued until after the Restoration. The next period of building improvements was the nineteenth century; in 1836 Richard Watson employed Salvin to renovate the interior and improve the exterior while maintaining many of the castle's Tudor features. The Saunders-Watsons who live at Rockingham today are direct descendants.

The gardens have been made on a series of terraces which rise round the house; on the north and west a seventeenth-century retaining wall replaced the original 'curtain'. The western terraces are divided by a double yew hedge, of billowing shapes resembling elephants (rather like those at Berkeley Castle) and the upper terrace, once a Victorian parterre of flower-beds, is now simply laid out in the form of a cross with grass and rose-beds. Beyond a raised and walled Mount, on the site of the old Norman keep, a circular Rose Garden is hedged with yew; beyond this, where once was the southern Norman bailey, is the Tilting Lawn; an old lime avenue and groups of cedars, tulip trees and a catalpa survive from the nineteenth century, hemmed in on either side by steep ravines. To the west the natural land fall has been fully exploited; at first formal terraces adjusted levels but by the end of the eighteenth century and during the nineteenth the Watsons gave this area a more naturalistic look: new varieties of trees and shrubs were planted in picturesque groves. In 1848 Joseph Paxton was invited to submit a plan for a formal water garden (plate 2) in the lower depths of this Wild Garden, although the design was not executed; instead later, George Watson extended existing ponds in more Robinsonian style, using exotic and native flora to fringe their banks.

The circular Rose Garden (illustrated in *Garden Ornament* and in early *Country Life* articles) has four arched entrances in the yew hedge which surrounds it. Originally rambling roses on rustic arches joined with swinging garlands formed an inner circle and formal flower-beds surrounded the outer rim of yew. Between the Rose Garden and the castle it was once supposed that treasure dating from a visit by King John in the thirteenth century was buried; after years of excavation the deep declivity has become a flowery dell.

The yew hedge alley (plate 111) between the upper terraces, painted by George Elgood at the end of the nineteenth century, may well be of seventeenth-century origin. It closely resembles the green alley at Crathes castle in Scotland (see page 123). Rockingham was visited by Charles Dickens and is generally supposed to have been the inspiration of Chesney Wold in *Bleak House*. Dickens wrote in the bay window looking down the alley, where the ghost of Lady Dedlock has been seen to wander.

The yew alley and Rose Garden still remain; borders filled with hardy perennials grow beneath the castle walls; indeed, Miss Jekyll, who wrote about the garden in *Some English Gardens*, would find little changed today except for the better. The most obvious improvements lie in the southern formal garden which was redesigned by John Codrington in 1910 when he was only fourteen; she would have approved of the new composition. John Codrington divided the flat garden area into a simple cross by much simplifying the elaborate Victorian layout; rose-beds planted with pink 'Pirneille Poulsen' were edged with lavender and catmint. In the Wild Garden beech, pterocaryas, hornbeam, groves of walnuts and a vast Sitka spruce (*Picea sitchensis*) survive and were added to by Commander Saunders-Watson's uncle; in the 1980s the demise of many old elms provides new vistas and space for more planting. In the valley gunnera, peltiphyllums and invasive petasites, plants which spread and need little maintenance, surround the water with tropical-looking foliage.

The gardens at Rockingham perfectly illustrate a combination of domestic formality round the old castle, entirely in keeping with its historic importance as a fortified site, with a romantic wilderness garden clothing the natural slopes which give the site such a dramatic quality. Fortunately both areas of the garden are maintained and cherished by the present owners.

TREBAH

Cornwall

It is pleasant and stimulating to write about a garden which combines a superb and dramatic situation, fully exploited when the garden was first made, with a rare and botanically interesting plant collection. It is even better to be able to talk confidently of such a garden's future. Between 1939 and 1980 Trebah changed hands frequently; as a result there was little replanting and minimum maintenance. Trebah now has a new owner, Major Tony Hibbert, who not only is a dedicated restorer but plans to establish a Trebah Foundation to raise funds for long-term development and maintenance.

The Fox family, Quaker shipping agents from Fowey and Falmouth, made many great Cornish gardens. Three, made by brothers in the first half of the nineteenth century, lie within a few miles of each other close by the Helford estuary on the south coast of Cornwall. Alfred Fox at Glendurgan, Charles Fox at Trebah and Robert Were Fox at Penjerrick all created spectacular gardens where planting began in the 1820s; the maritime pine from the Mediterranean, *Pinus pinaster*, was used to make shelter belts to protect plants from salt-laden winds. Stands of Monterey pine, *Pinus radiata*, introduced to Europe by Douglas in 1833, dominate most of the later garden sites (with *Cupressus macrocarpa* this pine was used extensively as a windbreak at Tresco). Most of the great plant collections are usually assumed to have been made after Sir Joseph Hooker's introductions from Sikkim in the middle of the century, but earlier it had become apparent that the high humidity and relatively mild winter temperatures in all west-coast gardens were ideal for many of the woody plants hitherto considered suitable only for glasshouses. As shipping agents the Fox family were in contact with owners and masters of clippers visiting the far east and southern seas, with opportunities to import exotic seeds which could be tried out in the favoured Cornish climate. These early experimental gardens set the scene for later development of many of our greatest plant collections.

Robert Were Fox of Rosehill gave Trebah to his youngest son Charles in 1842; he and his wife Sarah created the bones of the garden over the next twenty-five years, and, during the early

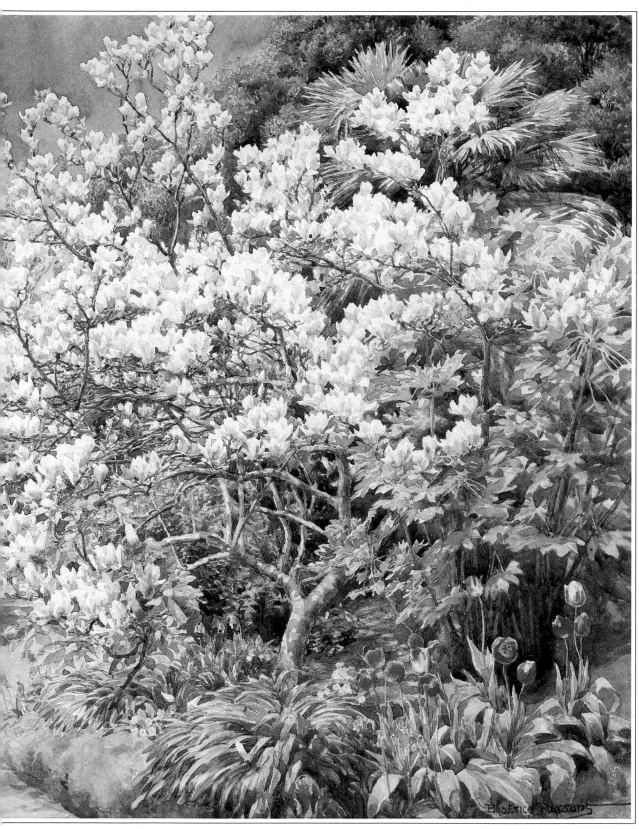

112. Beatrice Parsons. *Spring Garden with Magnolia Tree, Trebah*, Cornwall.

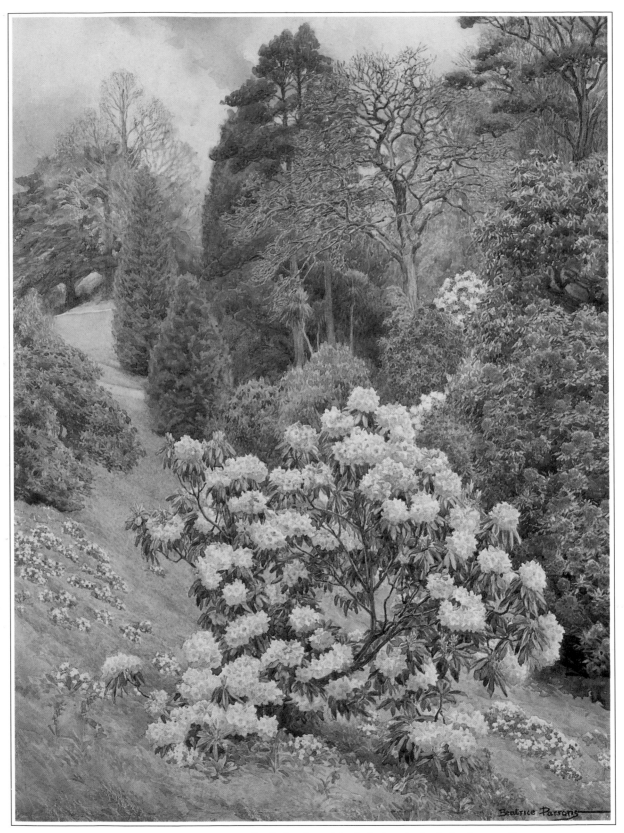

113. Beatrice Parsons. *Rhododendron 'Trebah Gem', Trebah*, Cornwall.

twentieth century many new plants were introduced. Trebah is situated on a low hillock just above a valley which falls dramatically down a steep ravine to the Helford river 230 feet below. To garden at all on this terrain it was necessary to lay paths following the contours with a sufficiently gentle gradient to allow access. In 1988, the results are theatrical: tall mature thujas (*Thuja plicata*, the western red cedar), *Podocarpus*, *Laurelia serrata*, an evergreen from Chile, Chusan palms (*Trachycarpus fortunei*), New Zealand tree ferns (*Dicksonia antarctica*) with shaggy brown stems and lace-like spreading fronds, and fine specimens of old arboreum rhododendrons clothe the valley sides, while still allowing a view to a pool and the Helford estuary far below. *Blechnum chilense* has spread in drifts under the trees while osteospermums in full sun carpet the rock at the head of the valley. The Canary Island fern, *Woodwardia radicans* (the walking fern, whose wide fronds have tip buds which root in adjacent soil) had spread to twenty feet across by 1904 and many other smaller sub-tropical plants flourish, defying recent bad winters which have decimated many of the great Cornish gardens. In fact judging from the lists of plants documented at Trebah in 1904 and 1907 by S. Windham Fitzherbert, it seems certain that lower winter temperature extremes prevail today.

After Charles Fox's death in 1868 little new planting was done until the early 1900s; by then a rare *Leucadendron argenteum*, the Cape silver tree from South Africa, and *Furcraea longaeva* were flourishing in the astonishing microclimate. However, Robert Were Fox at Penjerrick and afterwards his elder daughter Anna Maria continued to develop their garden, and not only by planting newly introduced trees and shrubs: their head-gardener raised rhododendron hybrids which were planted in the neighbouring Fox properties. In 1906 Mr and Mrs Charles Hext acquired Trebah and planting by skilled hands recommenced; pink flamingos and black swans added an exotic touch round the lower pool. Their head-gardener Harry Thomas was also interested in rhododendron hybridization and with Mr Gill of Tremough succeeded in crossing *Rhododendron arboreum* with *R. griffithianum* to produce 'Trebah Gem' with soft pink flowers and 'Trebianum', white with a red flush; it is the former which Beatrice Parsons painted, probably in the 1920s. Her painting (plate 113) illustrates Millais' *Rhododendrons* (1924 edition). Several fine specimens of 'Trebah Gem' now standing at forty feet, still survive at Trebah, and it is easy to identify the spot where Beatrice Parsons must have set her easel; the thujas across the ravine are grown huge today. Her second painting (plate 112) shows a magnolia in full flowering beauty, probably the Yulan, *Magnolia denudata*, backed by a tall Chusan palm. This painting is likely to have been done on the drive at Trebah, looking east towards the groves of camellias at the top of the slope. Identification of the exact site is difficult as the large Victorian mansion was destroyed by fire in 1948; today Major and Mrs Hibbert live in the old eighteenth-century house which adjoined the Fox's later building.

Most Cornish gardens reach their flowering peak in spring; this is also true of Trebah. *Magnolia campbellii*, *Cornus capitata*, *Pieris formosa* and *Erica arborea*, azaleas and rhododendrons fill the steep valley sides with scent and colour. A visit later in the season reveals fine flowering specimens of *Davidia involucrata* and *Cornus kousa* and a wealth of smaller moisture-loving plants which flourish by the sides of the stream-bed. Drought-loving beschornerias and yuccas thrive in rock faces. By August drifts of hydrangeas in full floral beauty fill the upper and lower reaches of the garden, their flower-heads decorative through all the winter months. But the drama at Trebah does not depend on fleeting flower colour. A great amphitheatre filled with exotic leaf shapes in different shades and textures of green curves round below the upper lawn and carries the eye down the ravine to the Helford waters far below; it is a garden view to be enjoyed in all the seasons.

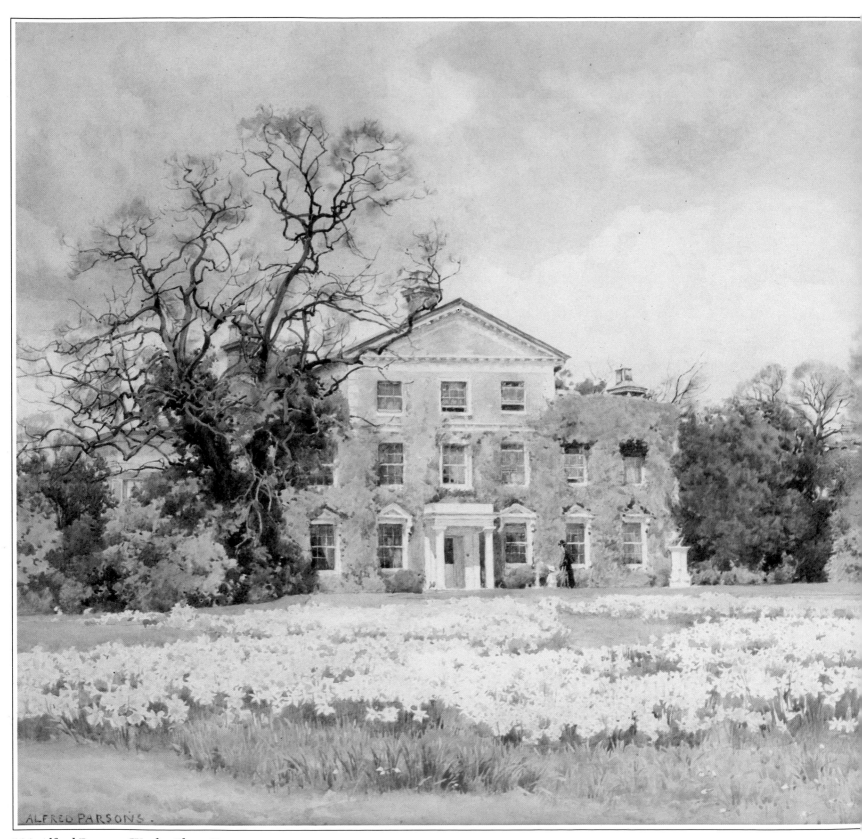

114. Alfred Parsons. *Warley Place*, Essex.

WARLEY PLACE

Essex

The whole estate of Warley Place near Brentwood, acquired by Miss Willmott's father in 1875, covered thirty-three acres; in 1882 her father acquired another twenty-two. Ellen Willmott was to inherit Warley after her parents' death (that of her father in 1892 and of her mother in 1898), but even during their lifetime she became the moving spirit behind garden developments. In 1875 she was eighteen and her sister Rose nearly fifteen (Rose was later to marry Robert Berkeley and to live at Spetchley Park in Worcestershire; she was grandmother to the present owners of Berkeley Castle). They were both to become gardeners, but the older sister Ellen became famous in the horticultural world both as owner of the Warley garden, where with a large team of gardeners, she experimented with plants and plant hybridizing, but also for her contribution to botanical horticulture and in particular her scholarly work, *The Genus Rosa*. This, with Alfred Parsons' illustrations, was published by John Murray between 1910 and 1914. In this book Miss Willmott described garden species roses and old garden forms and hybrids which she grew in her three gardens – Warley Place, Tresserve at Aix-les-Bains and Boccanegra at Ventimiglia; she had no interest in the new hybrids which were flooding the rose scene. Alfred Parsons painted the garden at Warley during the same period; four of his pictures are shown here.

In 1888 Miss Willmott inherited a fortune of £140,000 from her godmother, Countess Tasker; later, after her parents' death, she acquired these other gardens, as well as inheriting Warley Place. Thus she had wealth and opportunity; these attributes, combined with beauty and intelligence, made her formidable in her field. She is known to have been difficult and imperious, but also a generous friend. It is good to remember that her gardening enthusiasm dates from an early interest in wild flowers and 'natural' gardening and did not mark a rise in her fortunes or any ambition to be first in many fields.

At Warley Miss Willmott's mother, who was already a gardener, must have given her daughters encouragement. Both parents certainly recognized and indulged the gardening interest. In 1879 when she was twenty-one she obtained

permission from her father to lay out an alpine garden 'out of sight of his study window'; to the south-west of the main drive, below the bowling green. In April 1882 it was begun; mighty rocks of millstone grit brought from Yorkshire by the firm of James Backhouse and Son were piled into a gorge deep enough below higher ground to protect all future planting from harsh winds. It was hardly a natural rock garden site, but Ellen Willmott had boulders and stepping stones laid to look as natural as possible; a stream running through the centre towards the south pond, shown on the plan, provided humidity in winter and prevented harsh frosts. A cave stretching beneath the lawn nearer the house became a cool grotto where she collected native and New Zealand ferns. Meantime her sister Rose was laying out the main borders and Ellen gives her all the credit; Rose displayed 'a rare taste in effective grouping'. In 1881 her uncle Charles had emigrated to New Zealand, and he later sent seeds home to Ellen's mother; 'he was a fair botanist and a very good horticulturist and greatly interested in plants'; as a result plants from New Zealand were grown at Warley long before their general introduction to English gardens. In 1884 her father still had carpet beds in the garden, much disliked by his wife and two daughters; in the same year Ellen gave her mother a copy of *The English Flower Garden* by William Robinson. Gradually Warley became a known centre of garden innovation, but it was not until 1894 that Ellen, then aged thirty-five, joined the Royal Horticultural Society (in those days by invitation); she was now becoming established as a daffodil grower and hybridizer and within three years joined the Narcissus Committee. This marked the beginning of her horticultural influence outside the sphere of Warley Place itself. It seems appropriate that one of Alfred Parsons' paintings (plate 114), shows a spring view of the field before the house carpeted in drifts of the native *Narcissus pseudonarcissus* and some of its many hybrids produced at Warley. Ellen Willmott's diaries record her daffodil planting; but snowdrops, fritillaries, camassias (ten thousand from California for naturalizing), tulips and muscari were all planted in profusion. Miss Willmott was very professional; careful notes were kept of flowering perform-

ance; new hybrids were described, named and later distributed when of proven worth.

Sadly we do not have a Parsons painting of the famous rock garden, although a boulder in one of the paintings (plate 115) may place the group of white lilies in her rocky dell; today only the boulders remain, overgrown now with sycamore and ivy; alpines are not natural survivors and are easily smothered by vigorous neighbours. Contemporary writers give descriptions of *Primula sikkimensis*, gentians, countless sempervivums, tiny dianthus, trilliums, *Cistus* and erodiums, many of them treasures first acquired through her friendship with the Swiss horticulturist, Henri Correvon. She 'poached' another treasure, too, but apparently without incurring displeasure: Jacob Maurer, Correvon's garden boy, came to Warley in 1894 to become her head alpine gardener and propagator. Annual seed lists were printed at home for world-wide distribution; these remain an important source for any study of the range of plants grown at Warley by the hundred or so gardeners who worked there in its heyday. James Preece was in overall charge of the gardens but foremen under him looked after the alpines, the herbaceous plants, the roses, the chrysanthemums, and fruit and vegetables; each man had his own team. There were also orchid houses and hothouses to be maintained. Like Miss Jekyll at Munstead Wood, Miss Willmott herself worked in the garden; this clearly kept the men up to the mark but also insured that she knew the individual plants and watched them develop.

By the 1900s Ellen Willmott had become as well known in elite gardening circles as William Robinson and Gertrude Jekyll – all three gardening 'giants' who, in their time, stressed 'naturalism' in plant-growing and in garden layout. With Miss Jekyll, she received the Victoria Medal of Honour when this was first introduced by the Royal Horticultural Society in 1897; they were the only two female recipients among sixty men.

A plan of Warley Place (plate 118) signed by William M. Walker shows how the extensive garden areas were arranged. Old walled gardens lie to the north-west of the house, and the famous dell, Miss Willmott's rock garden, lies on the slope to

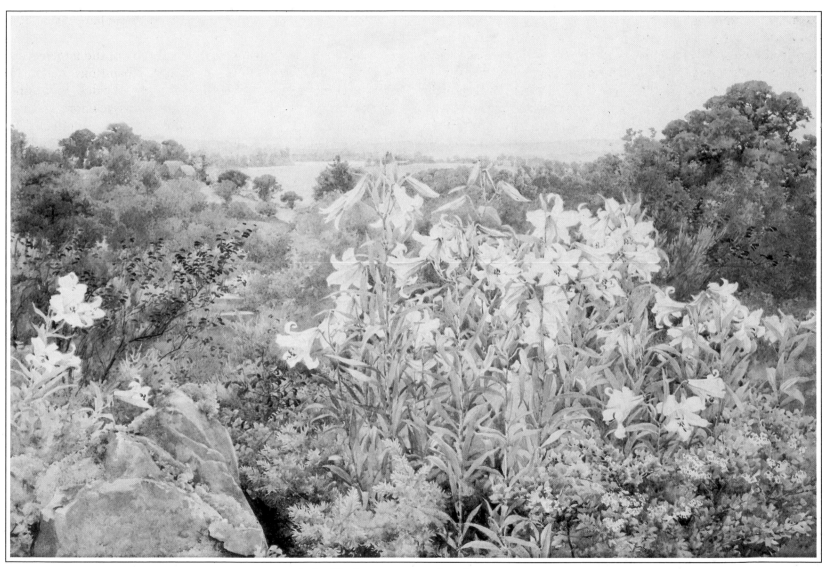

115. Alfred Parsons. *Warley Place*, Essex.

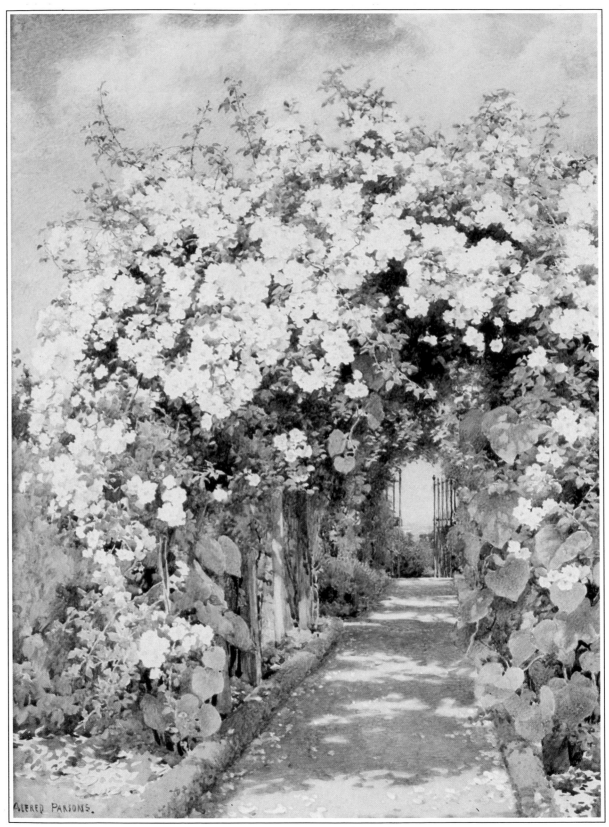

117. Alfred Parsons. *Warley Place*, Essex.

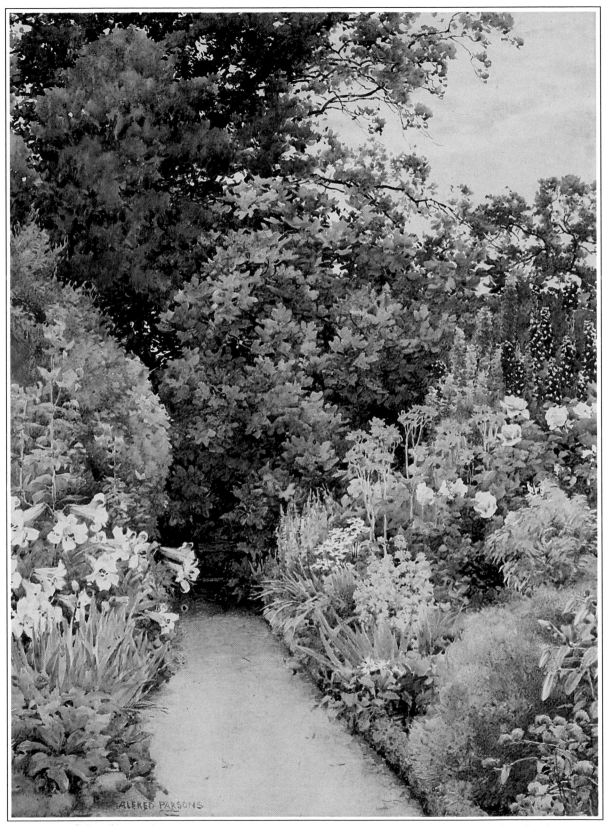

116. Alfred Parsons. *Warley Place*, Essex.

the south, towards the South Lodge. The Wild Bed is situated behind the Headley cottages and behind it the Well Mead Garden for Miss Willmott's rose collection; the Fuchsia Bed, the Strawberry Square, the Sycamore Bed in the main garden, the Walled Garden, the Headley Garden to the north-east, near where her sister and her husband Robert Berkeley lived, and the old orchard were all part of the garden. Alfred Parsons' paintings show the daffodil field and flower borders in the main garden, those borders which she gave credit to her sister in designing. It is impossible to identify the rambling rose with any certainty; it could be 'Aimée Vibert'. This scented rose, with double clustered white flowers, inherits its glossy leaves from *Rosa sempervirens*, and a repeat-flowering habit from *R.moschata*. First introduced in 1828, it is illustrated in *The Genus Rosa* and was one of Gertrude Jekyll's favourites. A vine, *Vitis coignetiae*, grows up the pergola and will produce its vivid autumn colours long after the rose has finished flowering. The summer borders, planted with a cool colour scheme of white, blue and yellow, seem to exemplify Robinsonian precepts, but some of the lilies planted in groups may be experimental rather than known to be reliably hardy.

Warley Place as a cohesive garden has vanished, but it is recognized that Miss Willmott's lasting contribution to horticulture lay in her love and interest in plants and her experiments in growing them in a natural way. Our gardens are the richer not only for her plant breeding but for the spirit in which they were grown. She was a somewhat flamboyant character, a beautiful woman who through misfortune went from riches to rags, a story which has poignancy as well as colour. Her name and that of Warley honours many plants which are still popular; in her day a 'Warley' garden cultivar was likely to be considered a good garden plant and was often awarded a Certificate of Merit from the Royal Horticultural Society. A number of newly introduced species such as *Corylopsis willmottiae*, *Ceratostigma willmottianum* and *Rosa willmottiae* also bear her name, in token of her financial support for plant-hunting expeditions as well as her fame. Among the plants named for her garden are *Helianthemum* 'Warley Rose' and *Crocus chrysanthus* 'Warley White'. There are many more, but perhaps the most personal of her plant connections lies with the biennial thistle *Eryngium giganteum*; it is always known affectionately as Miss Willmott's ghost – not only for its spectral almost luminous qualities when in flower, but because Ellen Willmott used to scatter its seeds in friends' and strangers' gardens without their knowledge.

Gertrude Jekyll described Ellen Willmott as 'the greatest of living women gardeners'. In its heyday her garden at Warley Place contained a hundred thousand species and was tended by one hundred gardeners. Today the property, privately owned, is in the care of the Essex Naturalist Trust. Graham Stuart Thomas visited the site in March 1986. He found a violet-blue carpet of *Crocus vernus*, an unadultered strain of the wild species, growing in the short grass under ancient oak trees. By tradition the seven Spanish chestnuts (*Castanea sativa*) found at Warley in 1875 may, with this crocus, have been planted by John Evelyn who owned the property from 1659–1666. It is nice to think that both these great gardeners have left an imprint on the place; Miss Willmott's planting of bulbs to naturalize is evidenced in the area which was the main garden, where thousands of snowdrops, mainly *Galanthus nivalis*, still survive and multiply. In the walled garden yellow aconites and sheets of blue scillas (*Scilla bifolia*) are equally prolific. It is even said that John Evelyn started his *Sylva* at Warley, although it would have been in an earlier house. However tenuous the connection Miss Willmott certainly enjoyed the idea that Evelyn had lived and planted at Warley before her.

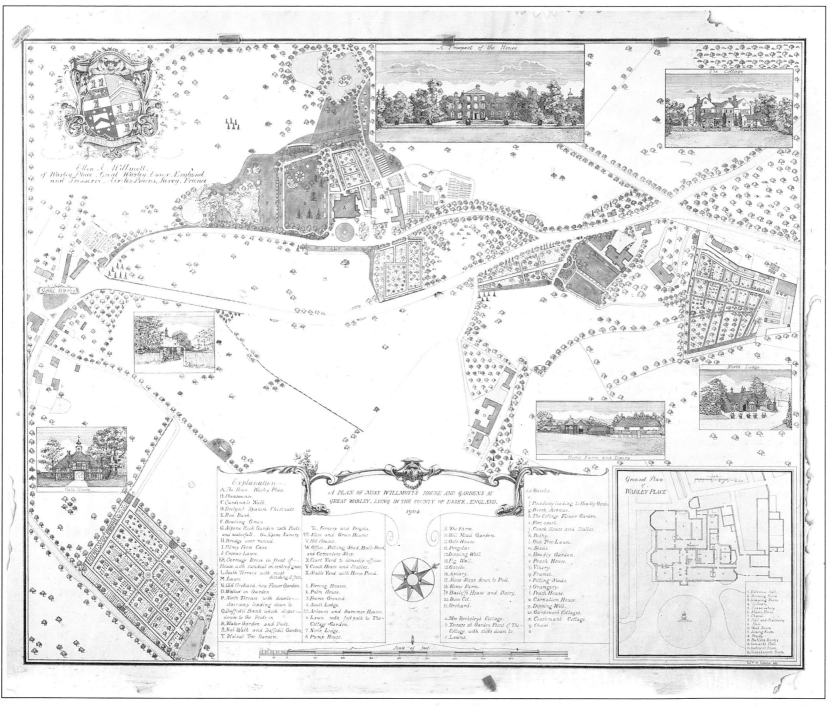

118. William Walker. *Plan of Warley Place*, Essex.

List of Illustrations

CREDITS

Rockingham Castle Collection 2
Reproduced from *Some English Gardens* by Gertrude Jekyll and G.S. Elgood 3,53, 60,68,73,75,76,85,93,96,111.
Rowe family 12,74,90–2,106,108.
Christopher Wood Gallery 14,15,16,17,18,28,35,36,38,48,54,61,62,64,70,71,78,80, 81,83,84,87,95,97,100,101,102,103,110.
Gavin Graham Gallery 26.
Studio Magazine 27.
William H. Frederick Jr. 31,32,33,40.
Bowood Collection Wiltshire 44.
Linley Library, Royal Horticultural Society 42–3,45–7,49–52.
Viscountess Ashbrook, Arley Hall, Cheshire 55,56,57,59.
Burlington Paintings 82,89.
Richard Green Gallery 94.
Victoria and Albert Museum 109.
Private Collections 1,4,5,6,7,8,9,10,11,13,19,20,21,22,23,24,25,29,30,34,37,39,41, 58,63,65,66,67,69,72,77,79,86,88,98,99,104,105,107,112,113,114–18.

Bibliography

JOURNALS

Architectural Review 1958–
Cottage Gardener 1848–1861 cont. as *Journal of Horticulture,*
Cottage Gardener 1861–1915
Country Life
Garden 1871–1927
Gardeners' Chronicle 1841
Gardener's Magazine (edited by J. C. Loudon)
The Garden History Society Journal
Flora and Sylva 1903–05
International Dendrological Yearbook 1970–1986
Journal of Garden History 1981–1987
Journal of the Royal Horticultural Society 1866–1975; cont. as
 Garden 1975–1987

GUIDES

Individual Country House Guides and Batsford Gardens of Britain
 Series

BOOKS

The Gardens of England Studio 1907–10
Gardens Old and New Country Life 1908

Allan, Mea *William Robinson 1838–1935* Faber 1982
Blomfield, Reginald *The Formal Garden in England* Macmillan 1892
Brown, Jane *Gardens of a Golden Afternoon* Allen Lane 1982
Brown, Jane *The English Garden in our Time* Antique Collector's
 Club 1986
Curtis and Gibson *The Book of Topiary* 1904
Desmond, Ray *Bibliography of British Gardens*
 St Paul's Bibliographies 1984
Desmond, Ray *Dictionary of British and Irish Botanists
 and Horticulturists* Taylor and Francis 1977
Elliott, Brent *Victorian Gardens* Batsford 1987
Fiennes, Celia ed. Christopher Morris *Illustrated Journeys*
 Macdonald 1982
Forsyth, Alistair *Yesterday's Gardens* Royal Commission of Historical
 Monuments 1983

Gilpin, William Sarwey *Practical Hints upon Landscape Gardening*
 1835
Girouard, Mark *Sweetness and Light: The Queen Anne Movement
 1860–1900* Oxford 1977
Godfrey, Walter *Gardens in the Making* Batsford 1914
Hellyer, Arthur *Gardens of Genius* Hamlyn 1980
Hervey, John *Medieval Gardens* Batsford 1981
Hobhouse, Penelope *Private Gardens of England* Weidenfeld and
 Nicolson 1986
Hunt, Peter *The Shell Gardens Book*
Jekyll, Gertrude *Garden Ornament 1918*
Jekyll, Gertrude and Mawley, Edward *Roses For English Gardens*
Jekyll, Gertrude and Elgood, George *Some English Gardens* 1904
Kemp, E. *How To Layout a Garden* Bradbury and Evans 1858
Law, E. *Hampton Court Gardens Old and New* 1926
Le Lievre, Audrey *Miss Willmott of Warley House* Faber 1980
Loudon, John Claudius *Encyclopaedia of Gardening* 1822
Loudon, John Claudius *Encyclopaedia of Gardening* 1835
Malins, Edward and Patrick Bowe *Irish Gardens and Demesnes from
 1830* 1980
Mawson, Thomas *The Art and Craft of Garden Making* 1926
Maxwell, Sir Herbert *Scottish Gardens* Edward Arnold 1908
Parsons, Beatrice and E. T. Cooke *Gardens of England* Black 1908
Pevsner, N. County Guides Penguin
Robinson, William *The English Flower Garden* 1933
Rockley, Lady *Historic Gardens of England* Country Life 1938
Sedding, John D. *Garden Craft Old and New* 1891
Smee, Alfred *My Garden* 1872
The Glory of the Garden Sotheby's 1987
Strong, Sir Roy *The Renaissance Garden in England* Thames and
 Hudson 1978
Tait, A. A. *The Landscape Garden In Scotland* Edinburgh 1980
Thomas, Graham Stuart *Gardens of The National Trust* Weidenfeld
 1979
Victoria and Albert Museum *The Garden* 1979
Ward, Cyril *Royal Gardens* Longmans Green 1912
Waterfield, Margaret *Garden Colour* Dent 1905

Index